A Thick and Darksome Veil

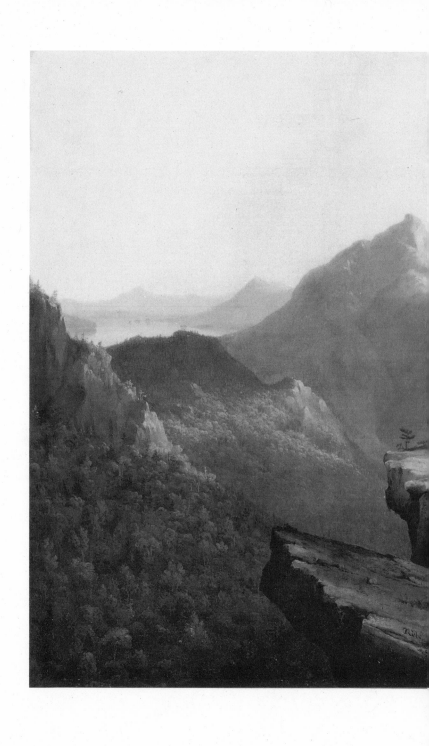

A THICK AND DARKSOME VEIL

The Rhetoric of Hawthorne's Sketches, Prefaces, and Essays

Thomas R. Moore

BOSTON Northeastern University Press

Northeastern University Press

Copyright 1994 by Thomas R. Moore

The frontispiece is *Cora Kneeling at the Feet of Tamenund* (a scene from Cooper's
Last of the Mohicans), by Thomas Cole. Reproduced courtesy of the
Wadsworth Atheneum, Hartford, Connecticut. Bequest of Alfred Smith.

Library of Congress Cataloging-in-Publication Data

Moore, Thomas R., 1941–
 A thick and darksome veil : the rhetoric of Hawthorne's sketches,
prefaces, and essays / Thomas R. Moore.
 p. cm.
 Includes bibliographical references (p.) and index.
 ISBN 1-55553-184-9 (cl)
 1. Hawthorne, Nathaniel, 1804–1864—Technique. 2. Rhetoric—
History—19th century. I. Title.
 PS1891.M66 1994
 813'.3—dc20 94-4527

Designed by David Ford

Composed in Weiss by DEKR Corporation, Woburn, Massachusetts.
Printed and bound by Thomson-Shore, Inc., Dexter, Michigan. The paper is
Supple Opaque Recycled, an acid-free stock.

In memory of my children,
Alexandra and Joshua

Preface

ON MAY 19, 1840, Hawthorne wrote to Sophia Peabody:

> It is not that I have any love for mystery; but because I abhor it — and because I have felt, a thousand times, that words may be a thick and darksome veil of mystery between the soul and the truth which it seeks. Wretched were we, indeed, if we had no better means of communicating ourselves, no fairer garb in which to array our essential selves, than these poor rags and tatters of Babel. (XV 462)

The recognition of language as a shifting entity — sometimes obscuring, sometimes illuminating the truth — is a thread weaving itself through the long fabric of Hawthorne's work. Although he is known as a writer of fiction, with veils and ambiguities shrouding his discourse in the tales and romances, it is the sketches, prefaces, and essays that fully reveal his preoccupation with the slippery, untrustworthy nature of language and rhetoric.

Market forces as well as artistic intention mediated Hawthorne's early writing: he had to write both within and against contemporary parameters of taste. One facet of the discourse of his early sketches is what I call in Chapter 1 a rhetoric of escape. Those who opposed the forces of economic expansion, those who during the first three or four decades of the nineteenth century perceived an erosion of U.S. values, often took refuge in the notion of a more idyllic past. This past was illustrated by the sentimental escapism in the discourse of Hawthorne's fellow authors in *The Token*, the gift book annual where he published several early sketches and tales. The paintings of Thomas Cole, whose work was also published in *The Token*, illustrate the contemporary predilection for idealized and romantic settings imbued with moral symbolism, the preoccupation with an imagined past believed to be purer and better.

xi

Hawthorne's early sketches, written within a specific historical
and social context, reveal a tension between the demands of his
readership for a sentimental and nostalgic style and his own demands
for a more truthful discourse and subject matter. But although he
addressed this first audience, Hawthorne also addressed a more
perceptive readership — Park Benjamin, the editor and critic, serves
as one example — who constituted a second audience.

Hawthorne was determined to publish, even if it meant playing
to popular taste, but he was equally determined to retain his artistic
integrity. He knew well the rhetoric of escape practiced by his
fellow authors in *The Token*, but he knew also how to undercut it by
practicing his own rhetoric of subversion. Much of his early sketch
writing stands squarely in opposition to the critical principles of the
first quarter of the nineteenth century that William Charvat ([1936]
1968) outlines in *The Origins of American Critical Thought: 1810–1835*.
These critical principles — one of which was that "literature should
deal with the intelligible, not the mystical or obscure" (21) and
against which Poe, Park Benjamin, and Melville chafed as reviewers
— inform us of contemporary audience expectation and serve as
the social, cultural, and moral norms that Hawthorne both ad-
dressed and undercut in his sketches.

The narrator in Hawthorne's sketches is himself a character, a
created persona who makes discoveries about himself as he lures us
into the text. Sometimes the narrator is a prober into others' hearts
("Sights from a Steeple"); sometimes he is a seeker of a past that
had a greater sense of community ("Fire-Worship"); sometimes he
is the contented, rummaging persona of "The Old Manse"; and
sometimes he is the historian of the moment, recording local events
and characters such as the old apple dealer in the Salem depot.

The dialectical nature of Hawthorne's discourse is sustained from
his early sketches to his last essays. Hawthorne assumed various
narrative postures in his sketches, and he proposed that some of his
readers would, at least on occasion, be his willing accomplices,
sympathizing with his implicit assumptions, agreeing with his skep-

tical observations. He could be self-critic, reviewer, humorist, sleight-of-hand artist, and instructor, at times admonishing and at times praising his readers. At other times, he could engage and then satirize his readers, as we see in the opening to "The Old Apple-Dealer" or in the moral appended to "Night Sketches." In his writing the negotiation takes place not only between the reader and the author, as in modern reader response theory, but among the reader, the author, and one of the author's several other selves as well.

Individual sentences reveal Hawthorne's negotiations — and games — with his readership. Insofar as his sentences are unified and harmonious, Hawthorne's discourse follows Hugh Blair's admonition in his *Lectures on Rhetoric and Belles Lettres* ([1783] 1965) that "simplicity" is "essential to all true ornament" (3). But insofar as the sentences are not pruned of superfluities and are purposely multivalent — thereby undercutting the expectations of his audience for easy intelligibility — his style may be labled a rhetoric of subversion.

Often his periodic sentences emblematize themes; the core sentence, a camouflaged image of the truth, is cloaked by modifying clauses and phrases. These veils allow the reader only masked images of the truth, and the discourse is thus mediated by reader as well as author. Hawthorne often sets the reader up to disbelieve him on one level so that another truth may emerge, perhaps in that "neutral territory," as he writes in "The Custom-House," "somewhere between the real world and fairy-land, where the Actual and the Imaginary may meet, and each imbue itself with the nature of the other" (I 36).

Rhetorical analysis may also be used to determine the Hawthorne canon with new accuracy. Scrutiny of the discourse of "The Haunted Quack," for example, a piece attributed to Hawthorne and published in the 1831 *Token*, suggests it is not his work at all. Characteristic cues of uncertainty and ambiguity are absent from the opening sentences as well as from the flat, matter-of-fact ending.

Hawthorne's fiction has overshadowed his remarkable *Our Old*

Home, a volume of essays drawn from his years as U.S. consul at Liverpool from 1853 to 1857. The discourse of the essays displays a rhetoric of oppositions, but the narrative voice is more assured in these later essays when contrasted with the coy and evasive earlier persona. The audience of *The Token,* satisfied with nostalgia and sentimental escapism, is a negative force on his early publishing; later, when Hawthorne is publishing in the *Atlantic,* the audience, although his political adversary, is a positive shaping influence.

Throughout his nonfiction, Hawthorne maneuvers and negotiates, both with himself and his audience. The discourse of "Chiefly About War Matters," published in the *Atlantic* in 1862, is ambiguous and ironic, refocusing attention on the multivocal Hawthornian text. Here he satirizes the convention of the footnote as legitimate textual commentary by commenting, as if in another persona, against his own text. Hawthorne's true voice, finally, is elusive and noncommittal. This analysis of the rhetoric of his nonfiction presents new approaches to reading his "thick and darksome veil" of language, and to discerning more clearly the images behind the mists, moonlight, and mirrors of his discourse.

<p style="text-align:center">* * *</p>

Quotations from Nathaniel Hawthorne's works and letters are from *The Centenary Edition of the Works of Nathaniel Hawthorne,* edited by William Charvat, Roy Harvey Pearce, Claude M. Simpson, and Thomas Woodson (1962–1988). References are indicated in parentheses in the text by volume number and page number.

Acknowledgments

MILTON R. STERN'S 1991 *Contexts for Hawthorne: The Marble Faun and the Politics of Openness and Closure in American Literature* has been the single most helpful critical analysis I have used in my study of Hawthorne's rhetoric. I thank Professors Lynn Z. Bloom, John J. Gatta, and Lee A. Jacobus for their provocative seminars at the University of Connecticut and for their encouragement to pursue research into Hawthorne's rhetoric. For resourceful readings during the preparation of the manuscript, I thank Helen M. Moore and Professors Sam Pickering, Michael Meyer, and Ann Phillips. I am indebted to the staffs of the Homer Babbidge Library at the University of Connecticut at Storrs, the Robert Hutchings Goddard Library at Clark University, the Mugar Memorial Library at Boston University, the American Antiquarian Society, and in particular to Richard Fyffe in the Special Collections Department of the University of Connecticut Library for locating key Hawthorne texts. I am very grateful to Boston University for financial assistance in the publication of this manuscript. I especially thank my friends Ann Taylor and Frank Blessington, and my wife, Leslie, for her multiple readings and unfailing support in the darker moments of this project.

Grateful acknowledgment is made to the following journals and organizations for their permission to reproduce published material.

Part of Chapter 3 of this volume appeared as "A Thick and Darksome Veil: The Rhetoric of Hawthorne's Sketches," *Nineteenth-Century Literature* 48, no. 3 (December 1993), 310–25. Copyright 1993 by the Regents of the University of California.

Acknowledgments

Part of Chapter 4 of this volume appeared as "Seized by the Button: Rhetorical Positioning at 'The Custom-House' Door," *Nathaniel Hawthorne Review* 18, no. 1 (Spring 1992), 1, 3–5.

Chapter 6 of this volume appeared in slightly different form as "Hawthorne as Essayist: *Our Old Home* and 'Chiefly About War Matters,'" *ATQ* 6, no. 4 (December 1992), 263–78. Reprinted by permission of the University of Rhode Island.

Four lines in chapter 6 from Ezra Pound, "Hugh Selwyn Mauberley," are from Ezra Pound, *Personae*, copyright 1926 by Ezra Pound. Reprinted by permission of New Directions Publishing Corp.

A Thick and Darksome Veil

1 Writing for Two Audiences:
The Rhetoric of Escape,
the Rhetoric of Subversion

> But with whatever motive, playful or profound, Nathaniel
> Hawthorne has chosen to entitle his pieces in the manner
> he has, it is certain that some of them are directly calcu-
> lated to deceive — egregiously deceive, the superficial
> skimmer of pages. To be downright and candid once
> more, let me cheerfully say, that two of these titles did
> dolefully dupe no less an eager-eyed reader than myself;
> and that, too, after I had been impressed with a sense of
> the great depth and breadth of this American man.
>
> — Herman Melville, "Hawthorne and His Mosses. By a
> Virginian Spending His Summer in Vermont"

IN A LETTER to Henry Wadsworth Longfellow dated June 4,
1837, a few weeks before Longfellow's favorable review of *Twice-told Tales*, Hawthorne wrote to his former Bowdoin classmate that he had "no consciousness that the public would like what [he, Hawthorne] wrote, nor much hope nor a very passionate desire that they should do so" (XV 252). The remark carries a peculiar mixture of tones — insensitive, aloof, facetious — and reveals a disdain for the marketplace and the literary appetites of the public. A question central to an understanding of the rhetoric of Hawthorne's sketches is the degree to which he wrote for the tastes and preferences of the readership of the gift book annuals and magazines where he first published. The subsequent question concerns the degree to which he chose to ignore those tastes and write to a more discerning — if more distant and inattentive — audience.

To determine if he "wrote down" to — and thereby satirized — the media and its readership, it is necessary to understand the media

3

in which he published. An analysis of the styles and themes of Hawthorne's fellow authors in *The Token* and the *New-England Magazine*, where he published several of his early sketches, will help to define the character of the medium he wrote for as well as the tastes of its readership. In addition to the audience, we must also take into account contemporary critical reaction to the gift books, particularly through the voice of Park Benjamin as editor of the *New-England Magazine*. As these two audiences emerge — the gift book readers and the more astute literary critics — in the following analysis, it will become increasingly clear that Hawthorne wrote for both — and how he did so. In subsequent chapters, when I analyze Hawthorne's sketches and prefaces as a response to marketplace forces, I consider how he used a rhetoric of subversion to fulfill the dual ambition of addressing two readerships.

The Token played to and reinforced the sentimental appetites and expectations of its nineteenth-century, predominantly female, middle-class readership. A gift book annual that went on sale in the autumn as a Christmas gift, *The Token* was tuned to the popular market and was expensive: Ralph Thompson points out in *American Literary Annuals & Gift Books: 1825–1865* that the 1838 volume, a special edition, sold for $5 (66). Regular editions sold for less. *The Atlantic Souvenir*, a gift book similar in style and format to *The Token*, sold for $2.50, with more elaborate issues selling for $3.75 or $4.50 (Thompson 7). This was in a time when Hawthorne spent nine cents for a glass of wine and a cigar (XV 237) and Thoreau two cents for a watermelon or four dollars for a thousand bricks ("Economy," *Walden*). Samuel Griswold Goodrich introduced *The Token* in Boston in 1827 and "was its guiding spirit, editor in name, at least, of thirteen of the fifteen issues, publisher of the first two, and the most reliable of contributors" (Thompson 65). Hawthorne published at least twenty-seven pieces in *The Token*; several other sketches and tales have been attributed to him but never included in his collected works. In Chapter 3 I discuss the rhetorical style of

one sketch of debatable authorship in the 1831 *Token*, "The Haunted Quack. A Tale of a Canal Boat."

The gift book, Thompson writes, was "an adaptation of the ancient and familiar almanac" (3). Nathaniel Ames, as well as the more famous Benjamin Franklin, was a writer and publisher of almanacs, and Ames began publishing his *Astronomical Diary* in 1726, eight years before Franklin's *Poor Richard*. Marion Barber Stowell in "The Influence of Nathaniel Ames on the Literary Taste of His Time" (1983) writes that "the almanac, with its 'conditioned' readership, was an ideal medium for inculcating an appreciation for literature in general and for poetry in particular" (143). As well as poetry, Ames wrote short essays for his almanacs, usually on health or astronomy; his *Almanack for 1755*, for example, includes the prose sketches "Diet," "Exercise," and "Of Air."

The combination of poetry and prose in an annual publication for consumption by a wide, general readership identifies the almanac as an ancestor of the nineteenth-century gift book. Stowell points out that "as many as 60,000 families were reading Ames's almanacs daily" between 1726 and 1764, many memorizing the poetry and proverbs (143). Ames included satires on the medical and legal professions, witty dialogues, predictions on subjects ranging from crops and weather to political change, calculations of eclipses and tides, and frequent jabs at womanhood. Directed at a rural readership — and, as Stowell says, "read by more men than women" — the almanacs frequently lampooned what Ames viewed as the pretensions of women and of town dwellers (139). For May in the 1745 *Almanack* he wrote, "Ladies appear in all their gay attire" (Briggs 183), and for July of the same year, "So much finery, so much Poverty" (183). For April 1750 he predicted, "French Fashions still in vogue. / *Joan's* back, must have a Sack" (Briggs 218).

Although the contents of the almanacs and the gift books were in some respects similar, the decorative — and pretentious — gift book annual was directed primarily at a rising middle-class and

female audience. The readership of the eighteenth-century almanac was drawn from a rural, agrarian society, but the gift book readership was becoming urban and industrial. "They [the gift books] appealed," Thompson says, "to the eye and the heart rather than to the mind; they were handsome and costly; they were 'artistic' and 'refined'" (4). It was not fashionable, Thompson notes, for men to concern themselves with spiritual affairs, particularly in these pre–Civil War years, and he continues,

> It was logical . . . that the gift books should be highly sentimental and exotic. Lords and ladies, far-off lands, and a somewhat impossibly glorious national history were normal products of romanticism as well as a means of transcending middle class existence. Tender and genteel verse satisfied emotional longings, unrealistic engravings the visual. (5)

These were the tastes of the audience that Hawthorne faced in his early publishing, tastes that, though alien to his vision, influenced the young author (he was twenty-six years old in 1830) eager to be in print: market forces as well as artistic intention mediated his early writing.

The rhetoric of the gift book annuals can be viewed as a manifestation of this desire for the "exotic" and the "unrealistic" in that both the prose and poetry of the gift books relied on a rhetoric of escape, a rhetoric that reinforced the normative cultural taste. Henry A. Beers, in his 1885 biography, *Nathaniel Parker Willis*, wrote that the fanciful gift book world had vanished, "brushed rudely away by realism" (79). He characterized both the gift books and the illusionary world they existed in:

> It was a needlework world, a world in which there was always moonlight on the lake and twilight in the vale; where drooped the willow and bloomed the eglantine and jessamine embowered the cot of the village maid; where the lark warbled in the heavens and the nightingale chanted in the grove 'neath the mouldering ivy-mantled tower; where the vesper chimes and the echoes of the merry bugle-ugle-ugle horn were borne upon the zephyr across the yellow corn; where Isabella sang to the harp (with her hair down) and the tinkling guitar of the serenader under her balcony made response. (78–79)

Beers describes here a rhetoric of escape, a romantic effusion of popular imaginings where euphemism is substituted for more pedestrian truth. "In the Annual dialect," he continues, "a ship was a 'bark,' a bed was a 'couch,' a window was a 'casement,' a shoe was a 'sandal,' a boat was a 'shallop,' and a book was a 'tome'" (79).

What I have termed here a rhetoric of escape, Ann Douglas places into both social and economic contexts of the 1830s and 1840s in her 1977 study, *The Feminization of American Culture*. Two forces, she suggests, were then surfacing in U.S. society: both the idea that industrialization and urbanization — the "masculine" goals — were the greatest good, and the opposing idea that such economic expansion eroded the "feminine" values, those she terms the "passive virtues . . . sorely needed in American life" (12). The parallel is clear between these two forces and Hawthorne's two audiences. On the one hand, we have the gift book audience, those who can be termed, in Douglas's phrase, "the champions of sensibility" (12) and sentimentality, made up of the "the ministers and women" (10) who saw as their mission the propagation of the "virtues of nurture, generosity, and acceptance" (10); on the other hand we find the critics of the gift books, the proponents of laissez-faire industrialism, primarily men, the best of whom, she says, demonstrated "toughness" and "had access to solutions" (11).

Those who opposed the forces of economic expansion could take refuge in a more idyllic past, could, in other words, *escape* from a harsh present through the gift book and its nostalgic presentation of what they, the readers, perceived as eroding U.S. values. Douglas writes that sentimentalism "is a form of dragging one's heels. It always borders on dishonesty but it is a dishonesty for which there is no known substitute in a capitalist country" (12). We see in her analysis the essence of Hawthorne's dilemma, the tug toward sentimentality and escapism in order to sell, the tug toward "higher" values in order to be true to his artistic calling. His sketches, written within a specific historical and social context, reveal a tension between the demands of his readership for sentimental prose and

subject matter and his own demands for a more truthful subject matter and style. In using a rhetoric of subversion — similar in some outward aspects to the other gift book contributors — in conjunction with a darker and more ambiguous subtext, Hawthorne, as we shall see, played to both audiences.

The art historian William Fleming writes that nineteenth-century romanticism "involved the psychology of escapism from an increasingly industrialized and mechanized world," and that "various escape mechanisms" included "revivals of the past, back to nature, and exoticism" (468). The rhetoric of the gift book annuals was a reflection of this artistic temperament (there were also other, opposing artistic temperaments, as we shall see), a rhetoric with its counterpart in the visual arts of the first decades of the nineteenth century. In the iconography as well as the rhetoric of the gift books, a romanticized and saccharine view of the world is depicted, an artistic stance common in contemporary portrait and landscape painting: magnificent waterfalls, grand sunsets, stylish trysts, and encounters with Indians in natural settings. American artist Thomas Cole, founder of the Hudson River School (Harbison 468), was a major force in U.S. painting during the decades of Hawthorne's early publishing. Cole frequently combined grand and romantic settings with moral symbolism in, for example, his two series "Course of Empire" and "Voyage of Life." Dean Flower, in "The Hallucination of Landscape" (1989), comments that in these two groups "he thought only to offer traditional Christian lessons about the vainglorious dreams of empire builders and the illusions of personal power and control" (751).

Cole's own description of "Voyage of Life" echoes the sentimental and romantic discourse of Hawthorne's fellow contributors to *The Token*. On March 21, 1840, Cole wrote to Rev. J. F. Phillips:

> There are many windings in the stream of life, and on this idea I have proceeded. Its course towards the Ocean of Eternity we all know to be certain, but not direct. Each picture I have wished to make a sort of

antithesis to the other, thereby the more fully to illustrate the changeable
tenor of our mortal existence. (Noble 211)

Cole was a poet as well, and his verse reflects what Marshall B.
Tymn describes as the parallel movements of "the Hudson River
School . . . [and] literary trends during the second quarter of the
nineteenth century" (Cole 15). In his poem "The Voyage of Life,"
Cole provides a seventy-eight-stanza verse accompaniment to his
allegorical paintings of the same name. Although his poems — 105
in Tymn's 1972 compilation — are a noteworthy accomplishment,
his style, in Tymn's estimation, is "little more than a conglomeration
of romantic techniques" (23). The stanzaic pattern of "The Voyage
of Life" is constant, five lines of iambic pentameter followed by an
irregular sixth, often with an added foot. The seventh stanza is
representative of the long poem:

> The song of birds uprose on every side
> And mingled sweetly in the jocund air
> That frolicked free across the dimpling tide
> And o'er that paradise of flowers so fair;
> And it did seem as though the sky and earth
> Sang choral hymns at some blessed Angel's birth.
> (Cole 146)

As well as reflecting Cole's moral and aesthetic values — and what
Tymn terms "a romantic fascination with the past" (21) — Cole's
other poems exhibit constant experimentation in rhyme, stanzaic
pattern, and figurative language.

The Token of 1831, in which Hawthorne had at least one sketch
(the authorship of another is contested), also included on page 55
an engraving by G. B. Ellis, "American Scenery," "from a Painting
by T. Cole in the possession of D. Wadsworth, Esq. of Hartford,
Connecticut" (vii). The painting — there are two almost identical
canvases, one in the Wadsworth Atheneum and one in the New
York State Historical Association in Cooperstown, New York (Bai-
gell 40) — depicts a scene in chapter 29 of James Fenimore Cooper's

The Last of the Mohicans. Cole finished the painting in 1827, the year following the publication of Cooper's novel. In the scene the Indians are gathered with their captives on a dramatic outcropping of rock, and, as the editorial comment in *The Token* makes clear, "it is not a view of a particular spot, but a combination of sketches from nature, taken in various parts of the country" (55). Critic Matthew Baigell comments in *Thomas Cole* (1981) that the painting reflected the contemporary desire "to dignify the wilderness with a real or imagined past" (40).

This "imagined past" composed from a "combination of sketches" links the historical moment in painting to the historical moment in literature. Both *The Token* and the work of Cole are informed by a rhetoric of escape that reinforces popular cultural taste, and, as Douglas has demonstrated, the sentimentality suggested by such escapism "always borders on dishonesty" (Douglas 12). Dean Flower further comments on Cole:

> none of [his] constructions offer to tell us anything about what the American architecture or landscape actually looked like to a viewer in the 1830s and 1840s. . . . Instead they offer preconceived constructions: allegories, projected visions, dreams of what the landscape ought to look like, and subjective nightmares of the reverse. (745–46)

Many of Cole's canvases from the time have a central dramatic focus on one object — a dead tree, a ledge, a waterfall — and the effect is of unreality, an idealized and romanticized view of what was once "the howling wilderness of the Puritans" (Baigell 11).

The iconography alone reveals the tone of *The Token* of 1831, in particular the images of womanhood. A half century later Beers described the gift book representations of women as "those steel-engraved beauties, languishing, simpering, insipid as fashion plates, with high-arched marble brows, pearl necklaces, and glossy ringlets — not a line in their faces" (78). The engravings, technically well executed, are indeed alien to a modernist critical sensibility, as they

portray cloying and artificial scenes such as the cherubim in a circular frame on the frontispiece, a delicate pitcher of flowers as background. The titles of the "Embellishments" suggest the style: "The Lost Boy" (27), "Just Seventeen" (141), and "Blind Mother" (187). Even "The Snow Shoe" engraving (285), accompanying a methodical poem of the same name, though it depicts a snowshoe accurately, places it incongruously across the lap of a fetching and wistful Indian girl. Idealized commonplaces about childhood, womanhood, motherhood, and Indian life color a harsher reality. Thompson writes that no contemporary critics

> had the acumen to criticise the illustrations as approximations of an abstract ideal. It was quite enough that they were by Americans and of America, that they portrayed refinement and the past rather than the reality of the present, and that they did not offend conventional conceptions of art, good taste, and beauty. (38)

In the *New-England Magazine*'s review of the 1832 *Token*, fully one-third of the critic's comments are devoted to the embellishments. The reviewer praises the "mechanical execution" of the book and writes that "some of the engravings . . . have not been surpassed in this country" (356).

In circuitous language the reviewer gives faint praise to the poetry in the 1832 *Token*, writing that "it might not be judicious to bestow much unnecessary praise on the poetical department" (356), but he does mention "Mrs. Sigourney, Miss Gould, and the Editor" — Goodrich — as names "sufficient to insure those who are fond of poetry against disappointment" (356). In his waffling praise of bad poetry the reviewer plays to the prevailing taste, sensing the true nature of the literary contents of *The Token*, but capitulating to the market and the taste of the moment. As I shall show in a moment, this was not the only critical stance possible: Park Benjamin, in his review of the 1836 *Token and Atlantic Souvenir*, is forthright in his comments on Goodrich's poetry. The 1831 reviewer of the 1832

Token — the gift book was published in September or October to guarantee time for pre-Christmas reviews and sales — also comments on the prose, but makes no mention of Hawthorne's four contributions: "The Wives of the Dead," "My Kinsman, Major Molineux," "Roger Malvin's Burial," and "The Gentle Boy." If the reviewer is Benjamin, these omissions and the faint praise of Goodrich's poetry reveal an as-yet-undeveloped critical discernment on his part — or reveal his fear of incurring a fellow editor's anger; in either case, the reviewer of the 1832 *Token* plays to the marketplace and to the sentimental tastes of both his and Goodrich's readership. Another prose selection, "My Wife's Novel," is rated the "best" of the prose pieces — better than Hawthorne's four stories — with the ambiguous qualification that it has "too many shapes of earth . . . to be entirely 'Fancy's Sketch'" (356). [1]

Lillian B. Gilkes in "Hawthorne, Park Benjamin, and S. G. Goodrich: A Three-Cornered Imbroglio" (1971) makes a strong case that this 1831 reviewer is Park Benjamin himself. Four years later, in his unrestrained 1835 denunciation of the literary taste represented in the gift books, Benjamin matures as a nineteenth-century H. L. Mencken — and as a champion of Hawthorne as well. Commenting on the 1831 *New-England Magazine* review, Gilkes suggests that we see a more tentative Benjamin as he develops his style and critical sense. Gilkes points out that he had been an early contributor to the *New-England Magazine* "with something in every issue from its first number — July, 1831," and that "Benjamin was assisting . . . editorially in the conduct of the Magazine" (83). Later, she notes that the 1831 review was written before Benjamin left Boston for New Haven to complete his law studies at Yale, and that the style of the review is Benjamin's as well: the "utterances and manner of expressing himself are unmistakeably [sic] Benjamin's" (88). Although Gilkes does not cite particulars, a comparison of the two pieces does reveal similar rhetoric in both the 1831 incipient reviewer and the 1835 confident critic. For example, both use the

first-person plural pronoun: in 1831 "we believe," in 1835 "we are disposed"; where the first voice is hesitant, but nonetheless making a definite evaluation — "Doubtless the better cultivated judgements of others might not agree with us" — the second voice, in the same circuitous and hypotactic style, is far more forthright: "If one could believe all that is said about it, it would be thought more splendid than were the illuminated tomes of the Alexandrian library."

The last third of the review of the 1832 *Token* quotes a long extract from "The Garden of Graves." Labeled "beautiful" by the reviewer, the sketch discusses the "favorable moral influence" of visiting a grave that "speaks in a voice full of tenderness and of truth" (357). The rhetoric echoes the contemporary conception of refined and moral thought. Death is personified as an armed warrior; the grave talks; youth is idealized; clichés and trite phrases abound: "youthful purity and truth," "humble confidence," "most dreadful." The sketch concludes:

> Does it [the grave] not bear its testimony to the value of youthful purity and truth, and of the power of an humble confidence in the Most High, to give dignity to the character of the young, and to disarm Death of the most dreadful of his weapons, even when he comes for his most dreadful work — to cut off life in the beauty of its morning? Does there not come up from his grave a voice, like that which comes down from the skies — a voice not meant for the ear, but addressed to the heart, and felt by the heart as the kindest and most serious tones of the living friend were never felt? (357)

Such graveyard literature reflects another aspect of sentimentality in the gift books.

In "The Domestication of Death," a chapter in *The Feminization of American Culture*, Ann Douglas points out that an attitude toward death such as we see in "The Garden of Graves" was part of what she terms "contemporary consolation literature" (201). Women and ministers in their writing "concentrated on illness and death: they were more interested in the moments at which crude energy failed

than in those at which it accelerated," because they were barred by
societal taboos from concentrating on sexual acts and childbirth
(202). Visiting the graveyard to talk to the deceased was a fashion-
able activity, and in the same year that "The Garden of Graves" was
published — 1831 — Mt. Auburn Cemetery in Cambridge, Mas-
sachusetts, was opened as the first American burial ground in the
new rural cemetery movement (208).[2] The same forces that were
responsible for the consolation literature "promoted and extolled
the rural cemetery and the innovative modes of burial which accom-
panied it" (208). The poem that concludes *The Token* for 1832
illustrates both consolation and graveyard literature. The first stanza
of "The Last Request," by B. B. Thatcher, reads,

> Bury me by the Ocean's side —
> O give me a grave on the verge of the deep,
> Where the noble tide,
> When the sea-gales blow, my marble may sweep —
> And the glistening surf
> Shall burst on my turf,
> And bathe my cold bosom, in death as I sleep! (319)

The attempt is to make death familiar, a more domestic event,
where the ocean will "sweep" the marble and the surf will "bathe"
the dead person's "cold bosom." Use of the pathetic fallacy is
common in gift book prose and poetry: in stanza 3 the speaker asks
the sea to spread "silent tears." The sense of the poem is that there
will be life in death, that the dead will indeed "sleep" (stanza 3) —
and perhaps be available for postburial graveyard communication
like Dickinson's two graveyard voices who talk "between the Rooms
— / Until the Moss had reached our lips — / And covered up —
our names — " (216). At this time the severe stones and inscriptions
of eighteenth-century churchyards gave way to more congenial
designs and verses that were meant to show that both the living and
the dead still cared. As a typical inscription of the time, an 1839
gravestone of a woman in the Riverside Cemetery in Barre, Mas-
sachusetts, reads, "Come children dear I pray draw near, / A mother's

grave to see, / A short time since I was with you, / You soon must follow me."

Orville Dewey's admonitory sketch, "The Mysteries of Life," opens the 1831 *Token* in the following fashion:

> To the reflecting mind, especially if it is touched with any influences of religious contemplation or poetic sensibility, there is nothing more extraordinary, than to observe with what obtuse, dull, and commonplace impressions most men pass through this wonderful life, which Heaven has ordained for us. Life, which, to such a mind, means everything momentous, mysterious, prophetic, monitory, trying to the reflections, and touching to the heart, to the many is but a round of cares and toils, of familiar pursuits and formal actions. (2)

Heavy with four subordinate clauses, Dewey's two hypotactic sentences are evasive and rambling. Sophisticated syntax is used in the service of sentimentality and emotional exaggeration, and the hypotactic structure further masks the nebulous and trite sentiment.[3] Hyperdramatic language — "extraordinary," "momentous," "prophetic," "touching" — is used to phrase an everyday truism: most "men" don't see the beauty of life.

Such language spoke to one segment of the nineteenth-century audience, a segment willing to purchase and read gift book annuals. As noted earlier, each age has a spectrum of literary tastes, and any drugstore or supermarket newsstand display today reveals our own propensity for the exaggerated, the sentimental, the dull, and the shocking. Later, in my discussion of Hawthorne's sentence styles in the sketches and prefaces, we will see the same subordinating style that Dewey used in "The Mysteries of Life" employed by Hawthorne to veil his own themes. Hawthorne's ambiguity, however, is intentional, part of the plan, even though often presented in the hypotactic, evasive rhetoric of his fellow authors in the gift books. Dewey concludes his piece:

> The bright cloud was borne as by the gentlest breath of air away from me; the features slowly faded, but with such a smile of ineffable benignity

and love lingering upon the countenance, that in the ecstasy of my emotions I awoke.

I awoke; the songs of the morning were around me; the sun was in the heaven; the earth seemed to me clothed with new beauty. I went forth with a firmer step, and a more cheerful brow, resolving to be patient and happy till I also "should see as I am seen, and know even as I am known." (23)

Hypotaxis gives way to a simpler paratactic style here, but clichés abound: "bright cloud," "gentlest breath," "firmer step," "cheerful brow." Such formulated phrases and pretentious escapism sold magazines and books in the 1830s: market forces dictated style.

In an unsigned review of the 1832 *Atlantic Souvenir* in the 1831 *New-England Magazine*, which follows on the same page the review of *The Token* discussed earlier, the reviewer, in all probability Park Benjamin, describes the readership's taste: [4]

> beautiful typography, expensive and finished engravings, and a gorgeous binding, have been so much surer passports to success, that, if we may judge from the contents, publishers have found it expedient to procure every thing to please the eye, and to offer little or nothing for the advantage of any other sense. . . . The books . . . if they contain an exuberant quantity of sickly sentimentality, or impure morality, and are, in effect, satires upon common sense and human nature, the publishers must be allowed to plead in justification that the error does not lie at their door; they furnish what the public appetite craves. (357–58)

In a forthright style presaging his later reviews, Benjamin notes here a satirical subtext of the sentimental prose, and shows how the tales and sketches — in modern critical parlance — deconstruct themselves by self-parody. With clearly unintended effect, the pieces in their "sickly sentimentality" satirize both the "public appetite" and the second-rate authors who pander to it. In Hawthorne's sketches, as we shall observe later, the satire — and the subversion — is intentional, because he is playing to two audiences: the gift book buyers and their reviewers as well.

The 1831 *Token* is subtitled "A Christmas and New Year's Present" and is edited by "S. G. Goodrich." Hawthorne had perhaps two pieces in this 1831 edition, one unsigned, "Sights from a Steeple," and one, mentioned earlier, of debatable authorship, "The Haunted Quack. A Tale of a Canal Boat," signed "By Joseph Nicholson." In the volume "Sights from a Steeple" precedes a poem written by Goodrich himself, "Lake Superior," ten plodding stanzas of unvarying *abab* rhyme in iambic tetrameter. Stanza 4 reads:

> Nor can the light canoes, that glide
> Across thy breast like things of air,
> Chase from thy lone and level tide,
> The spell of stillness, reigning there. (52–53)

Although Thompson politely terms Goodrich "the most reliable of contributors" (65) to his own gift book, Park Benjamin, in the October 1835 review of the 1836 *Token and Atlantic Souvenir,* calls Goodrich "a most wretched versifier" (Benjamin 295).[5] After suggesting that Goodrich should hold "the same rank in literature, as a quack vendor of universal nostrums in medicine" (295), Benjamin further demonstrates his critical sensibility by citing the author of "The Gentle Boy" — published in the 1832 *Token* without attribution — as "the most pleasing writer of fanciful prose, except Irving, in the country" (298).

Benjamin's review rises as a clear voice above the trumpery of the marketplace. Significantly, only a portion of the review — six or seven lines commenting directly on Hawthorne — is usually observed and quoted by critics, because those are the only lines that J. Donald Crowley includes in his 1970 compilation of Hawthorne criticism, *Hawthorne: The Critical Heritage.* The complete text of the review, however, reveals a devastating attack on literary cant. First deriding the "indiscriminate puffery" of the newspapers that "practice the grossest deceptions upon the reading community" (294) by advertising the gift book annuals, Benjamin then denounces the

middle-class hypocrisy and consumerism that account for the books' sales: "Few people, including those who foolishly spend their money for them, read the annuals. It was thought good taste, many years ago, to have them displayed upon centre-tables. It is now thought very bad taste" (295). Benjamin mentions "other instances of vulgarity in this 'gift for ladies,' which would forbid its presentation to a female by any gentleman of refinement" (297) — the diminishing of the generic "female" by comparison with the qualitative "gentleman" displays the contemporary sexist rhetoric. Benjamin offers these lines from "The Muse and the Album" by J. L. Gray as examples from "a wretched piece of doggerel": "The vixen, vexed because I *woke* her, / Was stiff as if she'd eat a poker!!" (297). Benjamin concludes his comments on the poetry by lambasting "I Will Forget Thee," another poem by B. B. Thatcher: "It is *first*, incomprehensible; *second*, silly; *third*, vulgar; *fourth*, far-fetched; and 'finally, to conclude,' altogether pitiable" (297).

The outspoken denigration of Goodrich's 1836 *Token* was, perhaps, an *ad hominem* attack. Wayne Allen Jones in "The Hawthorne-Goodrich Relationship and a New Estimate of Hawthorne's Income from *The Token*" (1975), points out that Benjamin was less cutting in reviews of two other 1836 gift books (112). Jones also notes the dual audience that Goodrich's gift books addressed, the reviewers and the readers: "In 1831 Goodrich must have been aware he was vulnerable to the barbs of reviewers whose tastes were more highly developed than those of most buyers of *The Token*, and whose sympathies could be eclipsed by a host of literary rivalries and personal misunderstandings" (113). Gilkes writes that Goodrich took Benjamin's attack "as a threat, seeing it as an attempt by an upstart to discredit him in the eyes of his publisher and his public" (94). It was Benjamin's ridicule of the poetry that drew "the yelps of rage" (Gilkes 94) from Goodrich in a later rebuttal. Whether Benjamin's barbs are directed at Goodrich or at bad poetry is of little consequence, however, since the result is the same; he labels

Goodrich's poetry "poor stuff" (295). Goodrich was driven only to make money from his publishing, Gilkes says, and he "didn't give a wooden nutmeg about lifting the standards of literature and art" (92). And Goodrich's relationship to Hawthorne reflects this mercenary attitude; Jones summarizes their dealings as a "pattern of exploitation as apparent to modern eyes as it eventually was to Hawthorne's" (95).

The literary quality of the sketches in the *New-England Magazine* was more sophisticated than the contributions to the gift books. A representative sketch, "A Rencontre on the Alleghanies," by "E. S.," was published in the November 1834 issue, the same one in which Hawthorne's "Passages from a Relinquished Work" appeared. "A Rencontre on the Alleghanies" is a frame narrative; an old man returning home meets a traveler and the old man describes his departure from New England for Kentucky, his prosperous life there, the massacre of his family by Indians, and his eventual pilgrimage home. The style is heavy with adjectives, as we observe in the first sentence: "The great national road, which traverses the vast ridges of the Alleghanies . . . often presents scenery of the most beautiful and imposing character" (359), and the author employs clichés, as the last sentences demonstrate: "The mists of the morning were by this time dissipated, and the sun shone forth with fervid brightness. I again mounted my horse, and continued, with new food for reflection, on my solitary way" (365). But except for the tired style created by so many adjectives and clichés, the suspense of the Indian massacre makes the sketch engaging.

We must not forget that heavy reliance on adjectives as a rhetorical strategy could be employed to great advantage by Poe, Hawthorne's contemporary. "The Fall of the House of Usher," published in *Burton's Gentleman's Magazine* in September 1839, begins,

> During the whole of a dull, dark, and soundless day in the autumn of the year, when the clouds hung oppressively low in the heavens, I had been passing alone, on horseback, through a singularly dreary tract of

country, and at length found myself, as the shades of the evening drew on, within view of the melancholy House of Usher. (1)

Poe's opening sentence has the same syntactical shape as Dewey's opening sentence for "The Mysteries of Life":

To the reflecting mind, especially if it is touched with any influences of religious contemplation or poetic sensibility, there is nothing more extraordinary, than to observe with what obtuse, dull, and commonplace impressions most men pass through this wonderful life, which Heaven has ordained for us. (2)

Both are hypotactic sentences that begin with prepositional phrases, attach adverbial modifiers, follow with main subject and verb, and end with a succession of modifying clauses and phrases. The difference between the two is that Poe's periodic sentence draws on the sound and the rhythm of the language and builds toward a climax; Dewey's sentence dwindles away. In *Analyzing Prose* (1983) Richard A. Lanham writes that the "periodic stylist works with balance, antithesis, parallelism, and careful patterns of repetition" (54) and that "things don't fall into place until the last minute, and when they do, they do with a snap, an emphatic climax. The juggler catches all the pieces, and takes his applause" (55). Dewey misses the moment, while Poe openly orchestrates the elements and then bows to his audience; Hawthorne, as we shall see in his rhetoric of subversion and ambiguity, directs and fine-tunes from the wings.

Poe's perplexing "Philosophy of Composition," published in *Graham's Magazine* in April 1846, presents another commentary on the double audience Hawthorne addressed. Poe's essay shows emotion at the service of intellect; he shapes an aesthetic at the borders of triteness and sentimentality that succeeds by its very acknowledgment of those qualities. "Beauty" is his "province"; "melancholy" is his tone, and the "refrain," the "rhythm," the "locale," and the "denouement" are laid out in crisp and rational detail. In "From Poe to Valéry" (1949) T. S. Eliot, after pointing out flaws in "The Raven,"

suggests that in "The Philosophy of Composition" Poe "was prac-
ticing either a hoax, or a piece of self-deception in setting down
the way he wanted us to think he had written it" (211). And the
essay can also be read as Poe's satire on his audience's predilection
for the romantic and the sentimental. Tongue in cheek, he gives
them a double dose of their own prejudices, and "The Raven" thus
succeeded — and still succeeds — by playing the tune the audience
wanted to hear. Poe's language not only satirizes the trite rhetoric
but transcends it.

In his 1973 study of Poe, Daniel Hoffman echoes this sentiment
as he writes, "We mustn't forget how much Edgar A. Poe liked to
trip us up — us, his readers, the very ones on whose complicity
with his designs his fame and immortality depend" (77). And we
must remember that these readers were essentially the same readers
whom Hawthorne was addressing. Hoffman continues,

> What, then, is the "philosophy" which Poe secretes in his poetic com-
> positions so that he may have the duplicitous pleasure of revealing it,
> so that he may revel in both the witless ignorance of those who cannot
> comprehend him and in injuring the sensibilities of those who can but
> find that they've been diddled by his mastering mind? (77)

Both Poe and Hawthorne toy with their audiences, Poe by playing
to their weaknesses and thereby satirizing them, Hawthorne by
ambiguous parody. Although both Poe and Hawthorne were finely
tuned to the market, and indeed were better than the market, both
perfected an undertone of subversion, audible enough to those who
would listen.

Returning for the moment to Park Benjamin's outspoken com-
ments on *The Token* for 1836, we see that the review is significant
in another respect as well, as it presents an essentially modern
literary sensibility in a nineteenth-century context and thus tends
to undercut one element of Jane Tompkins's otherwise excellent
argument in *Sensational Designs* (1985). In calling for a reappraisal of

Harriet Beecher Stowe and other nineteenth-century women writ-
ers, Tompkins asserts that "circumstances define the work" (7) and
that "novels and stories . . . offer powerful examples of the way a
culture thinks about itself" (xi). Hawthorne's tales, she writes, were
perceived as "completely ordinary" until 1836 "because the condi-
tions necesssary to their being perceived in any other way had not
yet come into being" (8). However, Benjamin's 1831 review of *The
Atlantic Souvenir* and the 1835 review discussed earlier work against
this stance in that they present astute critical evaluation of the
sentimental prose and poetry accompanying Hawthorne's pieces in
the gift books. Poe's May 1842 review in *Graham's Magazine*, in
which he labels Hawthorne an essayist as well as a storyteller, also
evaluates Hawthorne with modernist criteria, criteria that Tompkins
catalogues as "psychological complexity, moral ambiguity, episte-
mological sophistication, stylistic density, formal economy" (xvii). [6]
 A chart of the cultural tastes Hawthorne was addressing begins
to emerge; significantly, the tastes are not simplistic and sentimen-
tal, but twofold. We have on the one hand the readership of the
gift books, and on the other hand the critical voices of Park Benjamin
and Edgar Allan Poe. Richard H. Brodhead in the *The School of
Hawthorne* (1986) makes clear the distinction between the two levels
of authorship in mid-nineteenth-century America, a distinction cor-
responding to the two audiences I have delineated. The "social
status of authorship," he writes, was "refashioned," "creating a new,
inferior status for the popular writer, but also building for certain
literary writers a greatly augmented stature, as transcendent achiev-
ers and national treasures" (70). Brodhead also suggests that Haw-
thorne was "damaged" as a writer by his early publication in *The
Token*. "The short selection format," Brodhead writes, "miniaturized
his writing," requiring that he forgo plans for "larger compositional
structures" such as *Seven Tales of My Native Land*, *Provincial Tales*, and
The Story Teller (Brodhead 53; Stewart 30–31). Brodhead also points
out that the anonymity — or pseudonymity — of the authors in

the gift books undermined Hawthorne's attempt to establish "a public identity" (53).

Michael T. Gilmore discusses in *American Romanticism and the Marketplace* (1985) the dual nature of the contemporary audience. In commenting on Poe, Gilmore writes that he "had to deal with the problem of writing for the mass public. One would expect to discover that dependency on the market inspired [him] with a . . . mixture of accommodation and resistance" (11–12). Gilmore also points to Emerson's essay "Spiritual Laws," in which Emerson distinguishes between two readerships, "the partial and noisy readers of the hour" and "an eternal public," the latter being the only true judge of genius (202). In his often-quoted remark about "scribbling women" (XVII 304), Hawthorne chafed at the success of those who catered to popular taste, and, in Gilmore's words, "at the reading public whose preferences governed the market" (6). Significantly, the successful and the popular writers of the time were women (Gilmore 7).[7]

Economics and national pride were defining a new readership in the 1830s and 1840s. Gilmore points out that "belles-lettres had remained an upper-class or patrician pursuit" (3). The gift books thus appealed to those who were trying to improve their social positions, those who wished to show by outward display of a fancy book on the center table that they were socially acceptable. Ralph Thompson writes that "national wealth was rising" and that "among the people the dominant element was middle class, innocent, as a rule, of the habits of a leisured aristocracy" (3). Editors sought American authors to show foreign critics, who "sneered at American barbarity and crudeness" (Thompson 4), that a native literary tradition was emerging. In his August 1850 review of *Twice-told Tales*, Melville addresses this debate by calling on America to "prize and cherish her writers" and by comparing Hawthorne to Shakespeare, asserting that the difference between the still unrecognized American writer and Shakespeare "is by no means immeasurable" (119).

More significant for the discussion at hand, however, is the distinction Melville makes in the same review between Hawthorne's two audiences. Melville contends Hawthorne has been egregiously misread by the public: "the world is mistaken in this Nathaniel Hawthorne. He himself must have smiled at its absurd misconception of him" (116), and later, "Nathaniel Hawthorne is a man as yet almost utterly mistaken among men" (117). What emerges from Melville's discussion is one audience, the public, who misunderstands Hawthorne, who sees him as "a pleasant writer, with a pleasant style, — a sequestered, harmless man, from whom any deep and weighty thing would hardly be anticipated" (115). On the other hand, the critic Melville, like Park Benjamin and Edgar Allan Poe before him, constitutes a second audience, one that understands Hawthorne's complexity and evaluates him on the basis of other criteria such as Tompkins's "psychological complexity" and "moral ambiguity" (Tompkins xvii). Melville distinguishes between Hawthorne's two voices, which speak to two different audiences, in the following way: "For spite of all the Indian-summer sunlight on the hither side of Hawthorne's soul, the other side — like the dark half of the physical sphere — is shrouded in a blackness, ten times black" (115). Shakespeare, Melville asserts, is misread in the same way Hawthorne is. Shakespeare is remembered by the general public for his "Richard-the-Third humps and Macbeth daggers" (116) when the important aspects are ignored: "it is those deep far-away things in him; those occasional flashings-forth of the intuitive Truth in him; those short, quick probings at the very axis of reality; — these are the things that make Shakspeare, Shakspeare" (116).

Gilmore, in commenting on the Melville review, sees the dual audience in the following way:

> For Melville, in short, Hawthorne is an outwardly conventional author who smuggles into his stories dark, unpopular truths. He enters into a relation with the reading public marked by distance and manipulation,

not the ideal of mutual sympathy advanced by the review. Indeed, Hawthorne assumes the existence of two reading publics, a many . . . and a superior and discerning few. (59)

In *Twice-told Tales* (which includes several sketches first published in *The Token* that I analyze in later chapters), Hawthorne, Melville suggests, is consciously duplicitous, offering the same piece to be admired by different audiences for quite different reasons. And it is the polarities in Hawthorne's tales that account for nearly one hundred and fifty years of continuous popularity; he is admired today not for his sunshine and humor but for his ambiguity and his own "probings at the very axis of reality," the sort of spiritual maneuvering unpopular with gift book readers. But the polarities in the sketches, which are less popular today, are more difficult to discern. Melville comments on several sketches that intrigue him — "The Old Manse," "Fire-Worship," "The Old Apple-Dealer," "Monsieur du Miroir" — and suggests that "suffering, some time or other and in some shape or other, — this only can enable any man to depict it in others" (114). An analysis of the rhetoric of the sketches that Melville favored will perhaps help open them to modern readers.

Hawthorne's "two reading publics," as Gilmore calls them, may be considered within another context as well. In "Narrative of Community: The Identification of a Genre" (1988), Sandra A. Zagarell proposes that the response to industrialization occurring in the second two decades of the nineteenth century produced not only what I have labeled a rhetoric of escape but also a distinct literary enterprise, the narrative of community. This genre, Zagarell writes, gave "literary expression to a community they [the writers] imagine to have characterized the preindustrial era" (499). Where I have suggested that the gift book sketches were informed by a rhetoric of escape, by a flight *from* a troublesome present, Zagarell focuses on a pattern of preservation, a return *to* a less troublesome

past. Village sketch writers, predominantly women, "produced portraits of communities so focused and sustained that the communities have the quality of local cultures" (501). The intent was preservation of "the patterns, customs, and activities through which, in their eyes, traditional communities maintained and perpetuated themselves" (500).

Two selections in *The Token* for 1831 have characteristics of the narrative of community, though neither fits with ease fully into the category. In the unattributed "New England Village," the sketch — replete with Hawthornian guilt and secret sin — begins and ends in the speaker's village, a place where "All that nature ever did for a place, she has done for this" (155). Village industry is described: "Our forests are cut down for fire wood; our rocks hewn into state prisons"; they also "have straw bonnet manufactories, working societies, and reading societies" (155–56). The sketch ends on a note of nostalgia for a preindustrial past without "improvements": "I passed a few days with them, and took leave with the novel conclusion, that if there was any happiness in this world, it was to be found in a country village, where there were no 'improvements'" (176).

In the same *Token* "The Village Musician," by James Hall, has several characteristics of the narrative of community as well. The tale, strongly reminiscent of Irving's work, particularly "The Legend of Sleepy Hollow," which had been published only ten years earlier in 1820, gently satirizes the oafish main character, Johnny Vanderbocker, with Irving-like humor: "Often when a dance was ended, [Johnny] would continue to play on until admonished that his labors were unnecessary" (221). His love, Lucy Atherton, "the reigning beauty of the village" (224), spurns him in a fashion similar to the way Katrina Van Tassel, who was "so tempting a morsel" (Irving 827), spurns Ichabod Crane. The author supplies details of village customs and foods — "minced pies, egg-flip, and hot spiced gingerbread" (227) — and again ends on a nostalgic note, with Johnny

smoking contentedly "at the door of his cottage" (246). "The Village Musician" has as a four-line postcript (unattributed) from the Irish poet Thomas Moore's "The Harp That Once Through Tara's Halls."[8]

Hawthorne, in such sketches as "The Old Apple-Dealer," "Little Annie's Ramble," and "Sights from a Steeple," clearly participates in the narrative of community genre. One concern in these pieces is to record and preserve details of contemporary life: the railroad station peddler, the shop windows, the Sunday strollers in Salem. The impulse to write narratives of community, Zagarell says, was drawn from a commitment to render "the local life of a community to readers who lived in a world the authors thought fragmented, rationalized, and individualistic" (503). In analyzing the rhetorical shape of narratives of community, she writes that they "ignore linear development" and "remain in one geographic place. . . . They tend to be episodic, built primarily around the continuous small-scale negotiations and daily procedures through which communities sustain themselves" (503). In commenting on the narrator — a key presence in Hawthorne's sketches — Zagarell says the "narratives of community represent the contrast between community life and the modern world directly through participant/observer narrators, and these narrators typically seek to diminish this distance in the process of giving voice to it" (503).

Inasmuch as Zagarell's analysis focuses on elements to be found in several of Hawthorne's sketches, Hawthorne may be said to participate in this female-dominated literary tradition. Though the larger influences are male — Wordsworth, Scott, Irving — the genre, Zagarell says, was shaped mainly by middle-class white women (506). Among Hawthorne's fellow writers and competitors were many women, and in "Hawthorne and the Scribbling Women Reconsidered" (1990), James D. Wallace argues convincingly that the comment to Ticknor about "a d——d mob of scribbling women" (XVII 304) represented only a frustration of the moment on Hawthorne's part, not a lifelong bitterness or lack of admiration for

women writers. "In looking at the writing of the women he knew and read," Wallace writes, "Hawthorne saw abstracted qualities of his own writing," and "his response to them was structured by his satisfaction and dissatisfaction with his own accomplishments" (221).

Hawthorne's dissatisfaction was reflected in his social sphere as well. He could not easily be the great writer he wished and be accepted by society at the same time. Milton Stern, in his 1991 *Contexts for Hawthorne*, writes that Hawthorne had "opposing social and vocational identities" (41), and that the opposing forces led him in a circle:

> Hawthorne was both realist and dreamer, representative burgher and outcast. . . . Anything but an extrovert, Hawthorne nevertheless felt an impulse toward the conventional and gregarious. His avid desire "to open an intercourse with the world" was at least in part the desire for acquiescent belonging in an amiable and respected place in established society. (41–42)

Hawthorne had opposing identities, and he found as well that he was required to write for opposing audiences. Just as he never achieved a comfortable synthesis of his social and vocational identities, as Stern suggests, so in his early publication he never found a comfortable compromise in his perception of his audience: he had to write both against and within contemporary parameters of taste. To establish himself as an author, he found it necessary to address, in Emerson's phrases from "Spiritual Laws," both the "noisy readers of the hour" and the "court as of angels" at the same time (202).

2 "But tell it slant": Narrative Voice and Audience in the Sketches

We commonly do not remember that it is, after all, always the first person that is speaking.

— Henry David Thoreau, "Economy," *Walden*

PETER ELBOW explains the concept of multiple authorship in a nonfictional text when he writes (in "The Pleasures of Voice in the Literary Essay," 1989) that "always there are two 'authors' for any text: the implied author as it were *in* the text and the actual historical author as it were *behind* the text" (224).[1] In Hawthorne's sketches it is the inquisitive voice of the persona, not the voice of the historical Hawthorne, that controls and shapes the discourse. Hawthorne uses this "voice within" as a conscious rhetorical strategy and varies it from sketch to sketch, ranging from prurient inspector and manipulator of humanity in "Sights from a Steeple," to chronicler of social mores in "Fire-Worship," to objective recorder in "The Old Apple-Dealer," to rummaging historian in "The Old Manse," each voice reflecting a new facet of Hawthorne's shifting and evolving sense of self. Sometimes there are more than two authors at work in Hawthorne's sketches, insofar as the implied author can be a compound of voices. In setting out to characterize the narrative persona in the sketches just mentioned, my concern will be with what Elbow terms the voice in the text. I will also explore another rhetorical component that shapes the sketches, Hawthorne's perceived reader, or audience, often comprising the contemporary nineteenth-century readership of gift books and magazines.

Classification of Hawthorne's work is problematical: the distinctions between *tale* and *sketch, legend* and *biographical story, biographical*

29

story and *biographical sketch* — all terms George Parsons Lathrop uses in the 1883 edition of Hawthorne's works — are blurry. Indeed, the boundaries between fiction and nonfiction are indistinct in much of Hawthorne's writing: the imaginative faculties of the artist are always at play with the objective jottings of the recorder. We may question, for instance, whether or not "two ladies, swinging their parasols" ("Sights from a Steeple," IX 193), actually walked by the narrator's perch, and whether or not the old apple dealer actually had "a half-peck measure of cracked walnuts" ("The Old Apple-Dealer," X 440). We are never certain when Hawthorne is the nonfictional sketch writer and when he is the creator of tales.

The sketches, in their mix of personal observation with fictional techniques such as dialogue, scene, and characterization, lie between the factual recording of the notebooks and the psychological preoccupations of the tales and romances. First we discover the seeds for stories and the objective jottings in the notebooks, then the material reshaped into "essay" form in the sketches, then the fiction, with character — or symbol, in some cases — determining the narrative. In "The New Hawthorne Notebook: Further Reflections on the Life and Work" (1978), Hyatt H. Waggoner comments:

> If one knew Hawthorne only from the Notebooks, one might suppose that if he became a writer he would become a "realist," perhaps antici-pating Howells in his earlier work, an observer, recorder, and critic of the commonplaces of daily public life. But of course when Hawthorne wrote most creatively, he did not write this way at all. (223)

The categories can, finally, never be clear-cut — even though authorial intention *seems* to be clear in most cases — and arbitrary labels have to be assigned, at least for purposes of discussion, to differentiate between what is clearly a tale and what appears to be a sketch.

Another set of terms must be clarified for analytic purposes here: *sketch* and *essay*. Hawthorne did not call his pieces *essays* — with the exception of "The Old Manse" — even though the term had been in use since Montaigne's "Essais" were published in 1580 and Francis Bacon's "Essays" in 1597. But clearly Hawthorne is doing what essayists set out to do as they explore a topic in prose with the piece shaped by some organizing principle — subject, voice, or tone of voice — as well as by some inner shape, what Sidney in *The Defence of Poesy* (1595) calls "architectonics" (510), or the science of the order of knowledge. The 1889 edition of "the American *OED*," *The Century Dictionary*, published in New York and edited by William Dwight Whitney of Yale University, defines an essay as "a discursive composition concerned with a particular subject, usually shorter and less methodical than a treatise." The *OED* emphasizes the brevity of the sketch in comparison to the essay, defining a sketch as "a brief account, description, or narrative, giving the main or important facts, incidents, etc., and not going into the details; a short or superficial essay or study." We could add that while the essay tends toward the argumentative, the sketch tends toward the autobiographical or descriptive; and while the essay favors definition and seeks closure, the sketch favors exploration and deflects closure. But the form of the sketch, while resisting the firmer parameters of the essay, conforms to the essay in that both are short nonfictional prose forms relying on voice, audience, and subject as shaping forces. For purposes of discussion here, as well as for comparisons in Chapter 6 with other essayists, *sketch* and *essay* will be considered nearly equivalent, though not identical, terms.

We must recall also that Irving's popular *Sketch Book of Geoffrey Crayon, Gent.* had been published in 1819, only a decade before Hawthorne's first publishing efforts; the younger Hawthorne, not yet established as a writer when he wrote many of the sketches, may have chosen the term to associate himself with Irving's success.[2]

In "Hawthorne, His Narrator, and His Readers in 'Little Annie's Ramble'" (1987), Mary M. Van Tassel comments on the rhetorical shape of Irving's sketches:

> The sketch as popularized by Irving was a blend and modification of eighteenth-century didactic and travel writings, usually having two components — a frame consisting of introductory words from a modestly empathetic narrator presented as (and often assumed by readers to be) the author himself, and an inset fiction, often a series of sights selected to typify aspects of society about which the narrator makes moral observations. (168)

She goes on to contrast Irving and Hawthorne, making the illuminating suggestion that Hawthorne suppresses visual detail to throw "the weight of his sketches onto the narrative persona" (169), a point I will elaborate on. Although both Hawthorne and Irving draw upon local history for their tales and sketches, Hawthorne, in his association by guilt with his Hathorne forebears, differs fundamentally with Irving's romantic view of the past as an escape. Irving writes in "The Author's Account of Himself" in *The Sketch Book:* "I longed . . . to escape . . . from the commonplace realities of the present, and lose myself among the shadowy grandeurs of the past" (809). For Hawthorne, the past is no escape; the sins of his ancestors — both personal and national — are visited on him, burden him, and are exorcised by the act of writing. In the sketches, commonplace scenes in the present offer Hawthorne a certain escape or relief from the oppressive past, a past that resonates throughout his fiction.

The fifteen-year span of publication of the sketches under consideration here — from 1831 to 1846 — reveals Hawthorne's evolution from the reclusive Salem voyeur in "Sights from a Steeple" to the confident, socializing essayist in "The Old Manse." Several of the travel sketches — "My Visit to Niagara," "Rochester" — were drawn from Hawthorne's tour of 1832, discussed by Alfred Weber, Beth Lueck, and Dennis Berthold in *Hawthorne's American Travel*

Sketches (1989). Others — "A Rill from the Town-Pump," "Little Annie's Ramble," "The Old Apple-Dealer" — are rich with sociological detail of Salem in the 1830s and 1840s. In order to place them chronologically in the ensuing discussion, the dates of first publication follow: 1831, "Sights from a Steeple" and "The Haunted Quack"; 1835, "The Haunted Mind," "My Visit to Niagara," "Little Annie's Ramble," "A Rill from the Town-Pump," "Rochester," and "Sketches from Memory"; 1836, "Old Ticonderoga"; 1837, "Monsieur du Miroir," "The Toll-Gatherer's Day," and "Sunday at Home"; 1838, "Night Sketches"; 1843, "The Old Apple-Dealer" and "Fire-Worship"; 1846, "The Old Manse."

Hawthorne's narrator often emerges as a key character and shaping force in the sketches. In "The Old Apple-Dealer" the narrator is sly and elusive, playing good-natured games with both reader and subject. First, in Hawthorne's style of minute observation, amply evident in the notebooks, the narrator is the scrupulous observer: "Thus, unconsciously to myself, and unsuspected by him, I have studied the old apple-dealer until he has become a naturalized citizen of my inner world" (X 439). The narrator then dismisses the significance of the "faded and featureless old apple-dealer" (439) and in so doing piques the reader's curiosity, playing a sort of authorial reverse psychology: author manipulates persona who manipulates reader. The narrator says, in loose paraphrase, "It's pretty silly of me to be looking so carefully at this street peddler since there's nothing at all interesting about him." Because the reader wants to know at once why indeed the narrator is so fascinated by him, the reader is impelled to continue. The apple dealer cannot be so "faded and featureless" if he "has gained a settlement in [the narrator's] memory" (439), as we learn he has at the end of the first paragraph.

In the second paragraph, the narrator continues to engage the reader with a proliferation of detail about the apple dealer. The old man has a "gray stubble beard," "a shabby surtout of snuff color," "gray pantaloons," and a "thin, withered" face with a "moral frost"

on it. The paragraph ends with the reader-inclusive "you" pronoun
— "you pity him without a scruple" (440) — and the readers are
seduced: they must read on to understand the mystery of the *narrator's* interest in the old man. In the fourth paragraph the narrator's
powers of observation are underscored and compared to those of
ordinary observers — like the readers' — or those of the travelers
who rush by, unnoticing: "A slight observer would speak of the old
man's quietude. But, on closer scrutiny, you discover that there is a
continual unrest within him, which somewhat resembles the flut-
tering action of the nerves, in a corpse from which life has recently
departed" (441). But this narrative voice, shifting as we have seen
from self-deprecation ("It's silly to be watching this fellow") to self-
congratulation ("I am no 'slight observer'") must, we realize, be tied
to an actual observer, notebook in hand, standing attentively in the
railroad station. We may become as curious about this character as
we are about the apple dealer.

In *The Presence of Hawthorne* Waggoner emphasizes the central
importance of the narrator in "The Old Apple-Dealer," pointing out
that the only event in the sketch is what happens to the narrator.
The sketch, he says, "is purely descriptive and expository; in it
nothing happens except to the speaker, who gains a recognition
that alters his point of view, his way of seeing the apple dealer"
(22). Near the end of the piece the narrator admits the difficulty of
"sketching" his character, the narrator's humility further endearing
himself to the reader: "To confess the truth, it is not the easiest
matter in the world to define and individualize a character like this
which we are now handling" ("The Old Apple-Dealer" 444). My
point is that Hawthorne's narrator is himself a character, a created
persona whose good-natured observations lure us into the text as
much for discoveries about himself as for discoveries about the
subject. We find this same inspector of "the moral picturesque"
(439) perched above the town, equipped with a "pocket spy-glass"
(IX 193), in "Sights from a Steeple."

In this sketch, again the narrator is no less intriguing than his observations of the town. This self-labeled "watchman" (IX 192) selects a vantage point physically above his fellow creatures. This is the same narrator positioning we find in "Alice Doane's Appeal," a Hawthorne tale in which the narrator leads two young ladies to the summit of Gallows Hill (XI 266), and in "My Visit to Niagara," an early sketch in which the narrator from his "high seat in the sunshine" views his subjects "struggling against the eternal storm of the lower regions" (XI 286).

Both Irving and Hawthorne, it is interesting to note, preferred writing quarters aloft as well, Irving high in his Alhambra apartment in Spain "with a balcony overhanging the valley of the Darro" (Irving *Alhambra* 38), Hawthorne in his specially designed three-story writing tower at the Wayside in Concord. The elevated position in "Sights from a Steeple" suggests an element of control, or at least a desire for control, a puppeteer pulling the threads that animate the characters. It is as if the narrator has set the characters in motion, timed their encounters, and then projected himself into the action; he is the voyeur who prefers observation to action. In "Sights from a Steeple" the "young man" selects "the fairer" of the two girls to walk beside, the very one that the narrator speculated had "a treasure of gentle fun within her" (IX 193). "He has sanctioned my taste," the narrator says, "in regard to his companions by placing himself on the inner side of the pavement, nearest the Venus to whom I . . . adjudged the golden apple" (194). But, as if from guilt for such projection of self unto the scene, "the poor lover" is rejected when "the old merchant," the girls' father, "thrusts aside" the disconsolate youth (197).

The narrator, perched in the earthly house of God, assumes the role of creator, as well as the role of the minister as community leader. The scene he describes suggests a life cycle: incipient love between one of the "two pretty girls" and the young man, then war (the soldiers), commerce (the merchant), death (the funeral proces-

sion), and the grave. This cycle seems to be the narrator's chief concern: "The new born, the aged, the dying, the strong in life, and the recent dead, are in the chambers of these many mansions" (196). And the narrator also speculates about what goes on *inside* the houses — and hearts — of the people he views. His concern is guilt, a Hawthornian trademark:

> In some of the houses over which my eyes roam so coldly, guilt is entering into hearts that are still tenanted by a debased and trodden virtue, — guilt is on the very edge of commission, and the impending deed might be averted; guilt is done, and the criminal wonders if it be irrevocable. (196)

The narrator is fascinated by the possibility of probing into others' hearts, of controlling them like a "spiritualized Paul Pry, hovering invisible round man and woman, witnessing their deeds, searching into their hearts" (192), but he seems to counter this tendency by quickly shifting the visual focus in the next paragraph to another "fair street, extending north and south" in much the same way the youth is rejected after the abrupt meeting at the corner with the girls' father — all manipulated by the watcher and speculator from the steeple.

Whether "Sights from a Steeple" blends the fictional with the nonfictional is a moot discussion, but it is important to keep in mind that Hawthorne's observations are based on the actual town of Salem in the late 1820s and early 1830s during his so-called solitary years after Bowdoin. Few biographical details remain from this time, but Arlin Turner writes that Hawthorne returned with his family to "Castle Dismal," the Herbert Street house in Salem, after living beside his uncle Robert Manning near the North River in Salem from early 1829 to 1832 (47). Hawthorne read voluminously — between 1826 and 1837, 1,200 withdrawals from the Salem Athenaeum were made by his aunt Mary Manning and Nathaniel Hawthorne (Stewart 27–28) — and he took excursions to New Haven,

New York State, and New Hampshire. Although Salem was on the decline from its era as New England's second most populous town, it was still a relatively prosperous seaport with the aura and fascination of an international trading center.

The narrative voice is distinct and different in each of Hawthorne's sketches, and Van Tassel makes the point that the narrator is a "pervasive element," that he "weaves his way deeper into the fabric of the sketch, refusing to restrict his presence to framing positions" (169). Nowhere does this seem more evident than in "Fire-Worship," in which the narrator bemoans the loss of the social and spiritual center of the house, the open fire. Drawn from Hawthorne's residence at the Old Manse in Concord, the sketch is a plea for the preservation of a past without "improvements" that Zagarell details in her discussion of the narrative of community. It is the same desire for a more idyllic past observed in Hawthorne's fellow authors in *The Token* (see Chapter 1). Indeed, the narrator's repetition of the idea of loss, of his nostalgia for a past with a greater sense of community, is the thematic frame for the sketch. The narrator approaches his subject from successive angles: social historian, allegorist, clergyman (his predecessor in the house), and present occupant, as personified fire "whispers" and "moans" inside the airtight stove (X 144). These methodical angles of approach create a more contrived piece and a more self-conscious rhetoric than we find in "Sights from a Steeple" or "The Old Apple-Dealer." The narrator will never "be reconciled" to "the enormity" of the airtight stove (139); "social intercourse cannot long continue" now that firelight has been "subtracted" (145). What the narrator forgets, and what tends to subvert his paean to the past, is the yearly requirement of wood — sixty cords (141) — for the Old Manse's fireplaces. The annual consumption (a 4- by 4- by 480-foot pile) could not have been lost on the impoverished Hawthorne, and the contrast between an idyllic past and an "improved" present creates a dialectical tension sustained throughout the piece.

We discover, then, a different narrative voice in "Fire-Worship," social commentary with a conservative tone. Hawthorne here is the recorder of what he perceives to be a social event in eclipse, the fireplace and its attendant institutions of community and hearthside fellowship, and his created persona is the vehicle to argue the author's position. Zagarell, in discussing the focus of the narrative of community, comments,

> writers present details of local life as integral parts of the semiotic systems of the community, and readers are urged to recognize local language and activities like washing and gardening as both absolutely ordinary and as expressions of community history and values. (503)

The same focus is evident in "The Old Apple-Dealer," as Hawthorne, again "historian of the moment," is struck by the institution of the street peddler and is compelled to record it, to act as conservator of the past.

In "The Old Manse," on the other hand, the narrator concentrates on the present, recording the blissful moments of young adulthood and early marriage with only occasional references to the past as he muses over the old books he discovers in the house, mostly "dreary trash" (X 18). In "The Old Manse" the "abomination of the air-tight stove" can be postponed till "wintry weather" (28), as the narrator describes the couple drawing to the fireside in the October chill. The rummaging narrator, here, of course, close to the historical Hawthorne, picks through the garret — garrets provide the stuff of sketches — speculates on former inhabitants, and pauses to daydream at the north-facing window on "the obscure waters" of the river (6). He draws us a detailed picture of the grounds, from the "two tall gateposts of rough-hewn stone" (3) that lead us into the sketch, to the orchard, to the vegetable garden: beans, peas, corn, and summer squashes in "an endless diversity of urns and vases" (14). A tone of contentment, of a happy man with his young wife in a new Eden, characterizes the narrative voice in "The Old Manse."

In graphic contrast to "The Old Manse" — and thereby revealing the conflicts within him — Hawthorne also wrote two of his darkest tales during the three years' residence in Concord (July 1842 to October 1845): "The Birthmark" and "Rappaccini's Daughter."[3]

The audience as well as the persona shapes Hawthorne's sketches. Whereas in the notebooks Hawthorne addresses one of his several selves, and in the romances and tales addresses the public at large, the sketches were often composed with a specific audience in mind: the readership of a particular magazine or gift book annual. The first recorded publication of the sketches reveals the audience: "Sights from a Steeple" was first published anonymously in in 1831 in *The Token* (Clark 379); "Fire-Worship" was first published in 1843 in *The United States Magazine and Democratic Review* and was signed "By Nathaniel Hawthorne" (Clark 420); "The Old Apple-Dealer" was first published in 1843 by *Sargent's New Monthly Magazine of Literature, Fashion, and the Fine Arts* and was signed "By Nathaniel Hawthorne, Author of 'Twice-Told Tales'" (Clark 419); and "The Old Manse" was first published in the 1846 edition of *Mosses from an Old Manse.*

The discourse of Hawthorne's early sketches reflects to some degree the contemporary favoring of the sentimental and the romantic, but, significantly, Hawthorne seems aware of the concessions to contemporary taste he is making in order to be published. When his sketches are closely read, subject undercuts style. What we find most engaging and most Hawthornian in "Sights from a Steeple" — the good-natured, inquisitive narrator and the speculations on the "guilt . . . on the very edge of commission" (IX 196) in the townspeople — clashes with the discourse in which the sentiments are expressed. In this rhetoric of subversion, Hawthorne is caricaturing his fellow authors in *The Token* as he suggests that "guilt" may be committed by "the people covered by the roofs beneath" him (196): those who *appear* to take shelter in the sentimental and hypocritical notions of a "moral" social order may per-

haps be the first to lapse into sin, like Young Goodman Brown and
Arthur Dimmesdale. This shaking of a minatory finger at humanity
beneath him stands in direct contrast to the mood created by the
romantic and sentimental discourse.

The conclusion of "Sights from a Steeple" is a strained finale,
complete with pathetic fallacy:

> A little speck of azure has widened in the western heavens; the sunbeams
> find a passage, and go rejoicing through the tempest; and on yonder
> darkest cloud, born, like hallowed hopes, of the glory of another world
> and the trouble and tears of this, brightens forth the Rainbow! (IX 198)

Hawthorne's inclination to conclude the sketches with sentimental
endings, to use a rhetoric of escape for closure, is evident also in
"Night Sketches," to be discussed later, and "Sunday at Home,"
which ends: "There is a moral, and a religion too, even in the silent
walls. And, may the steeple still point heavenward, and be decked
with the hallowed sunshine of the Sabbath morn!" (IX 26). Indeed,
Hawthorne seems a bit embarrassed by his endings, his capitulation
to convention and civil pieties, as evidenced by his frequent use of
an exclamation point to punctuate the final sentence of the sketches.
He does not follow the advice he must have noted in Blair's *Lectures
on Rhetoric and Belles Lettres*, one of his texts as a first-year student at
Bowdoin (Stewart 16). "With respect to Exclamations," Blair states,
the writer "must be more reserved":

> Nothing has a worse effect than the frequent and unseasonable use of
> them. Raw, juvenile writers imagine, that, by pouring them forth often,
> they render their compositions warm and animated. Whereas quite the
> contrary follows. They render it frigid to excess. (357–58)

Because Hawthorne's final sentences often are not true exclamations,
the punctuation also indicates a certain uneasiness in what he is
about, an uneasiness mollified by the final, tentative exclamation
point.[4]

The modern reader grimaces at such endings, searching for, and

discovering, the essence of Hawthorne in *what* he says, not how he says it. We don't believe Hawthorne when he is sentimental because we know (most of the time) he knows better. That is not the case with the company he keeps in *The Token*: we suspect they believe in what they say as well as how they say it. Orville Dewey, whose sketch "The Mysteries of Life" opens the 1831 *Token*, concludes his piece in language similar to the conclusion of "Sights from a Steeple, " the sort of language clearly in Hawthorne's ear, but, significantly, language that does not have the underlying current of irony we discover in Hawthorne's prose. Dewey means exactly what he writes: "The bright cloud was borne as by the gentlest breath of air away from me; the features slowly faded, but with such a smile of ineffable benignity and love lingering upon the countenance, that in the ecstasy of my emotions I awoke" (23). Concern with narrative voice and audience is fundamental in Hawthorne's nonfiction. In his "station aloft" Hawthorne was perhaps shaped to a greater degree by his readership than the modern essayist who writes for a more eclectic audience. Yet, at the same time that he responds to his audiences, he undercuts them as well: Paul Pry can see inside the "deeds" and "hearts" (IX 192) of the townspeople. Moreover, what also unites Hawthorne with many modern essayists is a concern for remembering, for recording what is remarkable, for making the apparently insignificant valuable and memorable, so it will not be lost. This is Hawthorne's delight when, in describing "The Old Apple-Dealer, " he writes, "I have him now. "

In discussing the gift book and magazine audiences and the degree to which Hawthorne capitulated to them, Stern writes that "it would be foolish to pretend that he remained entirely above the influences exercised by the clearly established decalogues of the market within which he began to practice" (39). Hawthorne was determined to publish, even if it meant playing to popular taste, but he was equally determined to retain his artistic integrity; that is to say, he knew well the rhetoric of compromise or assurance practiced by his fellow

authors, but he knew also how to undercut it by practicing his own rhetoric of subversion. He was drawn two ways: to publish, and to remain true to his calling of artist. He was writing for and against himself as well as for and against his audience. Stern illustrates his dilemma "as the diametric opposition of basking within the sunshiny circle of those who belong or mooning with the outsiders in the chilly shades" (27). In *Literary Publishing in America: 1790–1850* (1959), William Charvat speculates that the provincial and unremunerative audience for which Hawthorne wrote also allowed him a freedom to experiment in both subject matter and style that the more successful Irving and Cooper did not experience (37).[5] Thus, Charvat suggests, Hawthorne's audience served him as well as hindered him, nudged him into satire, and invited him to explore new themes.

Dana Brand argues in "The Panoramic Spectator in America: A Re-Reading of Hawthorne's Sketches" (1986) that Hawthorne does not achieve "the panoramist's rhetorical ambition" in "Sights from a Steeple" (14), an ambition informed by the "flaneur" tradition — the "strolling or well-situated individuals who would observe and read urban crowds with a great affectation of ease" (6). Brand makes two points that help illuminate the discussion of both Hawthorne's narrative voice and his audience. First, Brand suggests that the sketches "may reflect Hawthorne's well-known ambivalence about the moral, as well as the epistemological, legitimacy of his art" (12). Brand then comments on the effects of an unsophisticated, non-European audience, writing that Hawthorne may "have been expressing his frustration about the cultural conditions under which, as an American writer, he was expected to write," and that he and other American writers were "constrained, by their audience and cultural situation" (13).

Brand's idea of "audience constraint" is fully documented by Charvat. In *The Origins of American Critical Thought 1810–1835* (1936),

Charvat sets out the underlying critical principles for the quarter century that was "the incubation of romanticism" and "the beginning of the best work of Emerson, Hawthorne and Poe" (3). These critical principles, against which Park Benjamin, Poe, and Melville chafed as reviewers, inform us of contemporary audience expectation and serve as the social, cultural, and moral norms that Hawthorne both addressed and undercut in his sketches. The first principle, Charvat writes, is that the critic "thought of himself as the watchdog of society"; second, that "literature must not condone rebellion of any kind against the existing social and economic order"; third, that "literature must not contain anything derogatory, implicitly or explicitly, to religious ideals and moral standards"; fourth, that "literature should be optimistic: it should not condone philosophical pessimism or skepticism"; fifth, that "literature should deal with the intelligible, not the mystical or obscure"; and last, that "literature should be social in point of view, not egocentric" (7–23).

Just as most of Hawthorne's fiction stands squarely in opposition to these precepts, so do many of the sketches as well. In "Sunday at Home," for instance, we observe Hawthorne subverting the third principle Charvat outlined as the narrator observes and comments on the "pious" churchgoers, all the while remaining "at home" himself. Hypocritical and sentimental "religious ideals and moral standards" are his target: "though my form be absent, my inner man goes consistently to church, while many, whose bodily presence fills the accustomed seats, have left their souls at home" (IX 21). Framed by references to sunlight on the steeple — "the sunrise stealing down a steeple" (19) and "the hallowed sunshine of the Sabbath morn!" (26) — the discourse clearly has a satiric subtext, one underscored by the "s" alliteration and the uncomfortable partnership of "sunrise," "steal," and "steeple." The audience of *The Token*, where "Sights from a Steeple" was first published, must have found the subtext astonishingly bold and subversive — if they understood

it. The sketch is complex; Hawthorne undercuts some conventions while he supports others. The steeple, the narrator suggests in ambiguous language, "reminds thousands of busy individuals of their separate and most secret affairs" and "speaks a moral" only to "the few that think" (20). The steeple has a "melancholy voice" and on weekdays a "moral loneliness"; the narrator finds the hymns more enjoyable from the *outside*, where "the music thrills through [his] frame, and plays upon [his] heart-strings" (24). If the sketch does not outwardly "condone rebellion," it surely chafes against, in Charvat's words, the prevailing "religious ideals and moral standards."

As one measure of the contemporary misreadings that Hawthorne endured, Andrew Preston Peabody's 1838 review of *Twice-told Tales* suggests that "Sunday at Home" is an affirmation of religious principles because it "could have been written only by one, who revelled in the hushed calm and holy light of the Sabbath, whose soul was attuned to its harmonies" (65). Peabody either does not observe the antiestablishment tone or chooses to ignore it. He praises "A Rill from the Town-Pump," calling it "a charming little idyll, as clear and refreshing as its own cool stream" (65). Four years later in an April 1842 *Graham's Magazine* review of *Twice-told Tales*, Poe astutely labels "A Rill from the Town-Pump" "the *least* meritorious" even though "it has attracted more of public notice than any one other of Mr. Hawthorne's compositions" (85). Peabody's critical position is informed by the principles Charvat identifies, the principles Hawthorne and Poe attacked, Hawthorne by acknowledgment and subversion, Poe — in this instance — by candid statement.

If "Sunday at Home" challenges the second and third critical principles Charvat outlines, "Night Sketches" stands directly against the fourth and fifth, that literature "should not condone philosophical pessimism or skepticism" and that literature "should deal with the intelligible, not the mystical or obscure." The sketch, subtitled "Beneath an Umbrella," is narrated by a dispassionate observer, quite literally an outsider, who peeks into windows and speculates about

the pedestrians he encounters. He is a self-labeled "looker-on in life" (IX 430), an alienated observer "wandering homeless . . . taking to [his] bosom night, and storm, and solitude, instead of wife and children" (431). As if in reply to the contemporary audience's expectation for the cheery and the bright, the discourse of "Night Sketches" resonates with images of pessimism and skepticism — conventions of the night: "a gloomy sense of unreality depresses my spirits" (427); "this is a lonesome and dreary spot" (428); "it is a cheerless scene" (429). When a "slender beauty" emerges from a coach and enters a "proud mansion," the thoughts that "Death and Sorrow" will visit the mansion "sadden, yet satisfy [his] heart." These thoughts, he says, "teach me that the poor man, in this mean, weather-beaten hovel, without a fire to cheer him, may call the rich his brother, — brethren by Sorrow, who must be an inmate of both their households, — brethren by Death, who will lead them to other homes" (431). "Night Sketches" stands squarely against — and thus subverts — contemporary audience expectation, the expectation fulfilled in such pieces (discussed in Chapter 1) as B. B. Thatcher's "The Last Request" and Orville Dewey's "The Mysteries of Life" in the 1831 *Token*.[6]

Hawthorne's focus on the mystical and the obscure in "Night Sketches" again dissents from popular expectation and from the fifth critical principle Charvat mentions in his outline of nineteenth-century critical aesthetics, that "literature should deal with the intelligible, not the mystical or obscure." "Fancy" is the narrator's muse, and "his words become magic spells" (426). A "sense of unreality" and "fearful auguries" come to him as he leaves his fireside (427); there is a "deceptive glare, which mortals throw around their footsteps in the moral world, thus bedazzling themselves, till they forget the impenetrable obscurity that hems them in" (429). Throughout the piece Hawthorne as chiaroscurist plays with images of illumination; figures and faces pass into momentary light and focus: a lamp "throws down a circle of red light" (428); beyond a

fire's warm light at the hearth the narrator warns that "darker guests are sitting . . . though the warm blaze hides all but blissful images" (431); and at the "utmost limits of the town . . . the last lamp struggles feebly with the darkness" (431). Finally, the sketch plays to the audience's taste for a conventional ending after depicting the dark and pessimistic panorama of humanity. (Dispensing with an exclamation point here, Hawthorne appears to have a more confident sense of his satiric thrust.) The last sentence reads, "And thus we, night-wanderers through a stormy and dismal world, if we bear the lamp of Faith, enkindled at a celestial fire, it will surely lead us home to that Heaven whence its radiance was borrowed" (432). For Hawthorne, this "lamp of Faith" can be no more tangible or trustworthy than Faith's pink ribbon, which "fluttered lightly down" in front of Young Goodman Brown and compelled him to cry, "'My Faith is gone!'" (X 83) on his journey to the blazing rock and the devil's baptism in the forest.[7] "Night Sketches" has subverted its trite moral: the rhetoric of escape, of reinforcement of the cultural norm, is quashed by its context.

Contemporary reader response critical theory shifts attention from a generalized "audience" to a generalized "reader" — and often subcategorizes that reader into "real" reader and "mock" reader (Walker Gibson) or "real" reader, "virtual" reader, "ideal" reader, and "narratee" (Gerald Prince). Gibson's distinction between the real reader and the mock reader is analogous to that between the historical author and the narrative voice, and, as Gibson writes, "the mock reader is an artifact, controlled, simplified, abstracted out of the chaos of day-to-day sensation" (2). We can understand the value of this concept for deciphering the subtext in Hawthorne's discourse if we ask ourselves the question that Gibson suggests the teacher of literature pose to himself or herself:

Is there among my students a growing awareness that the literary experience is not just a relation between themselves and an author, or even

between themselves and a fictitious speaker, but a relation between such
a speaker and a projection, a fictitious modification of themselves? (5)

Hawthorne consciously uses this multilevel addressee in the
sketches, asking the reader to participate in various transactions
imposed by the discourse. We become the kind of reader he wants
us to be, sympathizing with his implicit assumptions, agreeing with
the skeptical observations of his narrator. And if we, as readers,
reject the author's game, Gibson says, we have encountered a "bad
book, . . . a book in whose mock reader we discover a person we
refuse to become, a mask we refuse to put on, a role we will not
play" (5).

In the sketch "Fragments from the Journal of a Solitary Man," we
become willing mock readers. Hawthorne begins with some nimble
role-playing through the voice in the sketch, moving from historical
author to narrative voice — the first "I," which frames the narrative
— to Oberon, the second "I," the journal writer whose entries we
read. "Oberon" was Hawthorne's nickname at Bowdoin, as well as
the name of the jealous and manipulative fairy king in *A Midsummer
Night's Dream* whose flower, "love-in-idleness" (II i 168), imposes
roles on Titania, Lysander, and Demetrius. And it is Oberon in a
tale, "The Devil in Manuscript," who burns the manuscripts he
could not publish (XI 175–76), just as it is Hawthorne, in the preface
to *Twice-told Tales*, who writes that he had burned several of his
"condemned manuscripts" "without mercy or remorse" (IX 4). Con-
sider the following excerpt from the second paragraph of Oberon's
journal:

> Without influence among serious affairs, my footsteps were not im-
> printed on the earth, but lost in air; and I shall leave no son to inherit
> my share of life, with a better sense of its privileges and duties, when
> his father should vanish like a bubble; so that few mortals, even the
> humblest and the weakest, have been such ineffectual shadows in the
> world, or die so utterly as I must. Even a young man's bliss has not been
> mine. With a thousand vagrant fantasies, I have never truly loved, and

perhaps shall be doomed to loneliness throughout the eternal future, because, here on earth, my soul has never married itself to the soul of woman. (XI 314)

Hawthorne's expectation is that the reader will be as nimble in assuming the mock reader role as he — Hawthorne — is in his role-playing as narrator. To engage us in that role, he first elicits our sympathies: Oberon had no son, no "young man's bliss," no love, no marriage. "Oh, poor Oberon," he encourages us to say; "no soul-mate and no progeny!" But we also detect the triple-distancing Hawthorne is playfully imposing on us — Hawthorne to narrator to Oberon — and that sense of playful distancing allows us to chuckle at the then perceived self-pitying Oberon, who is really Hawthorne laughing at his own self-pity. We are willing mock readers because we see the game, and the discourse is set out in such a fashion that even the reader in Hawthorne's day, whose moral and social credos were based on the critical principles Charvat outlines, could participate.[8] Readers both then and now sense that the sketch is a vehicle for presentation of Hawthorne's own journal, for public display of his own dilemma as a young man. With a clearer picture of the author's biography, we can easily read the sketch as a mirror of Hawthorne's uncertainty as a young writer: his shifting and uncertain voice, his doubt about his calling.

"My Visit to Niagara" also places the reader in a willing role of mock reader through the assumptions it leads us to share about deferred enjoyment. We agree with the narrator's viewpoint about seeing the famous sight because we know that once we've seen it, done it, felt it, it's over: the allure of anticipation holds sway over the letdown of consummation. We sense why he wants to postpone the experience, savoring the moment to come:

Never did a pilgrim approach Niagara with deeper enthusiasm, than mine. I had lingered away from it, and wandered to other scenes, because my treasury of anticipated enjoyments, comprising all the wonders of

the world, had nothing else so magnificent, and I was loth to exchange the pleasures of hope for those of memory so soon. (XI 281)

The proleptic image anticipates a new wonder of the world in advance of the narrator's actual view of the falls. A quarter of a century later Hawthorne would have a similar reaction in Rome, writing in his *Italian Notebook* that Saint Peter's was not as overwhelming as its reputation, that it was "not so big as all out-doors, nor its dome so immense as that of the firmament" (XIV 59). (If the suggested litotes is at play here, however, we must read Hawthorne as uncertain or at least ironic in his description.) In "Rochester," a section of "Sketches from Memory," we are again engaged by the narrative voice, this time observing the occupants of a tavern, and we sympathize with the narrator's momentary unease as he sees someone "quizzing [him] through an eye-glass" (XI 303). As mock readers we feel as he does, and we participate in the scene. "That's the way I'd feel," we say to ourselves.

Hawthorne assumes various postures with his narrative voice and he proposes that his readership will, at least on occasion, be his willing accomplice as mock reader. As Nina Baym has phrased it, he set out "to develop a mode of authorship that would pacify an audience thought to be distrustful of imaginative activity" (*Shape* 84). By using a rhetoric of subversion he can satirize his nineteenth-century readers after engaging them in his games, perhaps without their knowledge, as we have seen, for instance, in the moral appended to "Night Sketches." The critical precepts Charvat sets out chart the beliefs that the nineteenth-century audience brought to their readings of Hawthorne, and Charvat thereby examines the rhetoric of reinforcement of the cultural norm that Hawthorne satirizes. An analysis of the rhetorical makeup of specific sentences will further reveal the complexities of Hawthorne's multilevel discourse.

3　Rhetorical Style: Text and Subtext in the Sketches

> One of the things I discovered is that rhetoric, in addition
> to being the synthetic art of how to put things together,
> how to compose something, was also a device with which
> you could look at something that had already been com-
> posed and analyze it and see how it was put together.
>
> — Edward P. J. Corbett, headnote to "Hugh Blair as an
> Analyzer of English Prose Style," *Selected Essays
> of Edward P. J. Corbett*

D URING HAWTHORNE'S first year as a student at
Bowdoin College in 1821–1822, his third term included the
study of Hugh Blair's *Lectures on Rhetoric and Belles Lettres* (Stewart
16). This text, which had gone through at least fifty editions be-
tween 1783 and 1835, was the most popular rhetoric in U.S.
colleges during the first quarter of the nineteenth century (Harding
xxvi). Drawing significantly on Quintilian's *Institutio Oratoria* (c. 95
A.D.), the lectures detailed the principles of classical oratory and,
in Blair's words, were "designed for the initiation of Youth into the
study of Belles Lettres, and of Composition" (3). Blair had been a
member of the Select Society in Edinburgh, a group of Scottish
education reformers whose focus was elocution and correct pronun-
ciation and who included in their membership David Hume, Adam
Smith, and Lord Kames (Bizzell and Herzberg 650).

One of Hawthorne's professors during that first year at Bowdoin
was Samuel Phillips Newman, author of the first American com-
position text, *A Practical System of Rhetoric, or the Principles and Rules
of Style, Inferred from Examples of Writing.* Newman's text focuses less
on elocution and more on written style and practice from example.
Although influenced by Blair and the Scottish rhetoricians, Newman
felt they had been too theoretical. Hawthorne boarded at Professor

51

Newman's house for at least part of his first year at college, and the 1832 edition of *A Practical System of Rhetoric* includes one sketch used as an "example of writing" that Louise Hastings argues convincingly is by Hawthorne himself.

Although Blair was accorded almost "spiritual reverence" (Bizzell and Herzberg 796) by nineteenth-century teachers of rhetoric, Hawthorne's own discourse reflects a blend of the unadorned and the elegant, a skeptical attitude toward Blair's admonition that "simplicity" is "essential to all true ornament" (Blair 3). By analyzing representative sentences from the sketches, I will demonstrate that Hawthorne's apparent stylistic simplicity is a veil, that his outward adherence to Blair's rules for "Structure of Sentences" masks a socially and culturally variant subtext that undercuts the contemporary critical principles articulated by Charvat in *The Origins of American Critical Thought, 1810–1835*.

It is Charvat himself, ironically, who cites Hawthorne as a straightforward and clear stylist. Charvat writes that in the first decades of the nineteenth century, prose style culminated in "the clear and simple style of Hawthorne" (111) and that *The Scarlet Letter* is "a model of good style" (116). Prose style is simpler to label than to analyze, and Charvat makes the easy assumption that Hawthorne's prose may without argument (or analysis) be termed "clear," "simple," and "good" — surprising judgments from Charvat, suggesting that he does not discern a secondary stratum in Hawthorne's discourse. Although Hawthorne's sentences may at first appear to be clear and simple, analysis reveals a subtext of ambiguity and subversion. After first summarizing the qualities that Blair lists "to make a Sentence perfect" (208), I will focus my discussion on the rhetoric of the opening sentences of two of Hawthorne's sketches: "Monsieur du Miroir" and "The Old Apple-Dealer."

In "Structure of Sentences," Lectures XI, XII, and XIII, Blair writes that four properties are "most essential to a perfect Sentence": "1. Clearness and Precision. 2. Unity. 3. Strength. 4. Harmony" (209).

Lack of clarity arises from "an ambiguous collocation of words" and may be avoided by placing "words or members most nearly related . . . as near to each other as possible; so as to make their mutual relation clearly appear" (209). This ambiguity — sense distorted within a sentence by ambiguous placement of words — is not the ambiguity we discover in Hawthorne, for he follows closely the rules Blair proposes for grammatical placement of adverbs and relative pronouns. Hawthorne's ambiguity, by contrast, is an ambiguity of theme, an intentional masking of meaning.[1] Of unity, the second characteristic, Blair writes, "there must be always some connecting principle among the parts" (216). Parentheses in sentences work against unity (222), and a unified sentence must have "a full and perfect close" (223).

For strength, the third principle, a sentence must be pruned "of all redundant words" (226); "after removing superfluities," Blair says, the writer must "attend particularly to the use of copulatives, relatives, and all the particles employed for transition and connection" (227). Strength is also achieved by having "the members of [the sentences] go on rising and growing in their importance above one another" because "in all things, we naturally love to ascend to what is more and more beautiful, rather than to follow the retrograde order" (237). For harmony, "the music of Sentences" (261) — Blair's fourth property — "we must be very attentive to vary our measures":

> This regards the distribution of the members, as well as the cadence of the period. Sentences constructed in a similar manner, with the pauses falling at equal intervals, should never follow one another. Short Sentences should be intermixed with long and swelling ones, to render discourse sprightly, as well as magnificent. (260)

Insofar as Hawthorne's sentences are unified and harmonious, his style follows Blair's admonitions, but insofar as the sentences are not pruned of superfluities and are purposely multivalent — thereby undercutting the expectations of the contemporary audience for

easy intelligibility — his style may be labeled a rhetoric of subversion.

The first sentence of "The Old Apple-Dealer" stands as a representative example of the way Hawthorne invites his two audiences — the popular and the literary — to read him in two different ways: "The lover of the moral picturesque may sometimes find what he seeks in a character, which is, nevertheless, of too negative a description to be seized upon, and represented to the imaginative vision by word-painting" (X 439). The sentence works with precision as a syntactic unit and builds to a climax: "the imaginative vision by word-painting." But this very precision contradicts the ambiguous content. Hawthorne says, in effect, "We moral types sometimes notice negative and insignificant characters we shouldn't write about" — and then he proceeds immediately to write about the character. He invites readers into the text by implicitly including them in the "moral" group, and by suggesting that he himself would never focus on such a negative and insignificant subject. The second sentence — "As an instance, I remember an old man who carries on a little trade of gingerbread and apples, at the depot of one of our rail-roads" — then proceeds to describe the person "of too negative a description" to be described. The self-labeled "moral" reader has unwittingly accepted the invitation to participate in an immoral enterprise: scrutinizing the old apple dealer in the depot.

The relationship between the first two sentences is slyly contradictory. If the "instance" is the character "of too negative a description to be seized upon," then Hawthorne is doing exactly what he — or his narrative persona, the implied lover of the moral picturesque — said ought not be done: he is initiating his "word-painting" of the "too negative" character. Another interpretive option is that the implied "we" — the author and his audience — are not included in that group, "the lover[s] of the moral picturesque"; that option, however, was not available to the moral readers — unless they

knowingly participated in the subversive game and projected them-
selves into the immoral group only for the moment, only long
enough to read Hawthorne's sketch. And the very cues in the
discourse that engaged and assuaged the contemporary reader —
"moral" and "too negative" — are cues to the modern reader, more
attuned to the ambiguities in Hawthorne's discourse, that the author
is being characteristically slippery.

In another sketch, "Monsieur du Miroir," Hawthorne's extended
hypotactic sentences engage the audience by encircling the readers
in subordinate clauses, making the content secondary to the bur-
geoning and dense syntactic foliage. The opening sentence ascends,
"growing in its importance to the very last word" (Blair 239), and
both sentences have a seductive cadence as well. But the sketch is
a game, a little joke of author upon reader, with verbal cues from
the outset ("beneath the surface" and "such grave reflection") that
"mister mirror" is indeed the narrator himself. The subversive per-
spective of the discourse lies in the speaker's implied schizophrenic
nature, his two selves, one within the mirror and one before it; the
extended implication is that reality itself is dualistic, shifting, am-
biguous. Such a literary configuration directly opposes the contem-
porary critical principle that "literature should deal with the intel-
ligible, not the mystical or obscure" (Charvat 21). [2]

The incremental building of the two opening sentences of "Mon-
sieur du Miroir" underscores the ambiguity:

MONSIEUR DU MIROIR

Than the gentleman above-named, there is nobody, in the whole circle
of my acquaintance, whom I have more attentively studied, yet of whom
I have less real knowledge, beneath the surface which it pleases him to
present. Being anxious to discover who and what he really is, and how
connected with me, and what are to be the results, to him and to myself,
of the joint interest, which, without any choice on my part, seems to
be permanently established between us — and incited, furthermore, by
the propensities of a student of human nature, though doubtful whether

M. du Miroir have aught of humanity but the figure — I have determined
to place a few of his remarkable points before the public, hoping to be
favored with some clew to the explanation of his character. — (X 159)

The inverted syntax beginning the first sentence cues readers to be
wary in venturing into the discourse; the prepositional phrase "be-
neath the surface" is a second cue that sublevels of meaning will be
the narrator's focus in the sketch. And the second sentence, opaque
in style, winding through parenthetical and successive adverbial
clauses, leads readers beneath the surface, into the text, rendering
them participants in the transaction for meaning. Readers are be-
witched by the opaque style and succumb; by the time they reach
the final prepositional phrase, they may well have lost sight — and
the sense — of where they began.

The successive adverbial clauses following the opening clause —
"Being anxious to discover" — spiral the readers into the vortex of
the sentence. "Who [he is]," "what he . . . is," "how connected with
me," "what are to be the results," lead into the core sentence "I have
determined." It is a self-conscious, opaque style; the readers are
lulled by the evasive medium and resist, or forget, the message —
the schizophrenic, double nature of reality — while the forgetting
of it is the author's intent. The self-consciousness is underscored by
the polyptoton in the second sentence, "a student of human nature
. . . aught of humanity," and by the Latinate diction. The dash
following the second sentence — readers are unsure if the sentence
ends or continues — promotes the conscious syntactic ambiguity.
The third sentence (or the continuation of the second, as the case
may be) ends with the suggestion that the readers are indeed now
part of a "dark investigation" led by "a blind man's dog." The sen-
tences are periodic, with a structure based on subordination and
rank as opposed to paratactic equality. Lanham writes that in the
periodic style "the mind shows itself after it has reasoned on the
event; after it has sorted by concept and categorized by size"
(*Analyzing Prose* 54). Syntactic ornamentation and organization un-

derscore thematic intention: core sentences are wrapped in shifting veils of clauses and phrases that allow only glimpses of the truth.

Hawthorne is using an opaque style here. In *Analyzing Prose* Lanham sets out the traditional opposition between the opaque prose style, a style that calls attention to itself, and a transparent prose style, a plain style where "the reader reads *through* the verbal surface . . . [and] accepts the 'content' to be as stated" (203). To employ a prose style that calls attention to itself "puts the reader on his guard," Lanham writes. "We start patting our pockets to make sure the wallet is still there" (199). Although the transparent or plain style has been defended by rhetoricians from Aristotle to Blair to Strunk and White (with their directive in *The Elements of Style* to prune and "to cut the deadwood" to create the "beauty of brevity" [ix]), Hawthorne's opaque style is set squarely against these ideals of clarity and concision.[3] Lanham's discussion of the contrasting styles complements Blair's analysis and provides helpful commentary on the rhetoric of the opening sentences of "Monsieur du Miroir" and "The Old Apple-Dealer," a rhetoric of unpruned prose mediated by a capricious sense of reality.

Charvat is not alone in misjudging Hawthorne's prose style to be "clear" and "simple"; several of Hawthorne's contemporaries saw both his style and his themes in the early sketches and tales as strictly moral and untainted with subversive undertones. Longfellow, in his review of *Twice-told Tales*, sees Hawthorne's style as "fresh and vigorous," and his language "very pure, his words uniformly well chosen, and his periods . . . moulded with great grace and skill. It is also a very perspicuous style, through which his thoughts shine like natural objects seen through the purest plate-glass" (82–83). Poe saw the style as "purity itself" (*Graham's Magazine*, April 1842, 85); E. A. Duyckinck wrote of "the perfectness of his style" (97); and Henry F. Chorley in the *Athenaeum* noted the "high finish and purity of style" in *Mosses from an Old Manse* (105). It is not until *The Scarlet Letter* that the reviewers comment on the subversive

element of Hawthorne's style. In October 1850 Orestes Brownson observes that while the style has "great naturalness, ease, grace, and delicacy," the story "should not have been told" and "moral health is not promoted by leading the imagination to dwell on" such crimes (176). By observing the rhetorical shape of Hawthorne's sentences as reflections of his "double voice," we see the conflation of style and theme.

Discourse as a veil is a recurrent strategy in Hawthorne, from statements in the letters, to the rhetoric of the sketches and prefaces, to the conscious use of actual veils and ambiguous images in the tales. In a May 1840 letter to Sophia Peabody, Hawthorne writes that he has "felt, a thousand times, that words may be a thick and darksome veil of mystery between the soul and the truth which it seeks" (XV 462) — a remarkable comment by the developing writer, even though we must take into account that Hawthorne frequently exaggerated and posed in his letters to his fiancée. The letter continues in a self-analytic and discouraging vein, when we take into consideration that the author is an aspiring artist, but it provides a significant commentary on both Hawthorne's rhetoric and his themes. The sentences in the letter that follow the "darksome veil" phrase suggest that the more profound issues of human existence — "the soul's life," for instance — cannot be explained by words, and that words may only be used with success to explain "outward acts" and "external things."

In "A Rill from the Town-Pump," first published in the June 1835 *New-England Magazine*, Hawthorne juxtaposes the purity of the water of the town pump against the "turbulence" and "disquietudes" of the world. In his opaque style, with the core sentence ("you cannot choose a better example than myself") enclosed and shadowed by a layering of prepositional phrases and subordinate clauses, the rhetoric itself becomes a veil. He opens with a prepositional phrase, modifies it with a subordinate clause, and then further digresses and shades his meaning by a parenthetical addition set off

between dashes — and all of this occurs before we arrive at the core sentence, which is in turn qualified by two more subordinate clauses that follow it:

> In the moral warfare, which you are to wage — and, indeed, in the whole conduct of your lives — you cannot choose a better example than myself, who have never permitted the dust, and sultry atmosphere, the turbulence and manifold disquietudes of the world around me, to reach that deep, calm well of purity, which may be called my soul. (IX 147–48)

In a style we shall observe in Chapter 4 in the discussion of the rhetoric of "The Custom-House," the syntax of the hypotactic periodic sentence balances on a core clause bracketed by subordinate clauses and builds to a resonant climax, "my soul." When viewed as a paradigm of Hawthorne's continuing concern with words "as a thick and darksome veil of mystery between the soul and the truth which it seeks," this configuration — a rhetoric of enclosure — functions as a repeated portrait of the fusion of rhetoric and theme.[4]

Hawthorne's uncertainty about his ability to pierce the "darksome veil" manifests itself in another rhetorical facet of his prose, what I label here a rhetoric of tentativeness. Nina Baym, commenting on the doubts that beset Hawthorne during the years 1825 to 1834, writes that his lack of critical recognition led to "a characteristic atmosphere of ambivalence and caution" (*Shape* 19) in the early sketches. The sketches frequently begin with cues of uncertainty: modals suggesting doubt, "if" clauses introducing conditions, "perhaps" clauses provoking speculation. The first paragraph of "Sights from a Steeple" has two "could" modals and a "perhaps" clause that itself holds an interior parenthetical question, yet another cue of tentativeness: "Perhaps — for who can tell? — beautiful spirits are disporting themselves there" (IX 191). The opening paragraph of "The Toll-Gatherer's Day" has one "could" speculation: "For such a man, how pleasant a miracle, could life be made to roll its variegated

length by the threshold of his own hermitage"; an "if" clause: "If any mortal be favored with a lot analogous to this, it is the toll-gatherer"; and a "perhaps" clause: "perhaps, it is good for the observer to run about the earth" (IX 205). "The Old Apple-Dealer" opens with a "may" modal suggesting tentativeness on the part of the narrator: "The lover of the moral picturesque may sometimes find what he seeks in a character, which is, nevertheless, of too negative a description to be seized upon" (X 439).

The repetition of such cues of tentativeness in Hawthorne's discourse suggests an uncertainty in his voice, a tone almost of apology. He is unsure of the response he will elicit, unsure of his calling as writer because of the lack of positive critical reaction to the earlier sketches. There is the suggestion as well that he perhaps knows what he wants to say, but has to couch it in acceptable terms, a maneuver we noted earlier in the subtext to the opening sentences of "The Old Apple-Dealer."

A comparison of the rhetoric of several entries Hawthorne made for "The Old Apple-Dealer" in *The American Notebooks* with the sentences in the completed sketch indicates that the tentativeness and uncertainty I have described as a Hawthornian trait are to some extent a conscious rhetorical pose, an element the author added while shaping the notebook entries into a sketch. On January 23, 1842, Hawthorne records eight paragraphs of description of the old peddler in the "rail-road station-house at Salem" (VIII 222–26). The definite "I will only add" of the notebook entry contrasts with the tentative "It may be added" of the sketch:

The American Notebooks:
> I will only add, that he is rather a small man, with gray hair, and gray stubble beard. There is nothing venerable about him, but he is altogether decent and respectable. (VIII 226)

"The Old Apple-Dealer":
> It may be added, that time has not thrown dignity, as a mantle, over the old man's figure; there is nothing venerable about him; you pity him without a scruple. (X 440)

Similarly, "He was a mechanic" (VIII 225) in the notebook becomes "He was perhaps a mechanic" (X 443) in the sketch, the hesitating "perhaps" helping to shape the conscious narrative pose.

Hawthorne uses several other rhetorical devices in "The Old Apple-Dealer": variation of sentence length, anaphora, and assonance. Three relatively short and abrupt sentences describe the fast-moving passengers as they alight from the cars at the station. In accordance with Blair's advice that "short sentences should be intermixed with long and swelling ones, to render discourse sprightly, as well as magnificent" (260), these rapidly paced sentences are followed by a slow and meandering periodic sentence that focuses the reader's attention back on the "hueless" (X 439) apple dealer:

> The travellers swarm forth from the cars. All are full of the momentum which they have caught from their mode of conveyance. It seems as if the whole world, both morally and physically, were detached from its old standfasts, and set in rapid motion. And, in the midst of this terrible activity, there sits the old man of gingerbread, so subdued, so hopeless, so without a stake in life, and yet not positively miserable — there he sits, the forlorn old creature, one chill and sombre day after another, gathering scanty coppers for his cakes, apples and candy — there sits the old apple-dealer, in his threadbare suit of snuff-color and gray, and his grisly stubble-beard. (X 445)

The final periodic sentence builds incrementally to the "grisly stubble-beard," and it does so by employing a double anaphora. First we have the repeated "there sits," "there he sits," and "there sits"; within this anaphora, however, is yet another, an epanaphora: "so subdued, so hopeless, so without a stake in life." As Corbett points out, such repetition is a conscious rhetorical maneuver, employed for deliberate effect: "Since the repetition of the words helps to establish a marked rhythm in the sequence of clauses, this scheme is usually reserved for those passages where the author wants to produce a strong emotional effect" (Corbett Classical Rhetoric 438). The sentence is resonant as well with over twenty repetitions of the assonantal "o" and "u" sounds, and is linked to both the preceding

and succeeding sentences by the "o" sound: "motion" completes the preceding sentence, and "folds" is the third word of the sentence that follows. In the intensity of sound repetition, we hear echoes of Poe.

The characteristic tentativeness is observable in Hawthorne's tales as well. The hypotactic sentence that opens "My Kinsman, Major Molineux," for example, has two qualifying clauses, and the tale ends with two prominent "if" clauses as "the gentleman" responds to Robin's request to show him "the way to the ferry" after the procession has passed: "'Some few days hence, if you continue to wish it, I will speed you on your journey. Or, if you prefer to remain with us, perhaps, as you are a shrewd youth, you may rise in the world, without the help of your kinsman, Major Molineux'" (XI 231). The distinguishing ambiguity and tentativeness derive from the use of the "if" clauses, the interjected "perhaps," and the "may" modal, and the question of whether or not Robin has indeed been dreaming is also reinforced by the rhetoric. "Young Goodman Brown" ends with a resonant periodic sentence, and the effect of such constructions, Lanham writes, "is often to throw the interest forward, create a mild suspense" (*Handlist* 113). In the sentence, Hawthorne employs prolepsis as several echoing long "o" sounds anticipate the final reverberating "gloom":

> And when he had lived long, and was borne to his grave, a hoary corpse, followed by Faith, an aged woman, and children and grand-children, a goodly procession, besides neighbors not a few, they carved no hopeful verse upon his tomb-stone; for his dying hour was gloom. (X 89–90)

The characteristic tentativeness and the periodic sentences are significantly absent from another piece attributed to Hawthorne in the 1831 *Token*. Following Corbett's suggestion that rhetoric may be used to analyze something already composed in order to "see how it was put together" (3), a scrutiny of the discourse in "The Haunted Quack" suggests it is not Hawthorne's work at all. The

first paragraph opens with simple sentences; there are no cues in the discourse of uncertainty or ambiguity, no suggestions of double meanings, no modals, no "if" or "perhaps" clauses injecting elements of condition or speculation:

> In the summer of 18—, I made an excursion to Niagara. At Schenectady, finding the roads nearly impassable, I took passage in a canal boat for Utica. The weather was dull and lowering. There were but few passengers on board; and of those few, none were sufficiently inviting in appearance, to induce me to make any overtures to a travelling acquaintance. A stupid answer, or a surly monosyllable, were all that I got in return for the few simple questions I hazarded. (XI 251)

The sentences do not illustrate the incremental building of Hawthorne's periodic style, and the direct, informative tone contrasts with the shuffling and uncomfortable maneuvering that is characteristic of Hawthorne's prose in the sketch openings we have considered. "Sights from a Steeple," also included in the 1831 *Token*, opens with a long hypothetical speculation about soaring high above "where the ethereal azure melts away from the eye, and appears only a deepened shade of nothingness!" (IX 191). And the flat, matter-of-fact ending of "The Haunted Quack" — "He shook hands with me, and, gaily jumping into the wagon, rode off with his friends" (XI 265) — is equally uncharacteristic of Hawthorne — of either his sentimental endings discussed in Chapter 2 or of the more visionary and expansive, as seen in "The Toll-Gatherer's Day":

> Now the old toll-gatherer looks seaward, and discerns the light-house kindling on a far island, and the stars, too, kindling in the sky, as if but a little way beyond; and mingling reveries of Heaven with remembrances of Earth, the whole procession of mortal travellers, all the dusty pilgrimage which he has witnessed, seems like a flitting show of phantoms for his thoughtful soul to muse upon. (IX 211–12)

Readers are directed from the firmness of earthly reality to a speculative dream of heaven and are finally left with a shadowed and ambiguous vision of the travelers.

Recent scholarship supports the rhetorical evidence that "The Haunted Quack" may not be Hawthorne's work. Attributing the piece to Hawthorne (XI 431, Clark 379) conflicts with research by Alfred Weber, Beth L. Lueck, and Dennis Berthold in *Hawthorne's American Travel Sketches* (1989), in that the attribution places a description of his trip to Niagara in the 1831 *Token* (compiled in 1830), at least two years before Hawthorne's tour, which they describe and date by references to a cholera outbreak that delayed his trip in the summer of 1832 (2).[5] It is possible, of course, that Hawthorne, from his reading of the contemporary travel literature that Weber details, simply selected the route to Niagara as the setting for the sketch — two years before he made the journey himself. But it is uncharacteristic of Hawthorne to use places he has not visited as settings for his sketches or tales — "Rappaccini's Daughter" is a notable exception — and further evidence makes it even more doubtful that "The Haunted Quack" is part of the Hawthorne canon.

On May 6, 1830, Hawthorne wrote to Goodrich, the editor of *The Token*, that he, Hawthorne, was sending "two pieces for *The Token*. They were ready some days ago, but I kept them in Expectation of hearing from you. I have complied with your wishes in regard to brevity" (XV 205). Although Nelson Adkins in "Notes on the Hawthorne Canon" accorded "The Haunted Quack" a "high degree of probability" (365) of being the second piece submitted by Hawthorne for the 1831 *Token*, neither its "brevity" — it is twice as long as "Sights from a Steeple," the other piece in the volume by Hawthorne — nor its rhetoric confirms Hawthorne's authorship. Visiting Niagara Falls was common in the 1830s, and a common subject for travel sketches as well. In a review of the 1832 *Token* in the October 1831 *New-England Magazine*, for example, the reviewer writes that "the description of the 'Falls of Niagara' by Mr. Greenwood . . . [is] beautifully written, excellent in tone and sentiment" (356). To attribute "The Haunted Quack" to Hawthorne because

of the Niagara setting is weak evidence, because visiting the falls was a common occurrence and because historical evidence dates his trip after 1832.

"The Haunted Quack" would have fit into Hawthorne's scheme, which never succeeded, for a group of stories framed by a story-teller, but there seems little evidence, aside from the letter to Goodrich, that Hawthorne indeed wrote the piece. [6] Another sketch in the 1831 *Token*, "The New England Village," has several thematic correspondences to Hawthorne's work — a secret sinner, a Chillingworth-like tormenter, a Dimmesdale-like clergyman, and a deathbed confession — but a close observation of the rhetoric again reveals few similarities to Hawthorne's discourse. [7] We find neither the characteristic tentativeness nor the hypotactic sentence structure in, for example, the opening sentences: "Some years ago it was my destiny to reside in a New England village. Nothing can be pleasanter than its situation. All that nature ever did for a place, she has done for this" (155). Thematic considerations alone suggest Hawthorne's touch, but rhetorical evidence contradicts that idea — and underscores as well the usefulness of rhetoric as a tool in determining the Hawthorne canon.

Critical attention directed toward another facet of Hawthorne's discourse, his "feminine" style, has focused almost exclusively on thematic concerns in the tales and romances; critical evaluation usually stops short of the rhetoric. Images, themes, and perhaps vocabulary are discussed, but not the various functions and manifestations of the sentence as a syntactic unit. [8] Keeping in mind that the readership of *The Token* as well as of *Godey's Lady's Book* and other magazines was largely female, we must assume Hawthorne was sensitive to the preferences and demands of this audience. [9] In her January 1837 editor's column, "The 'Conversazione,'" Sarah J. Hale writes in *The Lady's Book* — which in 1840 became *Godey's Lady's Book, and Ladies' American Magazine* (Hoornstra and Heath 93–94) — that she believes women are morally superior to men. "The

strength of man's character is in his physical propensities — ," she writes, "the strength of woman lies in her moral sentiments" (1–2). The implication was that men, in order to be published in the influential *Godey's* (where Hawthorne published "Drowne's Wooden Image" in 1844), would have to demonstrate certain feminine character traits — or at the least defer to them — and that professionalism of authorship, in the magazines and popular press at any rate, was linked to female morality and style.[10] Leland S. Person, Jr., argues convincingly that male writers reconciled this problem of participation in a "feminine" profession "by identifying the creative vitality of the works with the women embedded in them" and not by "exercising power over women" (8). The degree to which Hawthorne's rhetoric may be labeled "feminine," however, is an interpretive enigma of no slight complexity.

In *The Way Women Write* (1977), Mary Hiatt studies fifty modern female authors and fifty modern male authors, using an even balance of fiction and nonfiction titles, to determine the characteristics of a feminine versus a masculine prose style. From each author she randomly chooses four 500-word passages. Her results indicate that women writers are more terse, and that "men are comparatively long-winded and wordy" (121). Women, she determines, have "a more generalized pattern of complexity" in their sentences while men "favor one particular pattern of complexity" (122). Men use more exclamation points, while women use more parentheses and dashes (123); women also use more "rhetorical devices of repetition that may reinforce structural parallelism, such as polysyndeton, asyndeton, alliteration, and antithesis" (125).

Hiatt's findings highlight several aspects of Hawthorne's discourse, but it is well to keep in mind from the outset that her study is focused toward the dismemberment of certain stereotypical twentieth-century assumptions, assumptions that are only lightly supported by evidence in her study. Subjectless, passive voice assertions such as "Women's writing has been characterized as 'shrill' and

'hysterical,' as well as 'illogical'" (122), and the citation of "folk wisdom" (123) and "myth" (124) as sources for society's attitudes toward women writers, indicate a specific agenda in Hiatt's research: she feels women's writing has been mislabeled and she wants to renovate that labeling. We must also keep in mind that Hiatt's research on twentieth-century authors may be applied only with risk of misinterpretation to nineteenth-century writers. An application of her insights to Hawthorne's discourse, however, is profitable, if not conclusive.

To observe Hawthorne's prose in light of Hiatt's research, I tallied the sentence lengths and rhetorical devices in the fifth paragraphs of five of Hawthorne's sketches: "Fire-Worship," "Foot-Prints on the Sea-Shore," "Passages from a Relinquished Work," "A Rill from the Town-Pump," and "The Village Uncle." For comparison I also examined the sentence lengths and rhetorical devices of the fifth paragraphs of prose pieces by five contemporary women writers: Catherine Sedgwick's "Mary Dyre" in the *Token* for 1832; Lydia Sigourney's "Solace in Adversity" in the 1839 *Christian Keepsake*; Harriet Beecher Stowe's "Let Every Man Mind His Own Business" in the 1839 *Christian Keepsake*; Margaret Fuller's "The Great Lawsuit," published in 1843; and Rebecca Harding Davis's *Life in the Iron Mills*, published in 1861. Because Hawthorne's sketches are a blend of fiction and nonfiction, and because the contemporary selections by women authors are also a mix of fiction and nonfiction, I averaged Hiatt's fiction and nonfiction totals for a valid comparative figure.

Hawthorne's average sentence length is 29 words; his female contemporaries average 23 words. The modern male writers in Hiatt's study averaged 20 words per sentence; the female writers averaged 18.5 words. Whereas Hiatt uses her results to prove that the modern feminine style is not verbose (38), an equally valid conclusion is that Hawthorne employs the longer sentences typical of men's writing. By this initial criterion of sentence length, then, Hawthorne does not employ a feminine style in his sketches. In a

second category, use of exclamation points, Hawthorne uses six in contrast to only one use by the five women. Again the results of Hiatt's study place Hawthorne in the masculine category by comparison with twentieth-century authors; Hiatt observes that "the men use half again as many exclamation points as do the women" (40). In regard to use of dashes and double dashes, Hiatt observes a slightly higher occurrence in women authors — 179 compared to 169 (51) — a result she uses to suggest that women "regard more of what they say as dispensable, [and] are somewhat likely to add on new ideas rather than reach conclusions" (58). By this finding, Hawthorne's style once again shows a masculine characteristic; the five women authors used nine dashes, Hawthorne four. In a final category, the use of anaphora, one of the rhetorical devices of repetition that Hiatt tallies, Hawthorne is closer to the feminine style. Five times he uses repeated sentence openings in contrast to one instance in the five women writers observed. Hiatt's totals reveal a slightly higher usage of anaphora by women writers: 142 compared to 128 (65, 72).

Although the figures in the preceding paragraph may appear moot, for the style analyst figures are usually the basic tool for substantiating intuitions about rhetoric.[11] As Dennis Rygiel points out in "Stylistics and the Study of Twentieth-Century Literary Nonfiction," we must discover "a balance between rigor and insight." "Practical stylistics," he writes, combines "objective analysis based on principles, concepts, and techniques derived from linguistics with intuitive strategies characteristic of literary criticism." He concludes that "objective evidence" must "substantiate stylistic intuitions, intuitions to guide and motivate the search for evidence" (30). Nevertheless, reliance on the criteria just cited — Hiatt's figures and the figures from Hawthorne and his contemporaries — remains an inconclusive methodology for labeling Hawthorne's discourse either masculine or feminine. A more balanced approach to the

issue of gendered discourse is found in a 1987 article by Sara Mills, "The Male Sentence."

"The male sentence," Mills writes, "is a myth" (197), and the implication for the discussion of Hawthorne's style is that rhetoric does not have a conspicuous gender orientation. Mills sets out several characteristics of the so-called male sentence but points out that frequently confusion arises as to whether critics are "defining the gendered sentence in terms of subject matter or syntax, word order, completion, logic, or reference" (194). Mills deconstructs the notion of the male sentence, which according to her study is usually seen as having the following characteristics: it contains subordinate clauses for "hierarchising and ordering"; it tends to closure and completion; it tends to rationality, control, and reason; it has subject matter that describes experience in the male world; it tends to address males, not both sexes; and it has language used as "a transparent medium, not drawing attention to itself" (194–95). Two of these criteria — subordination and closure — apply to Hawthorne's sentences, and several (control, male audience, and transparency) do not, so his sentences could not conclusively be gender labeled even if Mills's criteria were accepted rhetorical characteristics. Mills's argument emphasizes that although certain traits are attributed to men's sentences, in fact those characteristics apply to sentences by both men and women. Mills's final assertion, that to term one variety of sentence better or worse, male or female, "is pure essentialism," seems like a sensible judgment (197).

Discussion of a "feminine rhetoric" does not appear to be a productive route for the discovery of sublevels in Hawthorne's discourse even though, as was observed in Chapter 1, Hawthorne knew he was writing for, and made certain concessions to, a feminine audience. Another sketch, however, does reveal how a surface reading of his prose may be both supported and subverted by the rhetoric. Nina Baym's excellent analysis of "The Haunted Mind" in

The Shape of Hawthorne's Career (64–67) directs us to the subversive issues of the sketch, but her reading stops short of rhetorical evidence, evidence that would complement her critical insights. "The Haunted Mind" — first published in *The Token* in 1835 — depicts that territory between the conscious and the unconscious mind that the sleeper inhabits when half-awake in the night, the psychological territory that is perhaps the source of inspiration to the artist. This territory lies, as Hawthorne later writes in "The Custom-House," "somewhere between the real world and fairy-land, where the Actual and the Imaginary may meet" (I 36). But while it is a fertile psychological state, a place where the muse is at play, it is also a dangerous place where, as Baym says, we discover "images ordinarily suppressed by reason or morality." These images, she continues, "testify to a continuous undercurrent of forbidden thought" (64). It is this subversive aura of "The Haunted Mind," I would argue, that is informed by the rhetoric.

Hawthorne is particularly sensitive to both audience and rhetoric in "The Haunted Mind," for, as Baym notes, the sketch is the only piece in his canon written in the second person (64), a cue that we are reading both reader-directed and reader-connected discourse. Several other cues tell us that the author is hyperconscious of his rhetoric in this sketch: in paragraph 1, he mentions he will "vary the metaphor"; in paragraph 3 he will "trace out the analogy." "Illusions," "the imagination," "thoughts . . . in pictures" are further indicators that both theme and rhetoric focus on the creative act and its subversive images, images that, as Baym notes, are "ordinarily suppressed by reason or morality." Throughout the sketch, the discourse draws us inside the narrative by incremental periodic sentences, assonance, antithesis, and anaphora. The third sentence, soothing in its assonantal "o" and "u" sounds, builds from the core "you find yourself . . . awake" to the final "undisturbed":

Or, to vary the metaphor, you find yourself, for a single instant, wide awake in that realm of illusions, whither sleep has been the passport, and behold its ghostly inhabitants and wondrous scenery, with a perception of their strangeness, such as you never attain while the dream is undisturbed. (IX 304)

The rhetorical effect is intentionally hypnotic. Paragraph 5 leads us down, away from the "lights" and "music" to a "tomb" or "dungeon," a forbidden place accessible only to those who defy the strictures of religion and morality: "In the depths of every heart, there is a tomb and dungeon, though the lights, the music, and revelry above may cause us to forget their existence, and the buried ones, or prisoners whom they hide" (306). The anaphora — "this . . . this . . . this . . . this" — in the last sentence of paragraph 6 completes the invitation to the dangerous world of the imagination with Poe-like rhythm of sound repetition: "Sufficient without such guilt, is this nightmare of the soul; this heavy, heavy sinking of the spirits; this wintry gloom about the heart; this indistinct horror of the mind, blending itself with the darkness of the chamber" (307). If "The Haunted Mind" is read as a statement of Hawthorne's aesthetic, it is evident how the rhetoric reinforces the subversive intention, how for Hawthorne the act of creation, with its sources deep in the recesses of the human imagination, must be a veiled area, guarded by "metaphor," "analogy," and layers of protective clauses.

Although Hawthorne read Blair's *Rhetoric* at Bowdoin, he was not unduly influenced by the call for simplicity in prose style, and in the sketches he balanced the audience's expectation for intelligibility against his own demands for a deeper truth, a truth best discernible for Hawthorne in the hazy light of "half-extinguished anthracite," as he writes in "The Custom-House," when a man can "dream strange things, and make them look like truth" (I 36). The rhetoric of the sketches may be seen as transparent or semivisible, unadorned or complex, straightforward or ambiguous, depending on the expec-

tation of the readership and the consequent willingness of that readership to participate in the negotiation for meaning. Nineteenth-century readers and reviewers, in their enthusiasm for "Monsieur du Miroir" or "A Rill from the Town-Pump," drew what they wished from the discourse, a discourse that we may now perceive as containing a secondary layer of ambiguity, subversion, and anthracite smoke. The prefaces to the tales and romances, read with sensitivity to Hawthorne's double voice and rhetorical maneuvering, reveal a similar double vision.

4 Poses in the Prefaces: A Rhetoric of Oppositions

> I stand upon ceremony now, and, after stating a few particulars about the work which is here offered to the Public, must make my most reverential bow, and retire behind the curtain.
>
> — Hawthorne, from the preface to *The Marble Faun* (1859)

> If I had written to seek the world's favor, I should have bedecked myself better, and should present myself in a studied posture. I want to be seen here in my simple, natural, ordinary fashion, without straining or artifice; for it is myself that I portray. My defects will here be read to the life, and also my natural form, as far as respect for the public has allowed. Had I been placed among those nations which are said to live still in the sweet freedom of nature's first laws, I assure you I should very gladly have portrayed myself here entire and wholly naked.
>
> — Montaigne, from "To the Reader,"
> *The Complete Essays of Montaigne*

HAWTHORNE'S RELATIONSHIP with his audience is an uncomfortable one, and the various poses he assumes in his prefaces reveal a narrator who evades a fixed identity, a persona who wishes to "open an intercourse with the world" and at the same time to delineate a self through his writing. We are never able truly to untangle the speaker's rhetoric or fully to remove his veils or fictive guises: M. de l'Aubépine, the "decapitated surveyor," "the obscurest man of letters in America," and Eustace Bright. The uncomfortable relationship with his audience that Hawthorne sustains in the prefaces is reinforced by an oppositional rhetoric; his frequent use of antithesis sets up frictional partnerships between reader and author, the real and the imagined, fact and fiction.

Although the intimacy of the preface calls for honesty, Haw-

thorne sidestepped this threat of disclosure by employing a rhetoric of polarities. (We must be aware that in any preface, especially a contrived and mannered one, the author is of course controlling the alleged intimacy, which becomes at best a pseudointimacy.) Such binary opposites as author versus reader and the actual versus the imaginary ("The Custom-House"), author versus the public (preface to *Twice-told Tales*), author versus reader (preface to *The House of the Seven Gables*), daydream versus fact and fiction versus reality (preface to *The Blithedale Romance*), youth versus old age and good versus evil (preface to *The Snow-Image*) illustrate the unresolved oppositions in the author. They also demonstrate the evasions he resorted to in his discourse when he was addressing his public directly and thus writing outside the protective parameters — and masks — of fiction. The intimacy of the preface, it is clear, placed Hawthorne in an uncomfortable rhetorical posture.

Hawthorne's strategy in the prefaces — his double purpose — is, first, to address both his popular audience and a more discerning readership. But second, and more important, his purpose is to employ the dialectical tension created by his rhetoric of oppositions to say what he could not say outright. When he writes, for instance, in *The House of the Seven Gables* preface that he is not speaking of "an actual locality" and that the personages "are really of the Author's own making," he is in fact saying a great deal more, not only about "the actual soil of the County of Essex" but about America — its economic system and its moral underpinnings — as well (II 3). His aim is not to "impale" his story with a moral like "sticking a pin through a butterfly," but to set out "a high truth, . . . brightening at every step" through his narrative (2).

With the exception of the preface to *The Marble Faun*, dated October 15, 1859, Hawthorne wrote the prefaces to his major works in the prolific two years and four months between January 15, 1850, and May 1852. These include "The Custom-House" (January 15, 1850), the preface to the second edition of *The Scarlet*

Letter (March 30, 1850), the preface to *Twice-told Tales* (January 11, 1851), the preface to *The House of the Seven Gables* (January 27, 1851), the preface to *The Snow-Image* (November 1, 1851), and the preface to *The Blithedale Romance* (May 1852).[1] The brief introductory piece "From the Writings of Aubépine," written while Hawthorne was at the Old Manse, functions as a preface to "Rappaccini's Daughter," and the autobiographical essay "The Old Manse" (1846) serves as an introductory to *Mosses from an Old Manse.* Hawthorne also wrote three prefaces to children's stories — a preface to *A Wonder-Book for Girls and Boys* (July 15, 1851), "The Wayside," an introduction to *Tanglewood Tales* (March 13, 1853), and a preface to *Grandfather's Chair* (November 1840) — as well as the politically explosive preface to *Our Old Home* (July 2, 1863).

The prefaces share several characteristics: they employ antithesis and a rhetoric of oppositions; they are self-conscious and exaggerated; they have a tone of self-deprecation; they are (seemingly) hostile toward the public — or at least to certain groups within that audience, such as "the many who will fling aside his volume" (I 3) and "the great bulk of the reading Public [that] probably ignored the book altogether" (IX 4). Finally, the narrative voice is untrustworthy, humorous, and evasive. In the consciously invoked writer-reader mode of intimacy, the prefaces have the characteristics and *supposed* truthfulness of a letter. The preface to *The Snow-Image* is presented as a letter to Horatio Bridge, and in the preface to *The Marble Faun* Hawthorne compares the preface to a letter "without a definite address" (IV 2). The prefaces, however, do not supply the directness and honesty we associate with the discourse of a letter, either private or public. In an actual letter to Longfellow written on May 16, 1839, when Hawthorne was considering publishing "a new volume of tales," he says, "If I write a preface, it will be to bid farewell to literature" (XV 310). Textual validities play against each other here, the statement in the letter, itself of doubtful veracity, commenting on the letterlike qualities of the prefaces with their

own whimsical subtexts. Clearly Hawthorne viewed the preface as
the appropriate medium for provoking — and evasively conversing
with — his readership, and for making cryptic pronouncements on
his art as well.

But in provoking his readers and in employing a rhetoric of
opposites, Hawthorne reveals yet another dimension of his appar-
ently hostile relationship with his audience. By presenting polar
positions in his prefaces, he requires his reader to consider two
positions, two terms, two concepts, and to choose between them;
that is to say, he forces an interpretive role on the reader, an
ultimately empowering position. A methodology for the reader to
derive meaning evolves from the imposed choice between opposed
terms, from the attempt to remove veils, and from the confrontation
with ambiguity. Philip Gura, in *The Wisdom of Words: Language,
Theology, and Literature in the New England Renaissance*, writes that the
first decades of the nineteenth century saw "bickering among Prot-
estant sects" and that increasingly "the truths of the Christian reli-
gion were to be understood not literally but symbolically" (7).
Ambiguity in scriptural language marked what some had previously
accorded a single fathomable meaning, and prose discourse also,
for Hawthorne and other Romantics, was no longer an entirely
stable and trustworthy medium. "Truth," Gura writes, "was to be
described only as a shimmering, ever-shifting premise, never to be
held firmly in hand" (7–8), and "ambiguity was regarded as a viable
mode for discerning truth" (11). Hawthorne's veiled truths and his
rhetoric of oppositions can readily be viewed as a reflection of this
new interpretive enterprise.

Dan McCall, in "Hawthorne's 'Familiar Kind of Preface,'" though
his discussion focuses primarily on aesthetics — what Hawthorne
says, rather than how he says it — directs attention to the idea of
an imposed choice in the prefaces. In the prefaces, McCall says,
Hawthorne "sets off Actuality and Allegorical Significance, as if a
choice were involved" (423). And McCall also suggests that the
choice is imposed on the *author* by the author as well as on the

reader by the author, that "two halves of Hawthorne are talking to each other" (427). Thus, both interpretation and choice extend from the antitheses proffered in the texts of the prefaces; both self and other, author and reader, are engaged and invited to respond, to negotiate for meaning.

The single page that makes up the preface to the second edition of *The Scarlet Letter* illustrates several of the characteristics of the prefaces just listed. Hawthorne distances himself from the text by use of the third person — "the author" (I 1) — and he sets up an oppositional rhetoric by placing this "author" squarely against "the public" (1). The tone is untrustworthy, and we quickly sense that no word or phrase may be taken at its face value. We know, for instance, that Hawthorne is angry at several Salemites because of his recent dismissal from the custom house; thus, when he calls Salem a "respectable" community we sense the ironic tone. "The Custom-House," he says, has the "effect" (2) of truth, suggesting that it does not present the whole truth, that truth wears a disguise. Similarly, by reference to "motives" (1), the motives, which might have remained undisturbed, are foregrounded: "As to enmity, or ill-feeling of any kind, personal or political, he utterly disclaims such motives" (1). In such a rhetoric of reversal, we sense that his intention is the opposite of his stated claim, and the reader is forced to choose, is maneuvered to participate in the negotiation for meaning.

In the preface to *Twice-told Tales*, which follows the success and notoriety of "The Custom-House," Hawthorne undermines the shaky marriage of reader and author. Written in the distancing third person, Hawthorne's combative rhetoric creates an adversarial relationship with his readership. Six times he mentions the (capitalized) "Public," positioning this group against the "Author," also capitalized. The tone is more hostile than humorous, as we see in the following excerpt from the preface:

> The circulation of the two volumes [of *Twice-told Tales*] was chiefly confined to New England; nor was it until long after this period, if it even yet be the case, that the Author could regard himself as addressing

the American Public, or, indeed, any Public at all. He was merely writing
to his known or unknown friends. (IX 4–5)

The "Public," we infer, does not comprise friends. The tone is also
disdainful; the public, he suggests, does not know how to read him.
J. Donald Crowley affirms the pedagogical function of the prefaces
by writing that Hawthorne "felt constrained not only to create
fiction but to instruct his audience about how to read it" (IX 532).
If the tales and sketches represent Hawthorne as artist, the prefaces
represent him — at least in one of his guises — as instructor, with
a continuing anger at his unresponsive students embedded in his
lessons. But like a posturing schoolmaster, Hawthorne has a positive
agenda; he asks his readers to react, and his oppositional discourse
prods them to make judgments.

 In not trusting his audience to read him accurately — in either
his tales or his prefaces — Hawthorne seized on the prefaces, as
Crowley says, "to mediate between his readers and his fiction"
(532). After setting up the partnership of author and public, Haw-
thorne underscores the adversarial stance by use of antithesis. A
tone of humorous self-deprecation, encouraged by the alliterative
"touches . . . tameness . . . tenderest" and the balancing opposition
of "merriest man" with "tenderest woman" and "broadest humor"
with "deepest pathos," shapes the rhetoric of the following sentence
from the preface to *Twice-told Tales*:

> Whether from lack of power, or an unconquerable reserve, the Author's
> touches have often an effect of tameness; the merriest man can hardly
> contrive to laugh at his broadest humor; the tenderest woman, one
> would suppose, will hardly shed warm tears at his deepest pathos. (IX 5)

Here Hawthorne treads a line between self-pity and dishonesty on
the one side, and humor on the other. But the discourse edges
toward further instruction on how he must be read. In reference to
the tales and sketches that follow in the volume, Hawthorne writes
with weakly disguised sarcasm: "Every sentence, so far as it embodies

thought or sensibility, may be understood and felt by anybody, who will give himself the trouble to read it, and will take up the book in a proper mood" (IX 6). Two paragraphs later the "Author"-"Public" polarity is again reinforced by sarcasm: "The Author would regret to be understood as speaking sourly or querulously of the slight mark, made by his earlier literary efforts, on the Public at large" (6). As "the obscurest man of letters in America" attempts "to open an intercourse with the world" he does so with what Hawthorne himself calls in this preface a "statement of opposite peculiarities" (6), a discourse of veiled disdain and a rhetoric of oppositions.

In *The Shape of Hawthorne's Career*, Nina Baym writes that Hawthorne had always conceived of his profession as "a meeting of author and audience, where the burden was largely on the author to make himself understood" (181). If we allow this reasoning, we must read the prefaces — the 1859 *Marble Faun* preface excluded — as a confession of Hawthorne's difficulties in engaging an audience, with the veiled bitterness in the discourse as an attempt to shift the blame from writer to reader, artist to audience. The brief — four-paragraph — *House of the Seven Gables* preface, dated January 27, 1851, in Lenox, sustains the confrontational rhetoric and the sarcastic tone. The preface is again written in the distancing third person, and the capitalized "Author" and "Reader" oppose each other. The rhetoric is structured around opposites: the "Romance" opposes the "Novel"; the "actual" opposes the "imaginary"; "fancy-pictures" oppose "realities"; "virtues" oppose "defects" (II 1–3). And again the sentences employ antithesis as a rhetorical device to foreground the abrasive, albeit epistemic, relationship between Hawthorne and his readership. Commenting on antithesis, Hugh Blair, in Lecture XVII of *Lectures on Rhetoric and Belles Lettres*, writes that "Antitheses are Figures of a cool nature" (355). The label is particularly apt to describe Hawthorne's calculating use of antithesis in the prefaces.

The strategy in the preface, as mentioned earlier, is double. In the guise of humility and diffidence, Hawthorne claims attention and legitimacy in order that he may discuss, as he says, "a high truth." The author thus nudges his readership — or at least his more discerning readership — toward a symbolic interpretation of his romance; the house, through the author's denial of the literalness of his tale, becomes symbolic of America, itself built on stolen Indian land. Inherited guilt, Hawthorne suggests, is part of the American psyche and may forever impede moral progress.

"My Dear Bridge," opens the preface to *The Snow-Image*, and the reader is invited to read someone else's mail, always a tempting and somewhat illicit adventure. But did the letter become a preface, or was the preface set in the form of a letter? Clearly the latter is the case — as we shall see momentarily — and just as clearly Hawthorne, the master of guises, is using the personal letter as a pleasant invitation, a benevolent mediation between author and text. The letter itself, dated November 1, 1851, is not included in the collected letters (XVI) — suggesting it is not a "real" Hawthorne letter — and another letter, dated two days later, makes clear the authorial intention of the November 1 text. On November 3 Hawthorne wrote from Lenox to his publisher, W. D. Ticknor in Boston, saying, "I send the preface to the new volume of tales" (XVI 501), with the implication that he encloses the preface-letter along with his own letter. Perhaps the preface-letter, during its stagecoach or train passage from Lenox to Boston in company with the real letter, acquired some validity as an actual epistle. Whichever the case, the Hawthornian resonance of form against form is humorous and effective.

In *The Snow-Image* preface, the public and critics (eight instances) are again foregrounded against the narrative "I" — signed "N.H." at the letter's end — and the rhetoric of oppositions is again operative. And, just as in the other prefaces, antithesis underlines the polarities. In the next-to-last paragraph Hawthorne opposes "youth" with

"the remainder of life," while fanciful truth is balanced against a substantial inner emotion:

> In youth, men are apt to write more wisely than they really know or feel; and the remainder of life may be not idly spent in realizing and convincing themselves of the wisdom which they uttered long ago. The truth that was only in the fancy then may have since become a substance in the mind and heart. (XI 6)

The usual shifting veils are operative as well. Even though Hawthorne's prefaces may give, as he says, an "appearance of confidential intimacy," he has been "especially careful to make no disclosures respecting" himself (XI 3). And then, as he speaks publicly in the playfully private letter that was, as we have seen, always intended to be public, he writes that he is "being cautious . . . that the public and critics shall overhear nothing which we [Hawthorne and Bridge] care about concealing" (4). He then contrarily proceeds to enumerate several private reminiscences from his time with Bridge at Bowdoin, when they "were lads together at a country college" (4).

Dated six months after *The Snow-Image* preface, the preface to *The Blithedale Romance* reflects a growing confidence in Hawthorne — the reviews of *The House of the Seven Gables* had praised him greatly — and a consequent diminishing of the oppositional rhetoric. We still have the third-person narrative voice and the capitalized Author (mentioned four times) set against the readers, but the relationship is less abrasive. Antithesis is employed, but in a more relaxed tone, and the focus of the opposites is aesthetics, not the author-reader relationship. "Actual reminiscences" opposes "fancy sketch"; "daydream" opposes "fact"; "fiction" opposes "reality" (III 1–2). The choices proffered indicate that the pedagogical function of the preface is Hawthorne's concern, as are the disclaimers: the setting, which resembles Brook Farm, "is incidental to the main purpose of the Romance," and he will argue no theory "in respect to Socialism" (III 1).

But, as we have seen in *The House of the Seven Gables* preface, the disclaimers are part of the strategy, for Hawthorne is indeed talking not only about Brook Farm but about the United States as well. The communistic Brook Farm — and by extension Fruitlands and the other experimental communities — is analogous to the U.S. experiment. All of them, Hawthorne suggests, have their defects.

Written while Hawthorne was living in Concord at the Old Manse, "From the Writings of Aubépine" functions as a preface to "Rappaccini's Daughter." "The Author" of the later prefaces is here "our author," the plural pronoun serving further to distance Hawthorne from the text. Aubépine (hawthorn) camouflages the persona who in turn camouflages Hawthorne, and a triple masking is effected. Here, as in the later prefaces, the narrative voice is both reviewer and instructor, first asserting that Aubépine's writings "are not altogether destitute of fancy and originality" (X 91), and then admonishing the reader "to take them in precisely the proper point of view" (92). Hawthorne had spent part of the summer of 1837 with his friend Horatio Bridge in Augusta, Maine, and there had taken French lessons from a Monsieur Schaeffer who had bestowed French names on his students: Bridge was Monsieur du Pont, Hawthorne was Monsieur de l'Aubépine (Mellow 91).

Kent Bales, in "Hawthorne's Prefaces and Romantic Perspectivism," points out that Comte de Bearhaven, named as the editor of *La Revue Anti-Aristocratique* in Hawthorne's preface — the real editor was Hawthorne's friend John L. O'Sullivan — is modeled on Hermann Boerhaven, "who directed Leiden's botanical garden" and is thus "the type which Rappaccini perversely mirrors" (78). Hawthorne also transforms *The United States Magazine and Democratic Review*, where "Rappaccini's Daughter" was first published, into *La Revue Anti-Aristocratique*, with lightly veiled commendation of his friend O'Sullivan, who, as the preface states, "has for some years past, led the defence of liberal principles and popular rights, with a faithfulness and ability worthy of all praise" (X 93). The tales and

sketches that Hawthorne translates into French had been published — although the publication dates are given incorrectly in the preface — in *The Democratic Review*.[2] The use of the French titles, of course, serves as another of Hawthorne's many veils, and after his "somewhat wearisome perusal of this startling catalogue of volumes" the narrator hopes that Aubépine may somehow be introduced "favorably to the American public" (X 92–93).

The humorous and ironic self-deprecation that marks Hawthorne's prefaces is also found in the introductory remarks to *Moby-Dick* (1851), which Melville had dedicated to his friend: "In Token / of my admiration for his genius, / This book is inscribed / to / Nathaniel Hawthorne" (4). Melville's whimsical prefatory posturings in "Etymology" and "Extracts" prefigure Hawthorne's self-mocking tone as Melville plays the "late consumptive usher to a grammar school" and the "sub-sub-librarian" who "belongest to that hopeless, sallow tribe which no wine of this world will ever warm" (11). Such humor and self-mockery are particularly evident in *The Marble Faun* preface, where Hawthorne writes that his previous attempts at literature were mere "scrolls which I flung upon whatever wind was blowing, in the faith that they [the 'honored' readers] would find him out" (IV 2). Although the tone is more mellow and meditative than confrontational, *The Marble Faun* preface again sets up the author-reader opposition. The author — not capitalized — fears that his "one congenial friend . . . that all-sympathizing critic . . . to whom he implicitly makes his appeal" may have "withdrawn to that Paradise of Gentle Readers" (IV 1–2). Hawthorne continues to foreground the opposition between author and audience and continues to bid his reader to make a choice: the flesh-and-blood reader, the one holding the book, must decide if he or she is sympathetic or antagonistic, for or against Nathaniel Hawthorne.

In a discussion of *The Marble Faun* preface John Franzosa, in "A Psychoanalysis of Hawthorne's Style," comments on "the all-or-

nothing quality which pervades the relationships Hawthorne describes and enacts, especially the idealizing of wife and reader" (388). Franzosa suggests that Hawthorne required "an affirming other" to "fill . . . out" personal relationships as well as literary endeavors. In a letter to John Lothrop Motley dated April 1, 1860, Hawthorne, in response to Motley's praise of *The Marble Faun*, writes:

> You are certainly that Gentle Reader for whom all my books were exclusively written. Nobody else (my wife excepted, who speaks so near me that I cannot tell her voice from my own) has ever said exactly what I loved to hear. It is most satisfactory to be hit upon the raw; to be shot straight through the heart. . . . You work out my imperfect efforts and half make the book with your warm imagination. (XVIII 256)

The for-or-against choice that Hawthorne so often imposed on his reader here finds its most genial response and fulfillment. Motley had praised the "Hawthornesque shapes flitting through the book" and the "misty way the story is indicated rather than revealed" (Crowley 327). Clearly Motley's praise cut straight to the author's center, and his was a voice Hawthorne had longed to hear. In the letter just quoted, written in response to Motley, Hawthorne also stated that "the romance is a success, even if it never finds another reader" (256).

Twice in *The Marble Faun* preface Hawthorne invokes the preface-letter analogy, echoing *The Snow-Image* preface. The author has not "corresponded through the post" with his "all-sympathizing critic," but his preface, like a "letter," was "duly received" when he sent his work "upon whatever wind was blowing" (IV 1–2). The subtext of this preface — which is signed "Leamington, October 15, 1859" — is that Hawthorne no longer has the capability to produce an *American* romance. He writes that "Italy . . . was chiefly valuable . . . as affording a sort of poetic or fairy precinct, where actualities would not be so terribly insisted upon, as they are, and must needs be, in America" (3). But Hawthorne, the author of three first-rate

American romances, outtricks himself in this preface. Overly ironic, he cannot have us believe that the "common-place prosperity" of his "dear native land" makes romance impossible (3). Nor can he have us believe that "the annals of our stalwart Republic" hold no theme for romance writers (3). He has already proved otherwise. If, on the other hand, his intention parallels the strategy of the prefaces to *The House of the Seven Gables* and *The Blithedale Romance*, we must read him here as consciously duplicitous, and see America as the very center of such romantic possibilities.

Written a decade before *The Marble Faun* preface, "The Custom-House" plays on many of the same themes we have noted in the shorter prefaces. The tension inherent in Hawthorne's self-conscious style, the interplay between what he seems to be saying and what he is actually saying, is an intentional rhetorical positioning. An elusive and playful style unfolds in "The Custom-House," and here, as is typical in his prefaces, Hawthorne is at his most slippery. The interplay between nonfiction and fiction, between truth and embroidery, sets the tone for this "Introductory" to *The Scarlet Letter*, and we must constantly pat our pockets to see if we've been taken — and remain alert as well to see where Hawthorne is taking us. The first two paragraphs, set apart as a discrete unit from the rest of the introductory sketch, establish the tone for the introduction, just as the introduction itself sets the tone for the romance that follows.

One characteristic of Hawthorne's opaque style illustrated in the opening two paragraphs of "The Custom-House" is what Lanham terms "compulsive parentheticality" (204). Each of the first three sentences of the first paragraph — and five all told in the two paragraphs under scrutiny here — has an amplification or digression set off between dashes.[3] This shifting posture forces the reader into a skeptical position: the second and third parenthetical additions are calculated exaggerations, and the first has embedded in it a tone of disingenuous humility:

It is a little remarkable, that — though disinclined to talk overmuch of myself and my affairs at the fireside, and to my personal friends — an autobiographical impulse should twice in my life have taken possession of me, in addressing the public. The first time was three or four years since, when I favored the reader — inexcusably, and for no earthly reason, that either the indulgent reader or the intrusive author could imagine — with a description of my way of life in the deep quietude of the Old Manse. And now — because, beyond my deserts, I was happy enough to find a listener or two on the former occasion — I again seize the public by the button, and talk of my three years' experience in a Custom-House. (I 3)

The tone is whimsical but tricky, and the reader is nudged off balance, unsure of what to believe.

In a preface or introduction readers usually expect to believe what they read; the preface is supposed to be the writer speaking honestly to the reader, without assuming the pose of character or mask of narrative persona. As Timothy Dow Adams points out in "To Prepare a Preface to Meet the Faces that You Meet: Autobiographical Rhetoric in Hawthorne's Prefaces," "readers expect the author to be his most straightforward self in a preface" (89). But Hawthorne is not straightforward here, and the "truth" is an elusive, evolving entity. We are in fact given so much "truth" in the first two paragraphs of "The Custom-House" that the real voice and the real authorial intention are successfully veiled. Nine times in the first two paragraphs Hawthorne makes reference to the truth or to speaking the truth: (my italics) "the example of . . . 'P.P.' . . . [is] *faithfully* followed"; "*the truth* seems to be"; "it is scarcely decorous, however, *to speak all*"; "unless the speaker stand in *some true relation* with his audience"; "but still keep *the inmost Me*"; "as offering proofs of *the authenticity* of a narrative"; "to put myself in *my true position* as editor"; and "*my true reason* for assuming a personal relation with the public" (I 3–4).

Hawthorne mentions the truth so often in these initial two paragraphs that we sense (accurately) that he doth protest too much,

that he is actually misleading us, misinforming us. But we also know that he knows we will know what he's doing: telling the "truth" in such a way that we know it is not the truth, and that the "real truth" lies elsewhere. The sleight of hand is so deft that we are left not knowing where truth ends and where embroidery begins. And this is the intended effect. Later in the sketch, when the Surveyor's "mysterious package" is found to contain "a certain affair of fine red cloth" (I 31) and "each limb prove[s] to be precisely three inches and a quarter in length," we are equally skeptical, and once again this is the intended effect; we are now willing players in the author's pleasant game. Hawthorne says, in loose paraphrase: "You thought you were reading a conventional preface, but I have something quite different in store for you. Watch your step."

Hawthorne is toying with our expectations about fiction and nonfiction. We expect the preface to be true; we expect the romance to be fiction. Modern nonfiction (and fiction) writer Annie Dillard says of the tacit pact between essayist and audience: "the elements in any nonfiction should be true not only artistically — the connections must hold at base and must be veracious, for that is the convention and the covenant between the nonfiction writer and his reader" (xvii). With Hawthorne, however, the fiction-nonfiction distinction simply does not hold: the covenant is broken and then reconstituted in other terms. In the opening two paragraphs, reader and writer jockey for positions in the new pact.

By calling attention to itself through its opaque style, the text is doing more than transmitting information, and we must ask two questions: first, "What do we do with it?" (that is, do we read it as fiction or nonfiction?), and second, "What is the author asking us to do with it?" (that is, how much of the manipulation are we intended to "get"?). Lanham suggests that when the fiction-nonfiction difference is unclear, this very distinction "becomes part of a much more complex transaction between reader and writer which allows both of them to delineate degrees of self-consciousness in

the kind of reality indicated" (217). The tension set up between the two questions "How do we read it?" and "What are we supposed to 'get'?" is the tension inherent in the opaque discourse in "The Custom-House."

We find the same tension between fiction and nonfiction in another rhetorically "honest" author-reader transaction, the preface to *The House of the Seven Gables*. Here Hawthorne ranks the truthfulness of texts, saying a "Romance" has "a certain latitude" that a "Novel," with its "very minute fidelity . . . to the probable and ordinary course of man's experience," may not follow (II 1). This preface — by label an even more "truthful" text than the romance or novel — is subverted, however, by Hawthorne's protestations, echoing "The Custom-House," that once again he is telling the truth in his introductory comments. Because we know that local characters do play roles in Hawthorne's fiction — Charles W. Upham is derided as Judge Pyncheon in *The House of the Seven Gables* — we find it difficult to believe that "It has been no part of his object . . . to describe local manners," that "the personages of the Tale . . . are really of the Author's own making," or that the tale has nothing to do with "any portion of the actual soil of the County of Essex" (II 3).[4] We do not believe him, and that is his intention.

For several Whig Salemites who read "The Custom-House" in 1850, the negotiation for meaning between writer and reader was a simple transaction. After the Whigs won the election in November 1848, Hawthorne, as a Democrat, knew his position at the custom house was in jeopardy, and, through charges leveled at him by Upham, Hawthorne "received his note of dismissal on June 8, 1849" (Stewart 86). Hawthorne was angry and vindictive, intent on a literary revenge, and his veils — his opaque rhetoric and his loosely disguised characterizations of William Lee and General Miller (Turner 197) — were easily penetrated by his Salem audience. He was quite aware how his "Introductory" would be received in Salem,

writing to his editor James T. Fields in Boston on January 15, 1850, after completing the manuscript:

> The article entitled "Custom House" is introductory to the volume, so please read it first. In the process of writing, all political and official turmoil has subsided within me, so that I have not felt inclined to execute justice on any of my enemies. (XVI 305)

Two months later he admitted to Fields that he would "catch it pretty smartly from [his] ill-willers, here in Salem" (letter of March 7, 1850 [XVI 322]). The response was unambiguous, "stirring up a furor in Salem" (Stewart 98).

In a letter to his friend Horatio Bridge on April 13, less than a month after the publication of *The Scarlet Letter* (and its "Introductory"), which sold out in ten days (Stewart 96), Hawthorne is strangely self-contradictory about the effect of his comments on his townspeople. Because we assume the personal letter to be an honest author-reader transaction, it is curious that in the same paragraph Hawthorne writes, "As to the Salem people, I really thought that I had been exceedingly good-natured in my treatment of them," and a few sentences later, "I feel an infinite contempt for them, and probably have expressed more of it than I intended; for my preliminary chapter has caused the greatest uproar that ever happened here since witch-times" (XVI 329). A conflation of good-naturedness and "infinite contempt" is beyond even Hawthorne's powers, so, as we again peer over Bridge's shoulder at the letter, we must sort out whether Hawthorne is dishonest, humorously self-mocking, or once again intentionally invoking the tension between fiction and nonfiction.

For the general reader of "The Custom-House," the transaction for meaning is more complicated than it was for the Salem Whigs. Because of Hawthorne's apparent self-consciousness about truth telling and his multiple audience-invoking gestures in the first two

paragraphs, readers are forced into the transaction, accurately sens-
ing a reluctance on the speaker's part to be forthright with them.
We find a similar shift in emphasis from the objective text to the
reader-shaped text in contemporary reader response critical theory.
In her Introduction to *Reader-Response Criticism: From Formalism to
Post-Structuralism*, Jane P. Tompkins writes that the destruction of
the objectivity of the text "yields . . . a way of conceiving texts and
readers that reorganizes the distinctions between them" (x). Haw-
thorne's opaque rhetoric is not forthright; it demands a response
from the reader, and meaning results, as Tompkins suggests, from
the tension and interplay between text and audience.

In the two paragraphs that begin "The Custom-House," Haw-
thorne feints and postures as he speculates on his readership, posi-
tioning audiences both inside and outside his discourse. Thirteen
times in these two paragraphs he refers to his listeners: "my personal
friends," "the public," "the reader," "the indulgent reader," "a listener
or two," "the public," "the many who will fling aside his volume,"
"the few who will understand him," "the one heart and mind of
perfect sympathy," "the wide world," "his audience," "a friend," "the
public" (I 3–4).

Gerald Prince, in "Introduction to the Study of the Narratee"
(1973), distinguishes the "real" reader (the one who holds the book),
from the "virtual" reader (the one for whom the author thinks he's
writing), from the "ideal" reader (the one who would understand
every nuance of the narration), from the "narratee" (an ear inside
the narrative to whom a narration is addressed) (9). Each of the first
three categories is evident in Hawthorne's list. The narratee, who
in Prince's words "constitutes a relay between the narrator and the
reader" (23), is a fictive entity whom the author addresses to clarify
ambiguities and "justify certain actions or underscore their arbitrar-
iness" (21). Hawthorne is understandably wary of his flesh-and-
blood listeners in Salem, so, like Coleridge's Ancient Mariner, who
grabs the fictive wedding guest with his "skinny hand," Hawthorne

metaphorically seizes his narratee — a fictional public — by the button. Hawthorne's narratee is, in Prince's words, "no one in particular" (17), a listener who is offered (in chapter 1 of the romance) a "sweet moral blossom" from the rosebush by the prison door: "Finding it [the rosebush] so directly on the threshold of our narrative, which is now about to issue from that inauspicious portal, we could hardly do otherwise than pluck one of its flowers and present it to the reader" (I 48). The rhetorical windup of the sentence, the hypotactic structure of modifying clauses culminating in a cloaked "we" proffering a rose to an ambiguous "reader," echoes the edgy relationship between narrator and narratee poised at the custom house door. Here in the romance Hawthorne is coyly coaxing his reader through another door with a fragrant rose from a bush rooted "almost at the threshold" of the prison door.

Negotiation with a readership, a more complicated transaction than a speaker-listener confrontation, was common in the nineteenth century, as Walter J. Ong explains in his 1975 article, "The Writer's Audience Is Always a Fiction":

> Nervousness regarding the role of the reader registers everywhere in the "dear reader" regularly invoked in fiction well through the nineteenth century. The reader had to be reminded (and the narrator, too) that the recipient of the story was indeed a reader — not a listener, not one of the crowd, but an individual isolated with a text. (17)

Besides being wary of the Salemites he's insulting, Hawthorne is perhaps recalling his fear and dislike of addressing the public that dated from an incident in grade school and also from his Bowdoin College days, when he was fined for not participating in mandatory declamation exercises (Turner 38).[5] This nervousness is expunged after publication of *The Scarlet Letter.* In "The Preface to the Second Edition," dated March 30, 1850, he writes that even though his readership has judged him guilty of "atrocities," he will "republish his introductory sketch without the change of a word" (I 1–2). "The

only remarkable features of the sketch," he writes, in a newly confident and defiant tone, "are its frank and genuine good-humor, and the general accuracy with which he has conveyed his sincere impressions of the characters therein described" (I 1).

The last sentence of the two-paragraph portal to "The Custom-House" completes the short text with a rhetorical flourish and a cloaked image of the truth. The style, typical of Hawthorne, is periodic and is characterized by a hypotactic structure, a structure built on subordination and rank as opposed to paratactic equality. Lanham writes that the periodic style "shows the mind after it has reasoned on the event; after it has sorted by concept and categorized by size" (54). Hawthorne shapes and ranks, then heightens a tone or obscures a feature like a visual artist. To balance the syntax, subordinate clauses bracket the sentence, prepositional phrases modify and retouch the core clause ("it has appeared allowable . . . to give a brief representation"), and the sentence builds to the firm and resonant "one" — the author himself ("The main purpose," a reference to the previous sentence, is to situate himself in his "true position as editor"):

> In accomplishing the main purpose, it has appeared allowable, by a few extra touches, to give a faint representation of a mode of life not heretofore described, together with some of the characters that move in it, among whom the author happened to make one. (I 4)

In this style of sentence, Lanham says, "things don't fall into place until the last minute, and when they do, they do with a snap, an emphatic climax. The juggler catches all the pieces, and takes his applause" (55). What emerges is a rhetoric of enclosure, an image of truth — the core sentence — camouflaged by the modifying clauses and phrases around it. The undulant style underscores the author's intention: the sentence is wrapped in a shifting veil that allows only glimpses of the truth.

The truth in this "Introductory" to *The Scarlet Letter* is thus mediated

by reader as well as author: Hawthorne sets us up to disbelieve him on one level so that a deeper truth may emerge, perhaps in that "neutral territory," as he writes in the body of the sketch, "somewhere between the real world and fairy-land, where the Actual and the Imaginary may meet, and each imbue itself with the nature of the other" (I 36). Through the carefully plotted pose of the introduction, we are conducted to the deeper truth of the romance.

The author relates to his reader with a controlled pose of awkward diffidence; Hawthorne is the artist here, and the artist often assumes a posture of disdain or perhaps defiance toward the outside world. Marshall van Deusen writes in "Narrative Tone in 'The Custom-House' and *The Scarlet Letter*" that Hawthorne's dilemma, as "alienated artist," is how "to negotiate without bitterness . . . the real but imperfect world around him" (66). This posture of Hawthorne's is reflected in the romance as Hester, Arthur, Pearl, and Chillingworth are all, to varying degrees, outsiders. The tone is thus set in the opening paragraphs, and the reader proceeds, a little wiser and a little more alert, under the eagle, between the wooden pillars, and through the custom house door.

The preface that received perhaps even more popular attention than "The Custom-House" was Hawthorne's "To a Friend," dated July 2, 1863, introducing *Our Old Home*, a collection drawn from *The English Notebooks* and first published as essays in the *Atlantic*. The "friend" is Franklin Pierce, whose antiabolitionist stance infuriated Hawthorne's friends, including Emerson, Longfellow, Harriet Beecher Stowe, and James T. Fields, his publisher (V xxv–xxvii, xxxvii). Hawthorne responded to the political debate over the preface with a strong affirmation of personal loyalty to his longtime friend Pierce, refusing to withdraw the dedication even after Fields suggested it would "ruin the sale" of the book (xxv).[6] Hawthorne's peremptory response fanned the author-audience embers to a hot blaze. In a July 18, 1863, letter to Fields he wrote, "As for the literary public, it must accept my book precisely as I think fit to

give it, or let it alone" (V 586). And once again "the truth" is an issue, as Hawthorne defends his loyalty to Pierce in the preface by writing:

> it is very possible that I may have said things which a profound observer of national character would hesitate to sanction, though never any, I verily believe, that had not more or less of truth. If they be true, there is no reason in the world why they should not be said. (V 5)

As in "The Custom-House," the preface has become a political act.

Three prefaces for collections of children's stories constitute the last unit of texts to be discussed. Written in Lenox, where the Hawthornes lived in what the author termed in an April 1851 letter to G. W. Curtis "the ugliest little old red farm-house that you ever saw" (XVI 425), the preface to *A Wonder-Book for Girls and Boys* reveals a calmer rhetoric devoid of oppositions and antitheses. Hawthorne does employ the third person — "the author has long been of the opinion" (VII 3) opens the preface — and the piece, dated July 15, 1851, falls chronologically between the preface to *The House of the Seven Gables*, dated January 27, 1851, and the epistolary preface to *The Snow-Image*, dated November 1, 1851. Hawthorne is more relaxed and gentle, less combative in the *Wonder-Book* preface than in "The Custom-House," but again he assumes the stance of instructor, commenting, on children as an audience, that they make apt and willing students of his stories. The unstated comparison, of course, is that adult readers misinterpret his work — and we must keep in mind that the furor over "The Custom-House" was still ablaze in Salem as Hawthorne, in Lenox, wrote the *Wonder-Book* preface. He states in the preface that he "has not always thought it necessary to write downward, in order to meet the comprehension of children." The preface concludes: "Children possess an unestimated sensibility to whatever is deep or high, in imagination or feeling, so long as it is simple, likewise. It is only the artificial and the complex that bewilders them" (VII 4).

Dated March 13, 1853, ten days before the U.S. Senate confirmed his appointment as consul at Liverpool (Lathrop IV 203), "The Wayside" serves as preface and "Introductory" to *Tanglewood Tales, For Girls and Boys*. Here Hawthorne assumes another fictive guise, the persona of Eustace Bright, a student "now in his senior year at Williams College" (VII 181). Bright functions as a voice through which Hawthorne may make pronouncements on authorship, writing that "by dabbling so early with the dangerous and seductive business . . . he will not be tempted to become an author by profession" (181). Though the humor is gentle, tuned to a child's ear and without the sarcastic flavor so evident in the prefaces to the major romances and tales, we are still keenly aware from such a comment that Hawthorne speaks to two audiences here, both the young and the mature. Within the text of the preface, Hawthorne has been named "editor" of the *Wonder-Book* by Eustace Bright, so we again have the double (or triple) distancing similar to the disguises in "From the Writings of Aubépine," but the heavy oppositional rhetoric of author versus audience is no longer part of the discourse.

On May 23, 1851, Hawthorne had written to his editor, Fields, in Boston of his plan for a framed narrative: "As a frame work, I shall have a young college-student telling these stories to his cousins and brothers and sisters, during his vacations, sometimes at the fireside, sometimes in the woods and dells" (XVI 436). In the preface, again through the voice and persona of Eustace Bright, Hawthorne comments on the creation of the tales, writing that "the stories . . . transform themselves, and re-assume the shapes which they might be supposed to possess in the pure childhood of the world" (VII 179). In the dry and understated rhetorical style of the modern radio monologue fashioned by Garrison Keillor, who creates a world of shy Minnesota Lutherans, Hawthorne in the preface creates a world peopled by his young listeners and endows them with names of fairies and elves in the English folk tradition: "Prim-

rose, Periwinkle, Dandelion, Sweet Fern, Clover, Plantain, Huck-
leberry, Milkweed, Cowslip, Buttercup, Blue Eye, and Squash-
Blossom" (VII 181–82). And in making his tales suitable for children,
we see that Hawthorne continues to wrangle over author-audience
problems. He writes that Eustace has overcome the "moral objec-
tions against these fables" (180) and that he has confronted "the
difficulties in the way of rendering them presentable to children"
(178).

In the November 1840 preface to *Grandfather's Chair* Hawthorne
is also the instructor (VI 6). He doubts that he will be read properly
— a doubt we saw assuaged in his praise of children as an audience
in the 1851 *Wonder-Book* preface — and wonders "whether he has
succeeded in writing a book which will be readable by the class for
whom he intends it" (6). He gives premonitions of later discussions
— in "The Custom-House" and in the preface to *The Blithedale
Romance* — of the novel versus the romance, writing here that he
hopes his imaginative details "do not violate nor give a false coloring
of the truth" (6). And in a final preface, it is appropriate that an
actual "other" speaks. In the preface to the 1883 George Parsons
Lathrop edition of the incomplete *Septimus Felton; or the Elixir of Life*,
Una speaks for her father, just as Aubépine, the decapitated sur-
veyor, Eustace Bright, and the others had spoken for the ever
slippery and self-fashioning Hawthorne. In the preface Una writes
that she believes the story

> is a striking specimen of the peculiarities and charm of his style, and
> that it will have an added interest for brother artists, and for those who
> care to study the method of his composition, from the mere fact of its
> not having received his final revision. (Lathrop XI 227)

The final resonance of Una's voice — the "other's" voice — echoes
her father's role as instructor of audiences. When considered as a
series of interconnected texts, the prefaces delineate the many poses

Hawthorne assumed before his readership. He is instructor, self-critic, reviewer, humorist, and sleight-of-hand artist, at times admonishing and at times praising his readership. His rhetoric of oppositions and his opaque, camouflaged sentences are constant threads through the prefaces, and both underscore his continuing and finally unresolved tensions with his readers.

5 Through a Different Lens: "The Old Manse" and *Las Meninas* of Diego Velázquez

> Velázquez's painting contains some very strange and subtle relationships between the painter, the model and the spectator. "Look at it," said Picasso one day when we were discussing 'Las Meninas,' "and try to find where each of these is actually situated."
>
> — Roland Penrose, *Picasso*

OBSESSED BY the ambiguous perspective and capricious reflections in Velázquez's *Las Meninas*, Picasso painted some twenty canvases in response to the seventeenth-century Spanish masterpiece. His concentration on *Las Meninas* (The Maids of Honor) may serve as an instructive model of how to read "The Old Manse," an essay intentionally "transmogrified" to such a degree that "reality" and "fancy" (Hawthorne's terms) may not be separated (XVI 105). Although Hawthorne's subtitle, "The Author Makes The Reader Acquainted With His Abode," directs our attention to the house, it is the author, coyly ducking into and out of the narrative, that is the focus of our curiosity: we want to learn more about the elusive young writer. Both Velázquez's painting and Hawthorne's essay contain portraits of the artist-writer, both impose interpretive roles on the viewer-reader, both incorporate real personages into the work, and both present whimsical distortions of "the truth." The impressionistic, word-picture quality of Hawthorne's discourse further links "The Old Manse" and *Las Meninas*.

Throughout his career Hawthorne was fascinated by the correspondences between writing and portraiture and in particular by the supernatural power within the work of art to evoke the innermost

nature of the subject. In "Edward Randolph's Portrait" (first published in 1838 in *The United States Magazine and Democratic Review*) the mysterious, dark painting, obscured by time with an "impenetrable veil" (IX 258), is believed to hold a spirit that appears in the likeness of a "demon . . . at seasons of public calamity" (260). The portrait in *The House of the Seven Gables* is similarly endowed with a supernatural quality as it hangs with "a dead man's silent and stern reception" above Judge Pyncheon's chair (II 238). And in "The Prophetic Pictures" (first published in 1836 in *The Token and Atlantic Souvenir*) the portrait painter says,

> "The artist — the true artist — must look beneath the exterior. It is his gift — his proudest, but often a melancholy one — to see the inmost soul, and, by a power indefinable even to himself, to make it glow or darken the canvass, in glances that express the thought and sentiment of years." (IX 175)

In this tale, the portrait fashions the person: as Walter and Elinor gaze at their likenesses, "the resemblance of both to their portraits [is] complete" (IX 181) and Walter's true nature, predicted by the artist, is revealed: he is a murderer. A similar spirit of artistic summoning and self-fashioning mediates "The Old Manse," Hawthorne's autobiographical word portrait.[1]

The painting by Velázquez, completed in 1656, shows the artist, palette and brush in hand, facing the viewer, with a reflection of King Philip and Queen Mariana in the mirror behind him. He is working on a large canvas, only the back of which is visible to the viewer of *Las Meninas*. The Infanta, Doña Margarita María de Austria, five years old, is the center of attention. On either side of her are maids of honor. A man disappearing through a doorway in the rear (identified as José Nieto, *Aposentador* of the Queen [Kahr 132]), two other servants, two dwarfs, and a large dog complete the scene. Picasso was entranced by the ambiguities of space, perspective, and association. Art historian Roland Penrose, in a discussion of Picasso

and *Las Meninas*, writes that "Velázquez can be seen in the picture, whereas in reality he must be standing outside it," and that "He faces a large canvas on which he seems to be at work but it has its back to us and we have no idea what he is painting" (431). The visual ambiguities coincide dramatically with the rhetorical ambiguities of Hawthorne's prose.

For Hawthorne, the three years and three months' residence at the Old Manse — from July 1842 to October 1845 — was productive of both tales and garden squashes, but neither provided a sufficient income to support the newly married couple. Poverty was a nagging problem, and, after the 1837 *Twice-told Tales* had been remaindered and the 1842 collection had also done poorly (X 511), the newlywed Hawthornes were driven to live apart briefly in 1844 — Nathaniel in Salem and Sophia and Una in Boston — in order to save money (XVI 65–74). Hawthorne wrote from Salem to his friend Horatio Bridge in November 1844 of "pecuniary difficulties" (65), and in December he wrote to Sophia in Boston that "The good that I get by remaining here [in Salem], is, a temporary freedom from that vile burthen which had irked and chafed me so long — that consciousness of debt, and pecuniary botheration, and the difficulty of providing even for the day's wants" (68). Impelled by lack of funds and encouraged by Evert A. Duyckinck, editor for Wiley and Putnam of New York, Hawthorne agreed in the spring of 1845 to assemble several tales and sketches into a new book. Duyckinck also suggested that Hawthorne write a preface for the volume, and on July 1, 1845, Hawthorne wrote to Duyckinck from the Old Manse that the "story" he was at work on made "no good progress." The letter continues,

> It was my purpose to construct a sort of frame-work, in this new story, for the series of stories already published, and to make the scene an idealization of our old parsonage, and of the river close at hand, with glimmerings of my actual life — yet so transmogrified that the reader should not know what was reality and what was fancy. (XVI 105)

The tension between fact and fancy mediates the piece from the outset, and the references to the preface in the other letters during the eleven months that Hawthorne was at work on "The Old Manse" — from May 1845 to April 1846 — indicate a continuing ambivalence about labeling the new piece.

The discordances among *tale, sketch, story, article,* and *essay* — all terms Hawthorne used in his letters to refer to his work in progress — reflect both a reluctance to categorize and an evolution from the fictional to the nonfictional mode, or to a mode, at least, that partakes of both fancy and reality. Writing to Duyckinck on May 2, 1845, he calls the piece a "story" (XVI 94) and two months later (in the July 1 letter just quoted from) it is still a "story" even though "for days and weeks together, sometimes, I forget that there is any story to be forthcoming" (105). By December, in another letter to Duyckinck, it has become "a wretched tale" that "still refuses to unfold its convolutions." The struggle to compose, he continues, is a burden: "I write continually — but am conscious, even at the moment, that I am not writing the true thing; and on re-perusal the next day, it turns out a sad business indeed" (136). By April 15, 1846, when he sends off the piece to Duyckinck in New York, the original "story" has evolved into an "article" and truth has had an "ideal light thrown over it" (152).

The mixture of terms points to the tension in the finished piece: as "story" evolves into "article," "truth" becomes more — not less — distorted or "idealized." And on completion — just as with Velázquez's painting — the participants are positioned, the mirrors are poised, the perspective is established, and the interplay of fiction and nonfiction, of fancy and reality, is ready for viewing. The first paragraph of the April 15 letter opens,

> I send you the initial article, promised so many thousand years ago. The delay has really not been my fault — only my misfortune. Nothing that I tried to write would flow out of my pen, till a very little while ago —

when forth came this sketch, of its own accord, and much unlike what I had purposed. I like it pretty well, at this present writing; and my wife better than I. It is truth, as you will perceive, with perhaps a gleam or two of ideal light thrown over it — yet hardly the less true for that. (XVI 152)

Clearly Hawthorne is satisfied with the essay (here referred to as both "article" and "sketch"). Uncharacteristically, he asks Duyckinck to send him the proof sheets, writing that he is "anxious about the accuracy of the press" (152).

The composition of "The Old Manse" had presented an inordinate struggle to Hawthorne when we consider that in the preceding months he had written several tales and sketches with comparative ease. Three of his most successful tales, "Rappaccini's Daughter," "The Birthmark," and "The Artist of the Beautiful," were completed without undue complaint at the Old Manse, while the work on the new preface — the transition from pure fancy to "idealized" non-fiction — was done with "leaden reluctance" (XVI 136). Hawthorne was always uncomfortable with autobiographical revelation; his difficulty in composing "The Old Manse" underscores his conscious avoidance of candid statements about himself, his insistence on veiling the truth — or perhaps perceiving a "higher" truth in a veiled image. Two years before "The Old Manse" was completed, he had written to Horatio Bridge giving advice on his project to describe his African voyage:

I would advise you not to stick too accurately to the bare fact, either in your descriptions or narrations; else your hand will be cramped, and the result will be a want of freedom, that will deprive you of a higher truth than that which you strive to attain. (XV 686)

Two recurrent images shape the rhetoric of the "The Old Manse." The first rhetorical configuration of the essay is the architectural motif, the house itself, which becomes "a spiritual medium" (X 3) and a "fairy-land" (33), where "there is no measurement of time" (33). After proceeding between the gateposts, the visitor-reader

senses a "powerful opiate" that provides rest for "world-worn spirits" (29). And "but a little way beyond the threshold," one finds "stranger moral shapes of men than might have been encountered elsewhere, in a circuit of a thousand miles" (30).

The second rhetorical configuration is water, its reflections, currents, mists, its "drip-drip-dripping and splash-splash-splashing from the eaves, and bubbling and foaming into the tubs beneath the spouts" (15). Water supports "the mosses, of ancient growth upon the walls" (15), and in the reflection of the "slumberous stream" "or any mud-puddle in the streets of a city" things "unsightly in reality" are transformed into "ideal beauty in reflection" (7–8). As well as being a life-giving and transforming power, water becomes a stimulant or an "opiate" as the narrator watches the river from the study, or paddles upriver on the Concord to the Assabeth River with Channing, whose talk becomes "evanescent spray" (24). Their conversation "up-gushed" "like the babble of a fountain" (24), and as the current floats them back to town, the Old Manse is "best seen from the river" (25). Water even provides the rhetoric of creation as the narrator reflects on "the stream of thought that has been flowing from [his] pen" (32).

In the essay, a "transparent obscurity" is "flung over" the Manse, and it is through this oxymoronic lens that the reader must view Hawthorne, his house, and his visitors (28). Images of distortion and reflection mark the discourse: "The usually mirrored surface of the river" is "blurred by an infinity of rain drops" (15–16), and a cloud, shaped like "an immensely gigantic figure of a hound" (25) keeps guard over the house. The reflection of foliage in the river prompts Hawthorne to question which "was the most real — the picture or the original?" (22). Reflection and reality, since both have "an ideal charm," fuse, but it is the reflections, "The disembodied images," that "stand in closer relation to the soul" (22).

The garden squashes are described in a rhetoric of transmogrification. The "summer-squashes" evolve into "beautiful and varied forms" and present "an endless diversity of urns and vases, shallow

or deep, scalloped or plain, moulded in patterns which a sculptor would do well to copy, since Art has never invented anything more graceful" (14). The "evanescent spray" — Channing's words at the Assabeth picnic site — evolves into "lumps of golden thought, that lay glimmering in the fountain's bed" (24). In the study (altered with "a cheerful coat of paint" [5]) where Emerson wrote "Nature" and gazed out at the river, even the windows become lenses of change, palpable images of distortion. "The study had three windows," Hawthorne writes, "set with little, old-fashioned panes of glass, each with a crack across it" (6). What he fails to record is that during their first spring in the Old Manse, Sophia and he had scratched antiphonal inscriptions (still visible to Old Manse visitors) into these same west-facing panes, further obscuring clear sight both into and out of the Manse:

Man's accidents are God's purposes.

Sophia A. Hawthorne 1843

Nathl Hawthorne
This is his study

1843

The smallest twig
Leans clear against the sky.
Composed by my wife,
and written with her dia-
mond

Inscribed by my
husband at sunset
April 3d 1843

In the gold light S. A. H.

"Transparent obscurity," sight distorted, mediates both the house and the prose in this domestic conversation. Both become texts; we must read the Old Manse as we read "The Old Manse."[2]

Hawthorne is candid about his lack of candor. In one of the final paragraphs of "The Old Manse" he writes,

So far as I am a man of really individual attributes, I veil my face; nor
am I, nor have ever been, one of those supremely hospitable people,
who serve up their own hearts delicately fried, with brain-sauce, as a
tidbit for their beloved public. (X 33)

Four years later, in the opening sentences of "The Custom-House,"
Hawthorne will refer to "The Old Manse" as an "autobiographical
impulse" with which he "inexcusably" "favored the reader" (I 3).
Although the writer of fiction masks reality, explores and interprets
experience in, perhaps, allegorical guise, Hawthorne as essayist
holds only disdain for those who "serve up" the autobiographical
"tidbit." His contempt for such impulses becomes clearer when the
earlier *American Notebooks* version of the "brain-sauce" quotation is
compared to the "Manse" version: the sarcastic "supremely hospit-
able people" begins as "people"; the fawning "beloved public" evolves
from "public"; and Byron's candor is cited disdainfully: "People who
write about themselves and their feelings, as Byron did, may be said
to serve up their own hearts, duly spiced, and with brain-sauce out
of their own heads, as a repast for the public" (VIII 253).

In the essay Hawthorne's minatory finger is raised against those
writers who inflict themselves unnecessarily on their audiences; here
he must be read in the same humorous context that characterizes
the 1844 *Notebook* entry because "The Old Manse" is in substance
and intention an autobiographical sketch. It is here perhaps that
the parallel with Velázquez's *Las Meninas* — and Picasso's reading
of it — again becomes a helpful avenue into the essay. Just as the
painting is a rare — perhaps the only — self-portrait of Velázquez,
so Hawthorne's essay is a rare autobiographical glimpse of the author
(Kahr 128). Both Velázquez and Hawthorne are in their works, yet
both deflect the focus of the viewer-reader away from themselves,
Velázquez by including portraits of the king, the queen, and the
Infanta Margarita, Hawthorne by including "portraits" of Emerson,
Thoreau, Channing, and others. Both titles are deflectors as well.
Velázquez's real subject is only peripherally *las meninas* — the
maids of honor — just as Hawthorne's real subject is only periph-

erally "The Old Manse." And just as Hawthorne's rhetoric of deflection, his lens of "transparent obscurity," controls the essay, so Velázquez's painting is mediated by ambiguous reflection.[3]

Hawthorne's inconsistent — but perhaps calculated — use of the pronoun "we" is another signal of rhetorical ambiguity. The first sentence of the essay refers to the newly married couple, since "we beheld," in the past tense, cannot logically refer to Hawthorne and his reader. There is also a specific time signal in the second sentence ("It was now a twelvemonth since the funeral procession of the venerable clergyman . . . had turned from that gate-way") that locates and defines the "we" of the first sentence as Nathaniel and Sophia. But the impersonal "we" is the closest we, as readers, will come to Sophia, who is never referred to by name or station in the essay. And the brush with familial revelation in paragraph 1 prompts the "safer" first-person singular in paragraph 2 ("that memorable summer afternoon when I entered it as my home") and the more distant "we" — now the author and the reader — of paragraph 5: "we stand now on the river's brink." In paragraph 6 "we" evolves into the generic "we": "Thus we see, too, in the world, that some persons assimilate only what is ugly and evil from the same moral circumstances which supply good and beautiful results . . . to the daily life of others"; and by paragraph 7 the pronoun is unstable, sliding from the possible "Nathaniel and Sophia" to the indefinite, singular-but-suggesting-reader-inclusive we, as used in *The New Yorker* "Talk of the Town":

> We will not, then, malign our river as gross and impure, while it cannot glorify itself with so adequate a picture of the heaven that broods above it; or, if we remember its tawny hue and the muddiness of its bed, let it be a symbol that the earthliest human soul has an infinite spiritual capacity, and may contain the better world within its depths. (X 8)

One method of self-definition Hawthorne employs in the essay is self-juxtaposition against other Concord luminaries. As he muses in "the most delightful nook of a study," Hawthorne recalls that

another essayist, Emerson, had written "Nature" in that same room, "its walls . . . blackened with the smoke of unnumbered years, and made still blacker by the grim prints of Puritan ministers that hung around" (X 5). Hawthorne evokes Emerson through ironic hints and proceeds quietly to savage his transcendentalist neighbor, with whom he had fundamental philosophical differences, differences that would grow more intense when Hawthorne continued to champion his antiabolitionist friend Franklin Pierce in the introduction to *Our Old Home* in 1863. In "The Old Manse" Emerson is depicted in association with the "blackened walls" of the study that are hung with the "grim prints of Puritan ministers." These inhabitants of the study are "like bad angels, or, at least, like men who had wrestled so continually and so sternly with the devil, that somewhat of his sooty fierceness had been imparted to their own visages" (5).

Later in the essay Hawthorne's insinuating humor is again directed at Emerson, whose fame has drawn to Concord "hobgoblins of flesh and blood" who come to revere the "great original Thinker, who had his earthly abode at the opposite extremity of our village" (30). Hawthorne's quiet rhetorical blade slices both Emerson, from whom Hawthorne "sought nothing . . . as a philosopher" (31), as well as Emerson's "earnest" followers:

> People that had lighted on a new thought, or a thought that they fancied new, came to Emerson, as the finder of a glittering gem hastens to a lapidary, to ascertain its quality and value. Uncertain, troubled, earnest wanderers, through the midnight of the moral world, beheld his intellectual fire, as a beacon burning on a hill-top, and climbing the difficult ascent, looked forth into the surrounding obscurity, more hopefully than hitherto. (30–31)

Emerson, continually present in the ghostly edges of Hawthorne's text — like Velázquez's disappearing *Aposentador* — serves as a counterpoint for Hawthorne's primary text of self-definition. Even Thoreau's transcendentalist eye and occasionally excessive ponderings on nature are lightly mocked in "The Old Manse." "Thoreau

tells me," Hawthorne writes, that the pond-lily "opens its virgin bosom to the first sunlight, and perfects its being through the magic of that genial kiss" (23). Thoreau, he continues (invoking Emerson's "Nature"), "has beheld beds of them unfolding in due succession, as the sunrise stole gradually from flower to flower; a sight not to be hoped for, unless when a poet adjusts his inward eye to a proper focus with the outward organ" (23).

Today, a visit to the Old Manse assures us we may trust the accuracy of Hawthorne's description of the house and the river, even if the glimpses of the man remain enigmatic. Are we to believe that he is truly so reluctant to talk about himself? Would he really never "take forth a roll of manuscript" and "intreat" his readers' attention to his tales (X 35)? Only two years before the composition of "The Old Manse" he had written to Horatio Bridge that "nobody's scribblings seem to be more acceptable to the public than mine" (XV 688). "How little have I told!" Hawthorne writes in the concluding paragraphs of "The Old Manse," "and, of that little, how almost nothing is even tinctured with any quality that makes it exclusively my own!" Are we to accept at face value such unnecessary self-effacement when we know he believed he had written a fine — I would argue, his best — piece? Perhaps his game of ducking politely behind a transparent curtain reveals more of his true nature than would a platter of autobiographical tidbits.

Distrustful, wary, but coy maneuvering characterizes Hawthorne's rhetoric as well as his relations with his reading public throughout his career. In "The Custom-House" he suggests that his writing may in fact reveal more to an astute readership than the author himself knew or intended to portray, that "the printed book, thrown at large on the wide world, were certain to find out the divided segment of the writer's own nature" (I 3–4). Similarly, in *The Marble Faun* preface, he fears that "unkindly eyes should skim over what was never meant for them" (IV 2). The implication of this troubled relationship with his public in the composition of "The

Old Manse" is that Hawthorne attempts to fashion his own life into a fiction, a melange of fact and image, "reality and fancy," revelation and obfuscation. On the one hand he wants to make "The Reader Acquainted With His Abode," and on the other he fears the intrusion, fears that the reader may have "gone wandering, hand in hand with [him], through the inner passages of [his] being" (X 32). In other autobiographical prefaces, as we have seen, Hawthorne considers such writing as a kind of auto-psychoanalysis, and it is in such writings that he perhaps comes closest to making sense of his private self, his home, and his profession — and comes closest, he senses, to letting "unkindly eyes" in on the secrets. Like Velázquez in his self-portrait in *Las Meninas*, Hawthorne remains in the shadows, off center stage. But as he feared, the astute reader would see "the writer's own nature" (I 4) before he, Hawthorne, "made his most reverential bow, and retire[d] behind the curtain" (IV 2).[4]

6 Hawthorne as Essayist: *Our Old Home* and "Chiefly About War Matters"

No American, complexly speaking, finds himself in England for the first time, unless he is one of those many Americans who are not of English extraction. It is probable, rather, that on his arrival, if he has not yet visited the country, he has that sense of having been there before which a simpler psychology than ours used to make much of without making anything of. His English ancestors who really were once there stir within him, and his American forefathers, who were nourished on the history and literature of England, and were therefore intellectually English, join forces in creating an English consciousness in him.

— William Dean Howells, *Certain Delightful English Towns*

Conduct, on the other hand, the soul
"Which the highest cultures have nourished"
To Fleet St. where
Dr. Johnson flourished.

—Ezra Pound, "Hugh Selwyn Mauberley"

L ABELING HAWTHORNE'S short nonfiction — with the consequent assignment to a literary genre — has presented difficulties to his critics and reviewers from the outset. Hawthorne himself, in response perhaps to Irving's successful *Sketch Book of Geoffrey Crayon, Gent.*, favored the term *sketch* for his early non-fictional pieces (with the exception, as noted in Chapter 2, of "The Old Manse," which he called an essay); Poe, in his April and May 1842 reviews of *Twice-told Tales* in *Graham's Magazine*, insisted on *essay*.[1] Henry James, in discussing *Our Old Home* in his 1879 *Hawthorne*, is uncomfortable with categorization, moving from *paper* (in reference to "Consular Experiences") to *articles* to *chapters* to *sketches*,

fastidiously avoiding the solider *essays* (117–22). Modern critics have been equally tentative in labeling the contents of *Our Old Home*, Raymona Hull calling "Leamington Spa" a "sketch" (83) in a 1981 article, and James A. Hijaya in 1974 using the improbable "chapters" (364) to identify the twelve essays. In the opening paragraphs of Chapter 2 I distinguish between the essay and the sketch, and I argue here that throughout his career Hawthorne wrote nonfiction within the established tradition of the informal essay. Accordingly, Poe's early designation of Hawthorne as essayist is accurate. *Our Old Home*, published the year before Hawthorne died, is a commonly mislabeled and critically undervalued collection of informal travel essays.

In his 1990 *The Rhetoric of the "Other" Literature*, W. Ross Winterowd — his title indicating the continuing difficulty of categorizing belletristic nonfiction — distinguishes between the formal and the informal essay. Citing Mark Twain, James Thurber, and E. B. White as American practitioners of the form, he writes that the informal essay "is personal and not as highly structured as the formal"; further, the informal essay is "anecdotal" and "the author has no obligation to assume a disinterested stance toward issues" (96). Emerson, who in 1856 had published his *English Traits*, a collection of nineteen essays drawing on his visits to England in 1833 and 1847, is cited as a practitioner of the formal essay. Winterowd also places the American essayists — omitting mention of Hawthorne, a common critical oversight — in the tradition of English and French essay writing, citing Montaigne, Swift, Hazlitt, and DeQuincey as informal essayists, and Addison, Johnson, Arnold, Mill, Newman, and Pater as formal essayists (96). As a writer of informal travel essays in *Our Old Home*, Hawthorne may also be positioned with twentieth-century travel writers and essayists such as Paul Theroux, William Least Heat Moon, John McPhee, Joan Didion, and E. B. White.

To label Hawthorne an essayist as opposed to a sketch writer

requires a working definition of *essay*. C. Hugh Holman and William Harmon, in *A Handbook to Literature*, begin by defining an essay as "a moderately brief prose description of a restricted topic." Their next sentence, however, states that "no satisfactory description can be arrived at." They write that the following terms have been used to classify the essay: "moralizing, critical, character, anecdotal, letter, narrative, aphoristic, descriptive, reflective, biographical, historical, periodical, didactic, editorial, whimsical, psychological, outdoor, nature, comical, and personal" (186). "Travel" is conspicuously absent from their list.

Both Robert Atwan in the Foreword and Justin Kaplan in the Introduction to *The Best American Essays 1990* attempt — without success — to define the form. In exploring the difference between *article* and *essay*, Atwan writes that "it is impossible to come up with an airtight definition of an essay" (ix). Kaplan notes the "hermetic, self-referential quality" of essayists such as Bacon, Lamb, and Stevenson, and says that "their covert subject matter, no matter what their titles said, was the act of writing itself" (xiii). But he also capitulates, writing that

> attempts at genre definition and subclassification in the end simply tell you how like an eel this essay creature is. It wriggles between narcissism and detachment, opinion and fact, the private party and the public meeting, omphalos and brain, analysis and polemics, confession and reportage, persuasion and provocation. All you can safely say is that it's not poetry and it's not fiction. (xiv)

The following rhetorical analysis of the essays of *Our Old Home* will help to demonstrate that Hawthorne is — a definition notwithstanding — an essayist of stature. The nineteenth-century term *sketch*, which carries with it suggestions of incompletion and resistance to closure, does not fairly evaluate Hawthorne's personal-reflective-travel essays such as "Chiefly About War Matters" and those that make up *Our Old Home*.

Hawthorne's interest in travel and travel writing dated from the

years in Salem following his graduation from Bowdoin. In a letter to Pierce on June 28, 1832, he mentions his "story-teller" project, a proposed series of tales and sketches united by a traveling story-teller; the project was never to prove successful (XV 224). His reading during these Salem years included much travel literature. Beth L. Lueck (with help from Marion Kesselring's careful tallying of books charged to Mary Manning, his aunt, from the Salem Athenaeum) writes that he read widely in the genre, "ranging from travels in Great Britain, Germany, Turkey, and Africa to those in his native land, including Bartram's *Travels*, and to his compatriot Washington Irving's *Tales of a Traveller*" (Lueck 156). In 1856 Hawthorne had high praise for Emerson's *English Traits*, writing to the author from Liverpool on September 10 that "undoubtedly, these are the truest pages that have yet been written, about this country" (XVII 540).

With characteristic self-deprecation Hawthorne told his publisher James T. Fields on October 18, 1863, that *Our Old Home* was "not a good or weighty book" and that it didn't "deserve any great amount either of praise or censure" (XVIII 603). A hundred and thirty years later, however, we may easily disagree with Hawthorne's cautious estimation of his work. These essays on English and American manners are pungent and prickly, still displaying the "beauty and delicacy" and "the appearance of a triumph" that Henry James hailed in 1879 (117). Readers in the intervening years have for the most part overlooked Hawthorne's essays; shadowed by the popu-larity of his novels and short stories, the essays have drawn little critical and even less popular attention. With the resurgence of interest in the personal essay and travel essay in our own age, Hawthorne's contributions deserve a fresh critical evaluation.

The essays are characterized by a dialectical rhetoric — America is contrasted with England — and they become, for Hawthorne's American audience, an assessment of the meaning of America, a theme echoing a subtext of the prefaces to *The House of the Seven*

Gables, The Blithedale Romance, and *The Marble Faun.* The essays are drawn from Hawthorne's *English Notebooks,* compiled during his consulship in Liverpool and travels in England from 1853 through 1857, and as Judy Schaaf Anhorn writes in "Literary Reputation and the Essays of *Our Old Home,*" they are "episodic and descriptive but related in subject and theme" with "the motif of literary pilgrimage" unifying the book (157). On his return to Concord and the Wayside in 1860, Hawthorne reshaped and distilled the notebook entries, creating twelve essays, ten of which were published in the *Atlantic Monthly* before all were assembled into one volume in 1863. The opening essay, "Consular Experiences," was printed in *Our Old Home* without prior magazine publication, and a segment of "Lichfield and Uttoxeter," entitled simply "Uttoxeter," was published in the English *Keepsake* in 1857 and also in the April 1857 *Harper's New Monthly Magazine* (V lvi).[2] "To a Friend," Hawthorne's staunch and unpopular pledge of allegiance to Franklin Pierce, serves as the preface for the collection.

One rhetorical configuration of the essays is the continuation of the debate on aesthetics begun in the prefaces, where Hawthorne poses "the Actual" against "the Imaginary," how things really are against the artist's perception and transmission of *images* of things. Hawthorne's aesthetic objectives in the composition of fiction and of nonfiction merge here: in both genres he must create an *impression* of reality. His objective as romance writer — as expressed in *The House of the Seven Gables* preface — is how to *disguise* reality, since "the Reader may perhaps choose to assign an actual locality to the imaginary events of this narrative" (II 3). Similarly, the objective as essay writer is how to *enhance* empirical reality, as Hawthorne writes in "Up the Thames," how to give "creative truth to my sketch, so that it might produce such pictures in the reader's mind as would cause the original scenes to appear familiar, when afterwards beheld" (V 258). Although these aesthetic and rhetorical purposes may appear to be at cross-purposes — the first disguising a scene, the

second enhancing a scene — they may also be viewed as similar in that both are concerned with creating images beyond mundane reality to move the reader. In both, in the fiction as well as in the nonfiction, the task for the writer is to create an *impression* of reality.

Hawthorne's discussion in "Up the Thames" of "the futility of the effort to give any creative truth" (V 258) to his essays serves as an important gloss in the preface-centered debate on the aesthetic and rhetorical issues at play in his discourse. Hawthorne writes, in *The House of the Seven Gables* preface, that "it has been no part of his object . . . to describe local manners," and that his romance has "a great deal more to do with the clouds overhead, than with any portion of the actual soil of the County of Essex" (II 3); in the same ironic vein, he writes in *The Blithedale Romance* preface that his concern is "to establish a theatre, a little removed from the highway of ordinary travel, where the creatures of his brain may play their phantasmagorical antics, without exposing them to too close a comparison with actual events of real lives" (III 1).

Just as romance writers must displace the "actual soil" and create a "theatre" in order to work their craft through impressions of reality, so essayists, Hawthorne writes, must work their craft by creating similar impressions of reality. For Hawthorne, the aesthetic and rhetorical issues of fiction and nonfiction come together in the creation of scene: both the essayist and the romance writer insist on a distancing from the actual. He writes in "Up the Thames":

> Impressions, . . . states of mind produced by interesting and remarkable objects, these, if truthfully and vividly recorded, may work a genuine effect, and, though but the result of what we see, go further towards representing the actual scene than any direct effort to paint it. Give the emotions that cluster about it, and, without being able to analyze the spell by which it is summoned up, you get something like a simulacrum of the object in the midst of them. (V 259)

Thus the "actual" scene — eschewed by the romance writer, as Hawthorne writes in "The Custom-House," who seeks a "dim coal-

fire," a "fairy-land, where the Actual and the Imaginary may meet"
(I 36) — is here in the essay created by impressions, by an effect,
by a similar distancing from the "actual."

The paragraph in "Up the Thames" just quoted from, functioning
as an aside on aesthetics, is inspired by a single notation in *The
English Notebooks*. On September 10, 1855, Hawthorne wrote — in
a line framed by prosaic recordings of the details of Westminster
Abbey — that "impressions, states of mind, produced by noble
spectacles of whatever kind, are all that it seems worth while to
attempt reproducing with the pen" (V 212). In "Up the Thames" he
amplifies this idea by asserting that the travel essay is a particularly
appropriate vehicle for "simulacrums" of the actual. He writes that
he draws the "comfortable inference, that the longer and better
known a thing may be, so much the more eligible is it as the subject
of a descriptive search" (259). In "Civic Banquets" he reiterates this
rhetorical objective of the essay, stating, with the familiar self-
deprecating tone, that "After all my pains, I fear that I have made
but a poor hand at the description, as regards a transference of the
scene from my own mind to the reader's" (315). After visiting the
scene of Samuel Johnson's penance — fifty years after disobeying
his father, Johnson returned to do penance (132) — in the square
at Uttoxeter, Hawthorne again suggests that the "actual" is better
communicated by an *impression* of the factual rather than by a literal
recording of "the sad and lovely story" in "the absurd little town"
(138). "Sublime and beautiful facts," he writes, "are best understood
when etherealized by distance" (138).

How the writer may perceive scene and character, and how the
writer may communicate those perceptions of the actual, serves as
one rhetorical configuration for *Our Old Home*, just as a shifting
perception of truth served as one rhetorical configuration in "The
Custom-House." What is noticeably different about the rhetorical
makeup of *Our Old Home* is the more flexible and less defensive
narrative voice in the later essays. Hawthorne assumes a more

confident and relaxed posture in *Our Old Home*, and this induces the narrator to makes discoveries as he writes. The discourse of the essays is epistemic; rather than simply conveying what he saw in the English scene and the English character, Hawthorne shows us how the act of writing fosters discovery. In "Leamington Spa" Hawthorne notes that "the article which [he is] writing has taken its own course"; he had set out to write about "the many old towns — Warwick, Coventry, Kenilworth, Stratford-on-Avon," but finds he is writing about "country churches" instead (V 61).

A loosening of the determined narrative control of such earlier sketches as "Sights from a Steeple" and "Sunday at Home" is evident in "Leamington Spa." The narrator feels "a singular sense of having been there before" when he views the "ivy-grown English churches" (V 63). He is reminded of the wooden Salem meetinghouses that "on wintry Sabbaths" were "the frozen purgatory" of his childhood (63). This sense of déjà vu triggers a

> delightful emotion, fluttering about me like a faint summer-wind, and filling my imagination with a thousand half-remembrances, which looked as vivid as sunshine, at a side-glance, but faded quite away whenever I attempted to grasp and define them. (63)

The relaxed narrative voice that organizes by free association reminds us of the voice in an earlier essay, "The Old Manse," where a similar associative consciousness mediates the discourse. In "The Old Manse" Hawthorne and Ellery Channing floated "from depth to depth" along the Concord River watching the changing shapes of clouds "couched above the house" (X 23, 25). When Hawthorne was happiest — as a young husband or traveling dignitary — his nonfiction style was imbued with a relaxed self-confidence.

Claude M. Simpson comments on this aspect of the discourse of *Our Old Home*, writing that Hawthorne showed "a willingness to let patterns of association govern the order of parts" in the essays (V xl). It is this reliance on impressions — and the subsequent departure from a more formulaic and less spontaneous organizing principle —

that allows us to read the essays today with as much sense of discovery as readers did in the 1860s. Hawthorne eschewed the sentimental and hackneyed descriptions of country houses and cathedrals — expectations for readers of the travel essay — and relied instead on metaphor and image to communicate his vision. The solid Englishwoman of "Leamington Spa," whose description stirred up Hawthorne's English reviewers, is "massive with solid beef and streaky tallow" and "has the effect of a seventy-four gun ship" (V 48–49). [3] In "Outside Glimpses of English Poverty," Hawthorne visits the laundry room of an almshouse. The "hot and vaporous" atmosphere becomes a democratic breath, inhaled by the paupers, the American visitors, and even Victoria, "had the Queen been there":

> What an intimate brotherhood is this in which we dwell, do what we may to put an artificial remoteness between the high creature and the low one! A poor man's breath, borne on the vehicle of tobacco-smoke, floats into a palace-window and reaches the nostrils of a monarch. It is but an example, obvious to the sense, of the innumerable and secret channels by which, at every moment of our lives, the flow and reflux of a common humanity pervade us all. (V 299)

The "transference of the scene" (315) to the reader's mind is enabled by the relaxed narrative voice extemporizing on the image of the laundry vapor.

How things are perceived and communicated is a recurrent rhetorical configuration of the twelve essays. As the narrator leaves Manchester on the Sheffield and Lincoln railway in "Pilgrimage to Old Boston," he notes that "on a railway . . . what little we do see of the country is seen quite amiss, because it was never intended to be looked at from any point of view in that straight line." It is, he continues, "like looking at the wrong side of a piece of tapestry" (V 140). He is more concerned with how it was, with "the old highways and foot-paths." The "brooks and rivulets," which require all objects to adhere to their "curves and undulations," are contrasted with the "perfectly artificial" line of the railway (140). Henry A. Tuckerman,

a contemporary American travel writer whom Hawthorne admired, wrote in a similar vein about the difficulty of viewing the past from the railway. In *A Month in England* Tuckerman writes that "the private and carriage-like cars" and "the telegraph-wires running parallel to the tracks" are "features of modern science . . . which do not suggest an inkling of the antiquated towns we are about to enter" (16).

In "Up the Thames," Hawthorne commented that Tuckerman's *Month in England* was "a fine example of the way in which a refined and cultivated American looks at the Old Country, the things that he naturally seeks there, and the modes of feeling and reflection which they excite" (V 259). Both Tuckerman and Hawthorne seek a literary-imbued past before — or despite — the inconveniences of modern technology. What they discover often does not fulfill their expectations. As Hawthorne enters Uttoxeter, his literary expectation — what he remembers from his reading — of the scene of Johnson's penance is altered by the actual view. Where Boswell had described Johnson's father's bookstall "as standing in the market-place, close beside the sacred edifice" (V 133), Hawthorne finds that the church and the marketplace are well separated. Tuckerman, to discover the past beneath the glitter of the present, explores the "subterranean chapel at the rear of a modern store . . . to decipher half-legible inscriptions, or the sculptures used by the early Christians" (20).

On occasion the discoveries beneath the façade, beneath the mask, are problematical. A curious scene of unveiling at the Cathedral of Lichfield has a "sinister effect" on Hawthorne, and he feels afterward "at odds with the proper influences of the Cathedral" (V 129). He has observed a group of boy choristers in white robes who look "like a peculiar order of beings, created on purpose to hover between the roof and pavement of that dim, consecrated edifice" (129). As one of the choristers pulls off his gown after the service, the boy is transformed into "a common-place youth of the day, in modern frock-coat and trowsers of a decidedly provincial cut" (129). The unveiling is an uncomfortable, un-Hawthornian gesture, re-

minding us of Father Hooper who was carried "a veiled corpse . . . to the grave" (IX 52), and the amiable narrator of "The Old Manse" who, though a gracious host to Channing, says, "So far as I am a man of really individual attributes, I veil my face" (X 33). Even if the removal of the chorister's robe in Lichfield Cathedral reveals only the drab reality of the present and not some secret sin or individual foible, the unveiling is unsettling to Hawthorne.

Although perception of scene and the creation of images constitute one rhetorical configuration of *Our Old Home*, a less confrontational — and less coy — narrative voice constitutes another. In "Consular Experiences," which describes the "shabby and smoke-stained edifice" where Hawthorne as consul "impart[ed] both advice and assistance in multifarious affairs that did not personally concern [him]" (V 6, 31), the narrator is humorous and direct, distinctly more at ease than the shifting and evasive persona of "The Custom-House." The first-person narrative voice is confident. Hawthorne no longer has to don disguises (M. de l'Aubépine, the decapitated surveyor, Eustace Bright) or masquerade as "the obscurest man of letters in America"; he is now the political emissary and famous author who has successfully opened an "intercourse with the world." But he is still the observer of humanity, "a man with a natural tendency to meddle with other people's business," and he finds that the Liverpool consulate "could not possibly be a more congenial sphere" for such observations (30). In "About Warwick," in a scene reminiscent of "Sights from a Steeple," Hawthorne ascends the tower of the chapel and looks down from a hundred feet to observe, not the secret sins of his Salem townsfolk, but "a rich and lovely English landscape, with many a church-spire and noble country-seat" (79). The memories — and scars — of Salem quietly persist, however. After descending the "winding tower-stair," Hawthorne sees the old men in the chapel garden and is reminded of "the Salem Custom-House, and the venerable personages whom I found so quietly at anchor there" (81).

Confident control of the narrative in the essays replaces the

coyness and vindictiveness of the prefaces; the defiant tone of "To a Friend" remains isolated in the preface to *Our Old Home* and does not infect the essays. In "Recollections of a Gifted Woman" the narrator feels "not the slightest emotion . . . nor any quickening of the imagination" while viewing Shakespeare's house (V 99). With Hawthornian reserve and control, the narrator draws back, reflecting that "whatever pretty and apposite reflections [he] may have made upon the subject had either occurred to [him] before [he] ever saw Stratford, or have been elaborated since" (99). The scene echoes earlier visits to public places. In "My Visit to Niagara" (*The Snow-Image*) the narrator, instead of running "like a madman, to the falls" (XI 281), "alighted with perfect decency and composure," commenting that "such has been [his] apathy, when objects, long sought, and earnestly desired, were placed within [his] reach" (282). In "Old Ticonderoga" (*Uncollected Tales*) the narrator again pulls back, preferring his own fancy to the young lieutenant's dry description, "as accurate as a geometrical theorem, and as barren of the poetry that has clustered round its decay" (XI 187).

In "Leamington Spa" the narrator comments that he carries to any public monument the accumulated perceptions of "history, poetry, and fiction, books of travel, and the talk of tourists" (V 63). Such perceptions confuse "the images of things actually seen" (63), and, in a passage that explains the psychological as well as the historical resonance of the volume's title, Hawthorne speculates on the "hereditary haunts" of our old home. His "pretty accurate preconceptions" mingle with "images of things actually seen":

> the illusion was often so powerful, that I almost doubted whether such airy remembrances might not be a sort of innate idea, the print of a recollection in some ancestral mind, transmitted with fainter and fainter impress through several descents, to my own. I felt, indeed, like the stalwart progenitor in person, returning to the hereditary haunts after more than two hundred years, and finding the church, the hall, the farmhouse, the cottage, hardly changed during his long absence — the

same shady by-paths and hedge-lanes — the same veiled sky, and green lustre of the lawns and fields — while his own affinities for these things, a little obscured by disuse, were reviving at every step. (V 63–64)

We are reminded of Hester Prynne's return, first to England, where Pearl had been bequeathed "a very considerable amount of property" (I 261), and then of Hester's reappearance in New England, where "there was a more real life . . . than in that unknown region where Pearl had found a home" (262–63). Pulled by "hereditary haunts" on both continents, Hester in the end chooses the place of "her sin . . . her sorrow . . . [and] her penitence" (263).

The confident narrator in the essays of *Our Old Home* on occasion ducks behind a veil of modesty when the author of *The Red Letter A* is recognized in his English travels. In "Pilgrimage to Old Boston," a bookseller had "heard the name of one member of our party" and the visitors are thus accorded "great courtesy and kindness" (V 158). Inside the bookshop, "veiled behind the unostentatious front," are two upstairs rooms, one of which contains "a counterpane of fine linen, elaborately embroidered with silk . . . in a most delicate style of needle-work" (158). In a scene echoing the fictitious discovery in "The Custom-House" of the "certain affair of fine red cloth" that shows a "wonderful skill of needlework" (I 31), the counterpane in the upstairs room in Boston, England, carries "the cypher, M.S." and "was embroidered by the hands of Mary Queen of Scots" (V 158). In "Near Oxford" the narrator, recognized, again slips behind a veil. Here the narrator comments that the famous American author is "a friend of mine" who, when asked if he had written *The Red Letter A*, responds "doubtfully" that he "believed so" (182).

In "Outside Glimpses of English Poverty," Hawthorne becomes "one member of our party" when an uncomfortable incident occurs in the almshouse (V 300). A "sickly, wretched, humor-eaten" foundling clings to "that individual, and he was bound to fulfil the contract [to fondle the child], or else no longer call himself a man among men" (300). The passage that follows in the text serves as a brief

and revealing self-analysis: Hawthorne stepping back to observe Hawthorne as a member of the party of Americans:

> it could be no easy thing for him to do, he being a person burthened with more than an Englishman's customary reserve, shy of actual contact with human beings, afflicted with a peculiar distaste for whatever was ugly, and, furthermore, accustomed to that habit of observation from an insulated stand-point which is said (but, I hope, erroneously) to have the tendency of putting ice into the blood. (V 300–301)

It is characteristic of the Hawthorne in the prefaces — though atypical of the usually straightforward voice of the essays — to include such a narrative gesture of distance and masquerade. Without revealing to the reader that he is engaging in self-analysis, Hawthorne first veils his fame and then his awkwardness in the almshouse encounter. Arlin Turner comments on the passage, writing that "it would not be easy to compose a better succinct statement of the way he saw himself — or the way he appears in the light of full biographical evidence" (291).

Another rhetorical configuration of the volume is the interplay of opposites, with frequent use of parentheses and dashes emphasizing the dialectical substructure of the pieces. The essays comprise an international debate on manners, morals, and physiognomies, with American vision and voice set in opposition to English vision and voice. The "elephantine" English matron of "Leamington Spa," composed of "steaks and sirloins" and "streaky tallow" (V 48–49), is contrasted with the "trim little damsels" of America described in "A London Suburb" (V 240). England produces "feminine beauty as rarely as . . . delicate fruit" (240); the "maiden blossom" matures into "an overblown cabbage-rose" or "an outrageously developed peony" (49–50). While the American male, in his "dry atmosphere," is becoming "too nervous, haggard, dyspeptic, extenuated, unsubstantial, [and] theoretic," John Bull "has grown bulbous, long-bodied, short-legged, heavy-witted, material, and, in a word, too intensely English" (64). And whereas the English farmer respects the

ancient paths where "the footsteps of the aboriginal Britons first wore away the grass," the American farmer would "plough across any such path, and obliterate it with his hills of potatoes and Indian corn" (51).

In "Recollections of a Gifted Woman," the account of Hawthorne's visit to Delia Bacon and Stratford, the English trees and landscape invite comparison with the New England countryside. New England's landscape, "even the tamest, has a more striking outline" than the "Old Country," which is "utterly destitute" of "lakelets" or "the wayside brooks that vanish under a low stone-arch, on one side of the road, and sparkle out again on the other" (V 90). The trees in England "have nothing wild about them"; an American tree would be "the more picturesque object of the two" (91). The English oak has "a certain John Bullism in its figure, a compact rotundity of foliage, a lack of irregular and variant outline, that make it look wonderfully like a gigantic cauliflower" (91). In Stratford, the narrator is impressed with the great number of old people, more "than you could assemble on our side of the water by sounding a trumpet and proclaiming a reward for the most venerable" (96). In explanation he suggests (in a list uncomfortably close to the television ads saturating our own nightly newscasts) that "hair-dyes, false teeth, modern arts of dress, and other contrivances of a skin-deep youthfulness, have not yet crept into these antiquated English towns" (96). The English "grow old without the weary necessity of seeming younger than they are" (96).

In "Outside Glimpses of English Poverty," the next-to-last essay in the volume, the oppositional tone is replaced by a tone of compassion. The ironically titled essay, compelling in its vigorous and unrelenting description of English slums and an almshouse, shows Hawthorne again looking beneath the façade, turning away from "the prosperous thoroughfares" to observe "precincts that reminded [him] of some of Dickens's grimiest pages" (V 277). He wanders the back streets with their gin shops and pawnbroker

establishments; he records the meager offerings in shop windows in Gogol-like details: "half-a-dozen wizened herrings, some eggs in a basket . . . fly-speckled biscuits, segments of a hungry cheese, pipes and papers of tobacco" (V 280). He writes that he is drawn to the "sombre phantasmagoric spectacle, exceedingly undelightful to behold, yet involving a singular interest and even fascination in its ugliness" (277). Here he is not a dispassionate Chillingworth or a "cold observer, looking on mankind as the subject of his experiment" (XI 99) like Ethan Brand, but the essayist intent on looking within his subject to discover his own moral position.

Arlin Turner comments that "Outside Glimpses of English Poverty" shows "how persistently the subject [of poverty] occupied his mind" (266). Visiting another room in the almshouse, after the episode of the foundling clinging to him, the narrator sees "a woman holding a baby, which, beyond all reach of comparison, was the most horrible object that ever afflicted my sight" (V 302). The baby

> was all covered with blotches, and preternaturally dark and discolored; it was withered away, quite shrunken and fleshless; it breathed only amid pantings and gaspings, and moaned painfully at every gasp. . . . Young as the poor little creature was, its pain and misery had endowed it with a premature intelligence, insomuch that its eyes seemed to stare at the bystanders out of their sunken sockets knowingly and appealingly, as if summoning us one and all to witness the deadly wrong of its existence. (303)

Although he has commented earlier in the essay, in the passage of Hawthorne describing Hawthorne, that he had the tendency to observe from an "insulated stand-point" and to put "ice into the blood" (300–301), clearly his compassion and moral judgment are evident here. "Outside Glimpses of English Poverty" ends by juxtaposing a luxurious English wedding, one the narrator had earlier observed, against the almshouse scenes. It is an affair of "joyful bells," "white drapery," and "shaven lawns" (308–9), and the narrator asks, "Is, or is not, the system wrong that gives one married pair so

immense a superfluity of luxurious home, and shuts out a million others from any home whatever?" (309).

Hawthorne's compassion and his genuine fascination with the underside of human life are also evident in an essay depicting the American scene, "Chiefly About War Matters," subtitled "By a Peaceable Man," published in the *Atlantic* in July 1862. In March of that year, in response to an invitation from Horatio Bridge, Hawthorne visited Washington, called on President Lincoln, went aboard the *Monitor*, watched General McClellan review his troops, and at Harper's Ferry visited the "old engine-house, rusty and shabby," that John Brown had used as a fortress ("War Matters" 327). Just as he had focused on the "horrible objects" in the English almshouse, here he focuses on a group of Confederate captives in "that dreary hole" of a fortress (330). Earlier, on the battlefield, one of them had "trampled the soul out of [the] body" of "a wounded Union soldier [who] had crept on hands and knees to his feet, and besought his assistance" (330). The Confederate was "a wild-beast of a man"; his face was "horribly ugly"; he "met nobody's eye, but kept staring upward into the smoky vacancy towards the ceiling, where, it might be, he beheld a continual portraiture of his victim's horror-stricken agonies" (330).

The scene echoes the description in "The Old Manse" of the boy at the Battle of Concord who "uplifted his axe, and dealt . . . a fatal blow" to the wounded British soldier "who raised himself painfully upon his hands and knees, and gave a ghastly stare" (X 9–10). In "Chiefly About War Matters" Hawthorne confronts not only the enormous issue of the morality and justification of the Civil War, but also the issue of the underside of the conflict, the sufferings of individuals caught up in it. In discussing "Chiefly About War Matters," Arlin Turner comments that the essay is "among the most helpful of his writings" in showing how Hawthorne's "mind worked and how he adapted the materials of observation to literary use" (364–65).

"Chiefly About War Matters" and the essays of *Our Old Home*
were both written with the readership of the *Atlantic Monthly* as a
shaping authority on Hawthorne, and here, in contrast to the earlier
publishing in *The Token*, market forces are a positive influence. The
Atlantic, founded in 1857, was purchased by Ticknor and Fields in
1859 while James Russell Lowell was still editor (Charvat *Profession*
170). It presented a more worldly audience than had the readership
of *The Token*, for whom Hawthorne had shaped his earlier sketches,
and it published the contemporary literary elite, including Oliver
Wendell Holmes, Thoreau, Edward Everett Hale, Whitman, Long-
fellow, and Henry Tuckerman, whose travel essays Hawthorne had
praised in "Up the Thames." Hawthorne was addressing a sophis-
ticated audience, in much the same way that modern essayists E. B.
White and John McPhee speak to the literate, eastern, upper-
middle-class readership of *The New Yorker*.

The audience Hawthorne addressed when he published essays in
the *Atlantic Monthly* was — in political terms at least — his adversary.
In 1903 M. A. DeWolfe Howe, in *Boston: The Place and the People*,
wrote that the "function of *The Atlantic*" was "to provide a full and
free opportunity for the expression" of three "strangely powerful
forces": "the spiritual cause of Transcendentalism," "the politico-
moral cause of antislavery," and "the intellectual and artistic interest
of purely creative writing" (242). Hawthorne was well aware that
his unsympathetic, non-Republican attitude toward the war would
antagonize the *Atlantic's* northern readership, and this awareness
accounts for the dialectical nature of the discourse and satirical tone
of the essay. The pro-Union position of Hawthorne's fellow authors
in the *Atlantic* is illustrated by Longfellow's patriotic poem about
the sinking of the Union sloop-of-war *Cumberland* by "the iron ship
of our foes" in the December 1862 issue (669–70), and by Whittier's
"The Battle Autumn of 1862" in the October issue of the same
year (510–11). Recognition of this historical context of "Chiefly
About War Matters" is helpful in analyzing the controversial dis-
course.

The rhetoric of "Chiefly About War Matters" refocuses attention on Hawthorne's shifting relationship with his text. Just as the introductory paragraphs to "The Custom-House" present a polyphonic conversation among "author," "reader," "some authors," "the inmost me," "editor," and several other speakers and listeners, so "Chiefly About War Matters" presents a multivocal text. Here Hawthorne uses footnotes — and undercuts the convention of the footnote as legitimate textual commentary or citation — to comment, as if in another persona, against his own text: narrative voice (Hawthorne) against footnote commentary (Hawthorne). In discussing John Brown after the visit to Harper's Ferry, Hawthorne writes that "nobody was ever more justly hanged" ("War Matters" 327). He continues, "any common-sensible man, looking at the matter unsentimentally, must have felt a certain intellectual satisfaction in seeing him hanged, if it were only in requital of his preposterous miscalculation of possibilities" (328). Anticipating the outcry from the North — and from his Concord friends in particular — for his unpopular stance, Hawthorne footnotes the passage just quoted with the following comment — humorous or sarcastic, depending on the reader: "Can it be a son of old Massachusetts who utters this abominable sentiment? For shame" (328). A year later Emerson cut out the preface — the dedicatory letter to Pierce — in his copy of *Our Old Home* (Howe *Memories* 15), and after Hawthorne's funeral Emerson wrote in his journal, on May 24, 1864, of "the painful solitude of the man" and of Hawthorne's "unwillingness and caprice" (*Journals* 306).[4]

Hawthorne glosses himself again in "Chiefly About War Matters." After observing the Confederate prisoners, he writes that it is "an immense absurdity that they should fancy us their enemies"; he continues, asserting that

> no human effort, on a grand scale, has ever yet resulted according to the purpose of its projectors. The advantages are always incidental. Man's accidents are God's purposes. We miss the good we sought, and do the good we little cared for. ("War Matters" 331–32)

The passage is footnoted, with the editorial "we" (Hawthorne) addressing "the author" (Hawthorne), and the footnote carries the ambiguous prediction that "the present war" will "illustrate our remark":

> The author seems to imagine that he has compressed a great deal of meaning into these little, hard, dry pellets of aphoristic wisdom. We disagree with him. The counsels of wise and good men are often coincident with the purposes of Providence; and the present war promises to illustrate our remark. (332)

Eight footnotes create a recurrent tension in the discourse of the essay, the contradictory voice from the bottom of the page in discord with the provocative analysis in the main text. In response to the narrator's comment that "it is so odd, when we measure our advances from barbarism, and find ourselves just here!" the debunking footnote voice retorts, "We hardly expected this outbreak in favor of war from the Peaceable Man; but the justice of our cause makes us all soldiers at heart, however quiet in our outward life" (321). And in reaction to the editorial excision of the portrait of Lincoln — whom Hawthorne referred to as "Uncle Abe," with hair that had seen "neither brush nor comb that morning" (310) — Hawthorne wrote in a letter to Fields, "What a terrible thing it is to try to let off a little bit of truth into this miserable humbug of a world!" (XVIII 461).

Henry James, along with many others, read the footnotes as additions by Hawthorne's editor at the *Atlantic*, noting only "the questionable taste of the editorial commentary, with which it is strange that Hawthorne should have allowed his article to be encumbered" (138–39). After consideration of the various manuscripts and letters involved in "Chiefly About War Matters," James Bense argues convincingly in "Nathaniel Hawthorne's Intention in 'Chiefly About War Matters'" (1989) that Hawthorne had conceived of the essay "as a censorship hoax" (200). "As a result of the con-

straints [Hawthorne] felt while trying to write honestly about the war," Bense says, "he created a satirical dialectic between his narrator and an imaginary editor" (200). Bense extends his observation of the dialectical nature of this essay, asserting that "the opposition within the essay is a corollary to the dialectical habit that probes for truth in much of [Hawthorne's] writing" (214). Bense's assertion congenially supports my own observations regarding the function of the oppositional rhetoric of the prefaces and essays.

"Leamington Spa," published in the October 1862 *Atlantic*, three months after "Chiefly About War Matters," includes a headnote addressed to "My Dear Editor" and signed by "A Peaceable Man," which is omitted from *The Centenary Edition*. Humor, irony, and ambiguity form a Hawthornian stew in the discourse of the headnote. The Peaceable Man, whose identity must have been clear to the *Atlantic* readership even though authorship in the magazine was identified only in a semiannual "Contents," refers to the editor's "cruel and terrible notes upon [his] harmless article in the July Number" (451). Thus, Hawthorne assumes yet another persona, commenting on his own editorial comments in the July issue. In the headnote the Peaceable Man, fully anticipating but seeming to relish the controversy he would create over his description of English womanhood in "Leamington Spa," concludes ironically,

> I cannot lose so good an opportunity of showing the world the placability and sweetness that adorn my character, and therefore send you another article, in which, I trust, you will find nothing to strike out, — unless, peradventure, you think that I may disturb the tranquillity of nations by my plan of annexing Great Britain, or my attempted adumbration of a fat English dowager! (451)

Perhaps a real anger at Ticknor and Fields's excision of the Uncle Abe profile — as well as the fundamental difference in Hawthorne's political views from his editors' — led to the inclusion of the "steaks and sirloins," a gratuitous and bizarre addition that diminishes the otherwise tasteful — if prickly — *Our Old Home*.

The closing lines of "Civic Banquets," the concluding essay of *Our Old Home*, serve as one of the last instances of Hawthorne's consciously addressing his readership, and the scene plays on the usual ambiguity about the composition of that audience. The English dignitaries who are gathered around the table to hear his after-dinner speech are an audience within the text, and the reader of the essay — in the shadows of the room or text — strains to hear the speech as well. The reader is maneuvered into the role of perpetual listener — perhaps one of "the few who will understand him, better than most of his schoolmates and lifemates" (I 3) — because he must imagine the words that do not follow in the text. Hawthorne stands, the audience applauds, silences, and waits for him to begin. The final lines of this last essay read:

> bidding my three friends bury me honorably, I got upon my legs to save both countries, or perish in the attempt. The tables roared and thundered at me, and suddenly they were silent again. But, as I have never happened to stand in a position of greater dignity and peril, I deem it a stratagem of sage policy here to close these Sketches, leaving myself still erect in so heroic an attitude. (V 345)

In "Some of the Haunts of Burns" Hawthorne ends the essay by suggesting that, after the visit to the places Burns knew, "there will be a personal warmth for us in everything that he wrote," that "we shall know him in a kind of personal way, as if we had shaken hands with him, and felt the thrill of his actual voice" (V 212). Hawthorne's own "actual voice" — distant, ambiguous, and slippery — is more difficult to isolate.

Notes

Notes to Chapter 1

1. The authorship of "My Wife's Novel" is contested. *The Centenary Edition* does not include it, even as an attributed tale. C. E. Frazer Clark, Jr., in *Nathaniel Hawthorne: A Descriptive Bibliography* (1978), describes it as "Attributed to Hawthorne by F. B. Sanborn, 'A New 'Twice-told Tale' by Nathaniel Hawthorne," *New-England Magazine*, n.s. 18 (August 1898), 688–696 (449). The Sanborn article, however, which deals with another sketch of contested authorship, "The Haunted Quack. A Tale of a Canal Boat," does not mention "My Wife's Novel." Nelson Adkins writes that the author is Edward Everett (365).

2. Douglas further describes "contemporary consolation literature":

> This enormously popular genre included obituary poems and memoirs, mourners' manuals, prayer guidebooks, hymns, and books about heaven. Such writings inflated the importance of dying and the dead by every possible means; they sponsored elaborate methods of burial and commemoration, communication with the next world, and microscopic viewings of a sentimentalized afterlife. (201–2)

Of the rural cemetery movement, Douglas writes,

> The intramural churchyard was replaced by the landscaped "garden" or "rural" cemetery, located away from the church on the outskirts of town or village. Developing awareness of the laws of hygiene in part motivated the shift from the old crowded churchyard to the spacious lawn cemetery; this awareness in no way accounts, however, for the conspicuous elaboration which characterized the layout and development of the new cemeteries. It is hardly surprising that the same groups who produced the consolation literature of the period promoted and extolled the rural cemetery and the innovative modes of burial which accompanied it. (208)

3. Such a rhetorical style need not necessarily be vague. Francis Christensen's 1963 study of several highly regarded modern American authors reveals that almost 95 percent of them use adverbial openers (9).

4. Wayne Allen Jones, in "The Hawthorne-Goodrich Relationship and a New Estimate of Hawthorne's Income from *The Token*," concludes that Benjamin is the author of the October 1831 *New-England Magazine* review of *The Atlantic Souvenir*. In support he cites Lillian B. Gilkes.

5. In 1833 Goodrich had purchased *The Atlantic Souvenir*, a rival gift book annual in Philadelphia, and merged it with *The Token* (Thompson 158).

6. In *Sensational Designs* Tompkins makes an error perhaps typical of modern critics who do not differentiate between Hawthorne's tales and his sketches. In discussing Poe's May 1842 review of *Twice-told Tales*, she writes that "the chief merit Poe recognizes in Hawthorne's tales is one that few modern commentators have seen: their repose. 'A painter,' Poe writes, 'would at once note their leading or predominant feature, and style it *repose*'" (11). In the review by Poe, however, he has just spent the preceding paragraph differentiating between Hawthorne's tales and his essays — or sketches (88). "Their" in the sentence Tompkins quotes clearly refers to the essays and not the tales. In modern critical discussions of Hawthorne, there is no clear demarcation between the tales (fiction) and the sketches, which contain elements of fiction and nonfiction. Even J. Donald Crowley slides from "sketch" to "tale" to "stories" interchangeably in one paragraph in discussing Hawthorne's work (XI 400).

7. Gilmore writes,

At a time when Hawthorne could hope to appeal to five or perhaps six thousand readers, a first novel by one of the female authors, Susan B. Warner's *The Wide, Wide World* (1850), amazed and delighted its publishers by selling over forty thousand copies in less than a year. The book went into its fourteenth printing by 1852 and eventually attracted more than a million buyers. (7)

8. Thomas Moore, 1779–1852, became the national bard of Ireland after he published his "Irish Melodies" in 1807. A romantic and sentimental lyricist, Moore was popular with Irish, English, and American audiences in the first decades of the nineteenth century. While still in his twenties, he traveled to America, visiting Niagara Falls and following a route similar to one Hawthorne would follow in 1832. In Moore's "Poems Relating to America," published in 1806, he writes disdainfully of "the inhabitants" in his preface:

The rude familiarity of the lower orders, and indeed of the unpolished state of society in general, would neither surprise nor disgust if they seemed to flow from that simplicity of character, that honest ignorance of the gloss of refinement, which may be looked for in a newer and

inexperienced people. But, when we find them arrived at maturity in most of the vices, and all the pride of civilization, while they are still so far removed from its higher and better characteristics, it is impossible not to feel that this youthful decay, this crude anticipation of the natural period of corruption, must repress every sanguine hope of the future energy and greatness of America. (166)

Notes to Chapter 2

1. Wayne Booth uses the concept of the "implied author" in *The Rhetoric of Fiction*.

2. William Charvat, in *Literary Publishing in America 1790–1850*, writes that "unexampled in the history of the profession [was] Irving's income of $23,500 in the year 1829 — all from books" (38), and that his income between 1829 and 1841 "ranged from $7000 in productive years, to a steady $1150 a year when he was being paid only for leases on his old works" (54–55).

3. Of Hawthorne's output during the Manse years, J. Donald Crowley writes, "Between July, 1842, and April, 1845, he published twenty-one new tales and sketches, an accomplishment equalling the most productive of his earlier years" (X 500).

4. Blair also says, of excessive use of exclamations,

> When an author is always calling upon us to enter into transports which he has said nothing to inspire, we are both disgusted and enraged at him. He raises no sympathy, for he gives us no passion of his own, in which we can take part. He gives us words, and not passion; and of course, can raise no passion, unless that of indignation. (358)

Examples of sketches that end with "insincere" exclamations are "Sunday at Home," "Little Annie's Ramble," "A Rill from the Town-Pump," "Sights from a Steeple," "Main-street," "My Visit to Niagara," "Fragments from the Journal of a Solitary Man," and "A Book of Autographs."

5. Charvat states that Cooper's average yearly income in the 1820s was $6,500 (38), and that before 1842, "when the bottom was dropping out of book prices," Cooper's "*Mohicans* sold for two dollars, sales were 5750, Cooper's rate was forty-three percent, and his returns were $5000" (54).

6. Contemporary critic Samuel W. S. Dutton commented on the pessimistic strain in Hawthorne, noting that he

> has a very pleasant and good natured, yet successful and effective way of hitting off, or satirizing the faults and foibles and errors of individuals and cliques, of schools, and communities, and ages. And, while he looks

with a kindly eye on human nature, and appreciates all its good qualities,
he seems to be aware of its dark depths and its universal fountain of
corruption. (137)

7. "Young Goodman Brown" was first published in the *New-England
Magazine* in April 1835, and "Night Sketches" three years later in the 1838
Token and Atlantic Souvenir. "Night Sketches" was published without attri-
bution (IX 574), and "Young Goodman Brown" was attributed to "the author
of 'The Gray Champion'" (X 573).

8. "Fragments from the Journal of a Solitary Man" was first published
without attribution in the *American Monthly* 10 (July 1837): 45–56.

Notes to Chapter 3

1. Ambiguous syntax can sometimes work to obscure meaning in the
tales as well. For example, in the last sentence of "The Wives of the Dead,"
the reader is uncertain whether it is Mary or Margaret who awakens: "But
her hand trembled against Margaret's neck, a tear also fell upon her cheek,
and she suddenly awoke" (XI 199).

2. In discussing "Monsieur du Miroir" in *The Shape of Hawthorne's Career*,
Nina Baym underscores the subversive nature of the rhetoric by pointing
out that "words like 'involuntarily,' 'wild,' 'blackness,' 'fated,' and finally
'awe' indicate the surrender of reason and the impulsion of imagination
past the limits of the decorous and sane" (63).

3. Aristotle, in Book III of *Rhetoric*, argues that "inappropriately poetic
language is both ridiculous and frigid; its verbosity also makes it obscure;
the accumulation of words which add nothing to the sense beclouds what
lucidity there is" (74).

4. In "Hawthorne's Stylistic Practice: A Crisis of Voice," Janice Milner
Lasseter argues that Hawthorne's prose shows "a crisis of voice, between
authorial voice and fictive voice, between reason and faith" (105). She
further suggests that this crisis of voice can be observed stylistically "in a
discourse of containment" (112) and a "syntax of antithesis . . . signalled
by parataxis" (113–14). She focuses on the split in compound-complex
sentences that are divided by a semicolon, and argues that this split reflects
"the collision of reason and faith" (107) in Hawthorne, particularly in the
tales. Her argument is insightful and helpful for my rhetorical analysis of
the sketches, but I would argue that it is the hypotactic, layered, veiled
sentence that more closely reflects Hawthorne's thematic concerns, and
not the balanced paratactic sentence — even though subordinating clauses
may constitute parts of the sentence on either side of the semicolon.

5. On June 28, 1832, Hawthorne wrote to his friend Franklin Pierce, who was then speaker of the New Hampshire legislature:

I was making preparations for a northern tour, when this accursed Cholera broke out in Canada. It was my intention to go by way of New-York and Albany to Niagara, from thence to Montreal and Quebec, and home through Vermont and New-Hampshire. I am very desirous of making this journey on account of a book by which I intend to acquire an (undoubtedly) immense literary reputation, but which I cannot commence writing till I have visited Canada. (XV 224)

6. Franklin B. Sanborn, in "A New Twice-Told Tale [sic], by Nathaniel Hawthorne" (New-England Magazine, n. s. 18 [August 1898]: 688–96), claimed that "The Haunted Quack" carried the "inimitable cachet" (688) of Hawthorne, but he gives no supporting evidence, either thematic or rhetorical.

7. Adkins writes that "objective evidence points to low degree of probability" that "The New England Village" is Hawthorne's work (365).

8. See Janice Milner Lasseter, "Hawthorne's Stylistic Practice," for a discussion of his style in the tales. For Hawthorne and feminist issues, see Nina Baym, "Thwarted Nature: Nathaniel Hawthorne as Feminist," in American Novelists Revisited: Essays in Feminist Criticism, ed. Fritz Fleischmann (Boston: G. K. Hall, 1982), 58–77, and The Shape of Hawthorne's Career. Also see Leland S. Person, Jr., Aesthetic Headaches: Women and Masculine Poetics in Poe, Melville, and Hawthorne (Athens: University of Georgia Press, 1988).

9. Nina Baym, in The Shape of Hawthorne's Career, writes that Hawthorne did not know his audience, a position I disagree with, given my analysis of the rhetoric of the early sketches. Baym writes:

Working in solitude, his pieces published anonymously, Hawthorne developed no real understanding of that audience whose favor he was soliciting; he was attempting to open an intercourse with a world he did not know. The audience he tried to please is one he invented, evidently composed of rational teachers and stern ministers — a readership of Parson Thumpcushions! (63–64)

10. Hoornstra and Heath write:

In 1837, Godey bought Mrs. Sarah J. Hale's Ladies' Magazine and obtained Mrs. Hale as editor; this marked the beginning of the magazine's best literary period. In the years between 1837 and 1850 all the popular

writers of the time appeared in its pages; contributors included Emerson, Longfellow, Holmes, Hawthorne, Harriet Beecher Stowe, and Edgar Allan Poe; in addition to tales and poetry, contents included light essays, biography, sketches, humor, book reviews, recipes, and articles on music, art, fashions, health, and beauty. Sentiment was abundant, and politics were excluded, but much on the education of women appeared. (93)

11. This is not always the case, however. Strunk and White do not use figures, nor does Wayne Booth or Clifford Geertz.

Notes to Chapter 4

1. Timothy Dow Adams, in "To Prepare a Preface to Meet the Faces that You Meet: Autobiographical Rhetoric in Hawthorne's Prefaces," points out that several tales and romances have prefaces embedded in them. "Many of Hawthorne's tales are prefaced by a brief statement that purports to speak with authority for the authenticity of the story," he writes, citing as examples "The May-Pole of Merry Mount" and "Egotism, or the Bosom Serpent" (90). He also demonstrates that in *The Blithedale Romance* there are "two fictional prefaces within the novel" (96).

2. *The United States Magazine and Democratic Review* was started in 1837 by John O'Sullivan. James R. Mellow writes that "O'Sullivan managed to secure contributions from all the most important authors of the period — Lowell, Whittier, Bryant, Poe, Longfellow, Thoreau, Bancroft, and Orestes Brownson" (85). The magazine had a definite political agenda, which was "to counteract the influence of such established Whig journals as the *North American Review*" (85).

One of the titles that Hawthorne lists as coming from Aubépine's recent works, "La Soirée du Chateau en Espagne," is not a translation of a title of a published Hawthorne story or sketch; it is either a reference to a lost tale or a whimsical coinage. The others are quickly identifiable: "Le Voyage Céleste à Chemin de Fer," "Le nouveau Père Adam et la nouvelle Mère Eve," "Roderic; ou le Serpent à l'estomac," "Le Culte du Feu," and "L'Artiste du Beau; ou le Papillon Mécanique."

3. Hugh Blair, in *Lectures on Rhetoric and Belles Lettres*, "Lecture XI: Structure of Sentences," comments:

I proceed to a third rule, for preserving the Unity of Sentences; which is, to keep clear of all Parentheses in the middle of them. On some occasions, these may have a spirited appearance; as prompted by a

certain vivacity of thought, which can glance happily aside, as it is going along. But, for the most part, their effect is extremely bad; being a sort of wheels within wheels; sentences in the midst of sentences; the perplexed method of disposing of some thought, which a writer wants art to introduce in its proper place. (222)

4. Arlin Turner writes that "In creating such a character as Judge Pyncheon, an esteemed public figure, but despicable in his display of beneficence to conceal selfishness and vindictiveness, Hawthorne could not have failed to think of Upham" (229). Randall Stewart, a little more circumspect, says "Hawthorne presumably pilloried Upham in the character of Judge Pyncheon" (89).

5. Turner writes that "Horatio Bridge remembered Hawthorne's telling him that once when he declaimed in school at the age of twelve or thirteen he was ridiculed by older boys" (39).

6. The offending dedication reads, "To Franklin Pierce, as a slight memorial of a college friendship, prolonged through manhood, and retaining all its vitality in our autumnal years, this volume is inscribed by Nathaniel Hawthorne" (V 2).

Notes to Chapter 5

1. Rita K. Gollin and John L. Idol, Jr., discuss Hawthorne's use of paintings in *Prophetic Pictures: Nathaniel Hawthorne's Knowledge and Uses of the Visual Arts* (New York: Greenwood Press, 1991).

2. On a dining room windowpane in the Manse, facing north, Sophia later inscribed:

Endymion painted in this
 room — finished January 20
 1844

 Una Hawthorne
 stood on this window
 sill January 22d 1845
while the trees were all
glass chandeliers a goodly
show which she liked
much tho' only ten
months old

3. On his European travels Hawthorne noted at least two reactions to Velázquez's work, although in all probability he never saw *Las Meninas*. At

an exhibition in Old Trafford, England, on August 2, 1857, he wrote that
"some portraits by Murillo, Velásquez, and Titian, were those which I
seemed most able to appreciate; and I see reason for allowing . . . that a
portrait may preserve valuable characteristics of the person represented"
(*English Notebooks* 555). (See Rita K. Gollin's discussion of Hawthorne's
visit to the exhibition in "'Getting a Taste for Pictures': Hawthorne at the
Manchester Exhibition.") On March 10, 1858, after visiting the Doria
Pamfili palace in Rome where Velázquez's portrait of Pope Innocent X
(c. 1650) hangs, Hawthorne wrote,

> One [painter] in a thousand, perhaps, ought to live in the applause of
> men from generation to generation, till his colors fade or blacken out
> of sight, and his canvas rots away; the rest should be put up garret, or
> painted over by newer artists, just as tolerable poets are shelved when
> their little day is over. Nevertheless, there was one long gallery, con-
> taining many pictures that I should be glad to see again. (XIV 126)

4. Chapter 1 of Michel Foucault's *The Order of Things* is an analysis of the
representation of space as well as of the "mirrors, reflections, imitations,
and portraits" in *Las Meninas* (16).

Notes to Chapter 6

1. Poe, in a review of *Twice-told Tales* in the April 1842 *Graham's Magazine*,
wrote that "most of them are essays properly so called. It would have been
wise in their author to have modified his title, so as to have reference to
all included" (85). In the May 1842 issue of *Graham's Magazine* he writes
that "many of them are pure essays; for example, 'Sights from a Steeple,'
'Sunday at Home,' 'Little Annie's Ramble,' 'A Rill from the Town-Pump,'
'The Toll-Gatherer's Day,' 'The Haunted Mind,' 'The Sister Years,' 'Snow-
Flakes,' 'Night Sketches,' and 'Foot-Prints on the Sea-Shore'" (87). Poe
adds that the "predominant feature" of the essays is "*repose*. There is no
attempt at effect. All is quiet, thoughtful, subdued" (88).
2. "Leamington Spa" was published in the *Atlantic Monthly* 7 (October
1862): 451–62; "About Warwick" was published in the *Atlantic Monthly* 10
(December 1862): 708–20; "Recollections of a Gifted Woman" was pub-
lished in the *Atlantic Monthly* 11 (January 1863): 43–58; "Pilgrimage to
Old Boston" was published in the *Atlantic Monthly* 9 (January 1862): 88–
101; "Near Oxford" was published in the *Atlantic Monthly* 8 (October 1861):
385–97; "Some of the Haunts of Burns" was published in the *Atlantic
Monthly* 6 (October 1860): 385–95; "A London Suburb" was published in
the *Atlantic Monthly* 11 (March 1863): 306–21; "Up the Thames" was

published in the *Atlantic Monthly* 11 (May 1863): 598–614; "Outside Glimpses of English Poverty" was published in the *Atlantic Monthly* 12 (July 1863): 36–51; and "Civic Banquets" was published in the *Atlantic Monthly* 12 (August 1863): 195–212 (V liv–lviii).

3. In an unsigned essay on *Our Old Home*, "A Handful of Hawthorne," in *Punch* 79 (October 17, 1863) the reviewer noted, "You have written a book about England, and into this book you have put all the caricatures and libels upon English folk, which you collected while enjoying our hospitality" (392). In the same essay Hawthorne's description of English matrons was termed "calmly terrible" (394). Henry Bright in the *Examiner* (October 17, 1863) wrote that Hawthorne's characterizations of the English were "cynical and contemptuous" (396). The anonymous reviewer in *Blackwood's Magazine* 94 (November 1863) responded to *Our Old Home* by writing, in "Hawthorne on England," that the English "shall not be more bulbous, longer-bodied, or shorter-legged, in consequence of the publication of his book — and that our women will still charm our purblind race though they have not the stamp of Mr. Hawthorne's approbation" (402).

4. Ticknor and Fields deleted, before publication in the *Atlantic*, several paragraphs of "Chiefly About War Matters" that gave an unflattering portrait of Lincoln to the abolitionist northern readership. Hawthorne wrote to Fields on May 23, 1862, complaining that Fields was omitting "the only part of the article really worth publishing" (XVIII 461). Hawthorne was, as we have seen, at political cross-purposes with the abolitionist stance of the *Atlantic*; his ambiguous footnotes in "Chiefly About War Matters" and the preface to *Our Old Home* further provoked his readers.

Works Cited

Adams, Timothy Dow. "To Prepare a Preface to Meet the Faces that You Meet: Autobiographical Rhetoric in Hawthorne's Prefaces." *ESQ: A Journal of the American Renaissance* 23 (1977): 89–98.

Adkins, Nelson. "Notes on the Hawthorne Canon." *Papers of the Bibliographical Society of America* 60 (1966): 365–67.

Anhorn, Judy Schaaf. "Literary Reputation and the Essays of *Our Old Home.*" *Studies in the Novel* 23 (1991): 152–66.

Aristotle. *Rhetoric.* In *On Poetry and Style.* Trans. G. M. A. Grube. New York: Bobbs-Merrill, 1958, 65–100.

Atwan, Robert. Foreword. In *The Best American Essays 1990.* Ed. Justin Kaplan. New York: Ticknor & Fields, 1990, ix–xii.

Baigell, Matthew. *Thomas Cole.* New York: Watson-Guptill, 1981.

Bales, Kent. "Hawthorne's Prefaces and Romantic Perspectivism." *ESQ: A Journal of the American Renaissance* 23 (1977): 69–88.

Baym, Nina. *The Shape of Hawthorne's Career.* Ithaca: Cornell University Press, 1976.

———. "Thwarted Nature: Nathaniel Hawthorne as Feminist." In *American Novelists Revisited: Essays in Feminist Criticism.* Ed. Fritz Fleischmann. Boston: G. K. Hall, 1982, 58–77.

Beers, Henry A. *Nathaniel Parker Willis.* Boston: Houghton Mifflin, 1885.

[Benjamin, Park]. Review of *The Atlantic Souvenir* for 1832. *New-England Magazine* 4 (1831): 357–59.

———. Review of *The Token* for 1832. *New-England Magazine* 4 (1831): 356–57.

———. Review of *The Token and Atlantic Souvenir* for 1836. *New-England Magazine* 9 (1835): 294–98.

Bense, James. "Nathaniel Hawthorne's Intention in 'Chiefly About War Matters.'" *American Literature* 61 (1989): 200–214.

Bizzell, Patricia, and Bruce Herzberg, eds. *The Rhetorical Tradition: Readings from Classical Times to the Present.* Boston: St. Martin's Press, 1990.

Blair, Hugh. *Lectures on Rhetoric and Belles Lettres* (1783). Ed. Harold F. Harding. Vol. 1. Carbondale: Southern Illinois University Press, 1965.

Booth, Wayne C. *The Rhetoric of Fiction.* 1961. Chicago: University of Chicago Press, 1968.

Brand, Dana. "The Panoramic Spectator in America: A Re-Reading of Some of Hawthorne's Sketches." *American Transcendental Quarterly: A Journal of New England Writers* 59 (1986): 5–17.

Briggs, Samuel. *The Essays, Humor, and Poems of Nathaniel Ames.* Cleveland: Short & Forman, 1891.

Bright, Henry. Review of *Our Old Home. Examiner* (October 17, 1863): 662–63. Rpt. in *Hawthorne: The Critical Heritage.* Ed. J. Donald Crowley. New York: Barnes and Noble, 1970, 395–98.

Brodhead, Richard H. *The School of Hawthorne.* New York: Oxford University Press, 1986.

Brownson, Orestes. Review of *The Scarlet Letter. Brownson's Quarterly Review* n.s. 5 (1850): 528–32. Rpt. in *Hawthorne: The Critical Heritage.* Ed. J. Donald Crowley. New York: Barnes and Noble, 1970, 175–79.

The Century Dictionary. Ed. William D. Whitney. 6 vols. New York: Century, 1889.

Charvat, William. *Literary Publishing in America: 1790–1850.* Philadelphia: University of Pennsylvania Press, 1959.

———. *The Origins of American Critical Thought: 1810–1835* (1936). New York: Russell & Russell, 1968.

———. *The Profession of Authorship in America, 1800–1870: The Papers of William Charvat.* Ed. Matthew J. Bruccoli. Columbus: Ohio State University Press, 1968.

Chorley, Henry F. Review of *Mosses from an Old Manse. Athenaeum* (August 8, 1846): 807–8. Rpt. in *Hawthorne: The Critical Heritage.* Ed. J. Donald Crowley. New York: Barnes and Noble, 1970, 104–6.

Christensen, Francis. "Notes Toward a New Rhetoric." *College English* 25 (1963): 9–18.

Clark, C. E. Frazer, Jr. *Nathaniel Hawthorne: A Descriptive Bibliography.* Pittsburgh: University of Pittsburgh Press, 1978.

Cole, Thomas. *Thomas Cole's Poetry.* Ed. Marshall B. Tymn. York, Pa.: Liberty Cap Books, 1972.

Corbett, Edward P. J. *Classical Rhetoric for the Modern Student.* 3d ed. New York: Oxford University Press, 1990.

———. *Selected Essays of Edward P. J. Corbett.* Ed. Robert J. Connors. Dallas: Southern Methodist University Press, 1989.

Crowley, J. Donald, ed. *Hawthorne: The Critical Heritage.* New York: Barnes and Noble, 1970.

Davis, Rebecca Harding. *Life in the Iron-Mills* (1861). In *The Norton Anthology*

of American Literature. Ed. Nina Baym et al. 3d ed. Vol. 1. New York:
 W. W. Norton, 1989, 2411–37.

Dewey, Orville. "The Mysteries of Life." In The Token: A Christmas and New
 Year's Present. Ed. S. G. Goodrich. Boston: Gray and Bowen, 1831,
 2–23.

Dickinson, Emily. The Complete Poems of Emily Dickinson. Ed. Thomas H.
 Johnson. Boston: Little, Brown, 1960.

Dillard, Annie. Introduction. In The Best American Essays 1988. Ed. Annie
 Dillard and Robert Atwan. New York: Ticknor & Fields, 1988, xiii–
 xxii.

Douglas, Ann. The Feminization of American Culture. New York: Alfred A.
 Knopf, 1977.

Dutton, Samuel W. S. "Hawthorne and the Natural Style." New Englander
 5 (1847): 56–69. Rpt. in Hawthorne: The Critical Heritage. Ed.
 J. Donald Crowley. New York: Barnes and Noble, 1970, 135–40.

Duyckinck, E. A. "Nathaniel Hawthorne." Democratic Review 16 (1845):
 376–84. Rpt. in Hawthorne: The Critical Heritage. Ed. J. Donald
 Crowley. New York: Barnes and Noble, 1970, 96–100.

Elbow, Peter. "The Pleasures of Voice in the Literary Essay: Explorations
 in the Prose of Gretel Ehrlich and Richard Selzer." In Literary
 Nonfiction: Theory, Criticism, Pedagogy. Ed. Chris Anderson. Carbon-
 dale: Southern Illinois University Press, 1989, 211–34.

Eliot, T. S. "From Poe to Valéry." Hudson Review (Autumn 1949). Rpt. in
 The Recognition of Edgar Allan Poe. Ed. Eric W. Carlson. Ann Arbor:
 University of Michigan Press, 1966, 205–19.

Emerson, Ralph Waldo. The Heart of Emerson's Journals. Ed. Bliss Perry. New
 York: Dover, 1958.

———. "Spiritual Laws." In The Selected Writings of Ralph Waldo Emerson.
 Ed. Brooks Atkinson. New York: Modern Library, 1950, 190–209.

Fleming, William. Arts and Ideas. 3d ed. New York: Holt, Rinehart and
 Winston, 1975.

Flower, Dean. "The Hallucination of Landscape." Hudson Review 41 (1989):
 745–51.

Foucault, Michel. The Order of Things: An Archaeology of the Human Sciences
 (1966). New York: Vintage, 1973.

Franzosa, John. "A Psychoanalysis of Hawthorne's Style." Genre 14 (1981):
 383–409.

Fuller, Margaret. "The Great Lawsuit" (1843). In The Norton Anthology of
 American Literature. Ed. Nina Baym et al. 3d ed. Vol. 1. New York:
 W. W. Norton, 1989, 1515–31.

Gibson, Walker. "Authors, Speakers, Readers, and Mock Readers." *College English* 11 (1950): 265–69. Rpt. in *Reader-Response Criticism: From Formalism to Post-Structuralism.* Ed. Jane P. Tompkins. Baltimore: Johns Hopkins University Press, 1980. 1–6.

Gilkes, Lillian B. "Hawthorne, Park Benjamin, and S. G. Goodrich: A Three-Cornered Imbroglio." In *The Nathaniel Hawthorne Journal 1971.* Ed. C. E. Frazer Clark, Jr. Washington: Microcard Editions, 1971, 83–112.

Gilmore, Michael T. *American Romanticism and the Marketplace.* Chicago: University of Chicago Press, 1985.

Gollin, Rita K. "'Getting a Taste for Pictures': Hawthorne at the Manchester Exhibition." In *The Nathaniel Hawthorne Journal 1977.* Ed. C. E. Frazer Clark, Jr. Detroit: Bruccoli-Clark, 1980.

Gollin, Rita K., and John L. Idol, Jr. *Prophetic Pictures: Nathaniel Hawthorne's Knowledge and Uses of the Visual Arts.* New York: Greenwood Press, 1991.

Goodrich, S. G. "Lake Superior." In *The Token.* Ed. S. G. Goodrich. Boston: Gray and Bowen, 1831, 52–54.

Gray, J. L. "The Muse and the Album." Rpt. in Park Benjamin, "Review of *The Token and Atlantic Souvenir.*" *New-England Magazine* 9 (1835): 297.

Gura, Philip. *The Wisdom of Words: Language, Theology, and Literature in the New England Renaissance.* Middletown, Conn.: Wesleyan University Press, 1981.

Hale, Sarah J. "The 'Conversazione.'" *The Lady's Book* 14 (January 1837): 1–5.

Hall, James. "The Village Musician." In *The Token.* Ed. S. G. Goodrich. Boston: Gray and Bowen, 1831, 216–46.

"A Handful of Hawthorne." *Punch* 79 (October 17, 1863): 339–40. Rpt. in *Hawthorne: The Critical Heritage.* Ed. J. Donald Crowley. New York: Barnes and Noble, 1970, 392–98.

Harbison, Robert. "On the Hudson River School." *Partisan Review* 56 (1989): 468–72.

Harding, Harold F. Introduction. In Hugh Blair, *Lectures on Rhetoric and Belles Lettres* (1783). Ed. Harold F. Harding. Vol. 1. Carbondale: Southern Illinois University Press, 1965, vii–xl.

Hastings, Louise. "An Origin for 'Dr. Heidegger's Experiment.'" *American Literature* 9 (1938): 403–10.

Hawthorne, Nathaniel. *The Centenary Edition of the Works of Nathaniel Hawthorne.* Ed. William Charvat, Roy Harvey Pearce, Claude M. Simp-

son, and Thomas Woodson. 20 vols. Columbus: Ohio State University Press, 1962–88.

——— . "Chiefly About War Matters" (1862). In *The Complete Works of Nathaniel Hawthorne*. Ed. George Parsons Lathrop. Vol. XII. Boston: Houghton, Mifflin, 1883, 299–345.

——— . *The English Notebooks*. Ed. Randall Stewart. New York: MLA of America, 1941.

——— . "Leamington Spa." *Atlantic Monthly* 10 (1862): 451–62.

Hawthorne, Una. Preface to *Septimus Felton; or the Elixir of Life*. In *The Complete Works of Nathaniel Hawthorne*. Ed. George Parsons Lathrop. Vol. XI. Houghton, Mifflin, 1883, 227.

"Hawthorne on England." *Blackwood's Magazine* 94 (November 1863): 610–23. Rpt. in *Hawthorne: The Critical Heritage*. Ed. J. Donald Crowley. New York: Barnes and Noble, 1970, 398–404.

Hiatt, Mary. *The Way Women Write*. New York: Teachers College Press, 1977.

Hijiya, James A. "Nathaniel Hawthorne's *Our Old Home*." *American Literature* 46 (1974): 363–73.

Hoffman, Daniel. *Poe Poe Poe Poe Poe Poe Poe*. New York: Anchor Press, 1973.

Holman, C. Hugh, and William Harmon. *A Handbook to Literature*. 5th ed. New York: Macmillan, 1986.

Hoornstra, Jean, and Trudy Heath, eds. *American Periodicals 1741–1900*. Ann Arbor: University Microfilms International, 1979.

Howe, M. A. DeWolfe. *Boston: The Place and the People*. New York: Macmillan, 1903.

——— . *Memories of a Hostess*. Boston: Atlantic Monthly Press, 1922.

Howells, William Dean. *Certain Delightful English Towns*. New York: Harper & Brothers, 1906.

Hull, Raymona E. "Nathaniel Hawthorne's 'Old Home.'" *American Transcendental Quarterly: A Journal of New England Writers* 50 (1981): 83–91.

Irving, Washington. *The Alhambra* (1832). Ed. William T. Lenehan and Andrew B. Myers. Boston: Twayne, 1983.

——— . "The Legend of Sleepy Hollow" (1820). In *The Norton Anthology of American Literature*. Ed. Nina Baym et al. 3d ed. Vol. 1. New York: W. W. Norton, 1989, 822–42.

——— . "The Author's Account of Himself" (1819). In *The Norton Anthology of American Literature*. Ed. Nina Baym et al. 3d ed. Vol. 1. New York: W. W. Norton, 1989, 808–10.

James, Henry. *Hawthorne* (1879). Ithaca: Cornell University Press, 1956.

Jones, Wayne Allen. "The Hawthorne-Goodrich Relationship and a New Estimate of Hawthorne's Income from *The Token*." In *The Nathaniel Hawthorne Journal 1975*. Ed. C. E. Frazer Clark, Jr. Englewood, Colo.: Microcard Editions, 1975, 91–140.

Kahr, Madlyn Millner. *Velázquez: The Art of Painting*. New York: Harper & Row, 1976.

Kaplan, Justin. Introduction. In *The Best American Essays 1990*. Ed. Justin Kaplan. New York: Ticknor & Fields, 1990, xiii–xix.

Kesselring, Marion L. *Hawthorne's Reading 1828–1850: A Transcription and Identification of Titles Recorded in the Charge-Books of the Salem Athenaeum*. New York: New York Public Library, 1949.

Lanham, Richard A. *Analyzing Prose*. New York: Charles Scribner's Sons, 1983.

———. *A Handlist of Rhetorical Terms*. 2d ed. Berkeley: University of California Press, 1991.

Lathrop, George Parsons, ed. *The Complete Works of Nathaniel Hawthorne*. Vol. IV. Boston: Houghton, Mifflin, 1883.

Lasseter, Janice Milner. "Hawthorne's Stylistic Practice: A Crisis of Voice." *American Transcendental Quarterly* 4 (1990): 105–22.

Longfellow, Henry Wadsworth. "The Cumberland." *Atlantic Monthly* 10 (December 1862): 669–70.

———. Review. *North American Review* 56 (1842): 496–99. Rpt. in *Hawthorne: The Critical Heritage*. Ed. J. Donald Crowley. New York: Barnes and Noble, 1970, 80–83.

Lueck, Beth L. "Hawthorne's Ironic Traveler and the Picturesque Tour." In *Hawthorne's American Travel Sketches*. Ed. Alfred Weber, Beth L. Lueck, and Dennis Berthold. Hanover, N.H.: University Press of New England, 1989, 153–80.

McCall, Dan. "Hawthorne's 'Familiar Kind of Preface.'" *ELH* 35 (1968): 422–39.

Mellow, James R. *Nathaniel Hawthorne in His Times*. Boston: Houghton Mifflin, 1980.

Melville, Herman. "Hawthorne and His Mosses. By a Virginian Spending His Summer in Vermont." *Literary World* 7 (August 17 and 24, 1850): 125–27, 145–47. Rpt. in *Hawthorne: The Critical Heritage*. Ed. J. Donald Crowley. New York: Barnes and Noble, 1970, 111–26.

———. *Moby-Dick* (1851). Ed. Alfred Kazin. Boston: Houghton Mifflin, 1956.

Mills, Sara. "The Male Sentence." *Language and Communication* 7 (1987): 189–98.

Montaigne, Michel de. *The Complete Essays of Montaigne* (1580). Trans. Donald M. Frame. Stanford: Stanford University Press, 1989.

Moore, Thomas. *The Poetical Works of Thomas Moore.* New York: Worthington, 1887.

"The New England Village." In *The Token; A Christmas and New Year's Present.* Ed. S. G. Goodrich. Boston: Gray and Bowen, 1831, 155–76.

Newman, Samuel Phillips. *A Practical System of Rhetoric, or the Principles and Rules of Style, Inferred from Examples of Writing.* 3d ed. Boston: William Hyde, 1832.

Noble, Louis Legrand. *The Life and Works of Thomas Cole.* Ed. Elliot S. Vesell. Cambridge, Mass.: Belknap Press of Harvard University, 1964.

Ong, Walter J. "The Writer's Audience Is Always a Fiction." *PMLA* 90 (1975): 9–21.

Peabody, Andrew Preston. Review of *Twice-told Tales. Christian Examiner* 25 (1838): 182–90. Rpt. in *Hawthorne: The Critical Heritage.* Ed. J. Donald Crowley. New York: Barnes and Noble, 1970, 64–67.

Penrose, Roland. *Picasso: His Life and Work* (1958). New York: Harper & Row, 1973.

Person, Leland S., Jr. *Aesthetic Headaches: Women and Masculine Poetics in Poe, Melville, and Hawthorne.* Athens: University of Georgia Press, 1988.

Poe, Edgar Allan. "The Fall of the House of Usher" (1839). In *Selected Prose, Poetry, and Eureka.* Ed. W. H. Auden. New York: Holt, Rinehart and Winston, 1950, 1–21.

———. "The Philosophy of Composition" (1846). In *Edgar Allan Poe: Essays and Reviews.* New York: Library of America, 1984, 13–25.

———. Review of *Twice-told Tales. Graham's Magazine* 20 (April 1842): 254. Rpt. in *Hawthorne: The Critical Heritage.* Ed. J. Donald Crowley. New York: Barnes and Noble, 1970, 84–85.

———. Review of *Twice-told Tales. Graham's Magazine* 20 (May 1842): 298–300. Rpt. in *Hawthorne: The Critical Heritage.* Ed. J. Donald Crowley. New York: Barnes and Noble, 1970, 87–94.

Pound, Ezra. "Hugh Selwyn Mauberley" (1920). In *The Norton Anthology of Modern Poetry.* Ed. Richard Ellmann and Robert O'Clair. 2d ed. New York: W. W. Norton, 1988, 382–89.

Prince, Gerald. "Introduction to the Study of the Narratee." *Poétique* 14 (1973): 177–96. Rpt. in *Reader-Response Criticism: From Formalism to*

Post-Structuralism. Ed. Jane P. Tompkins. Baltimore: Johns Hopkins University Press, 1980, 7–25.

Rygiel, Dennis. "Stylistics and the Study of Twentieth-Century Literary Nonfiction." In *Literary Nonfiction: Theory, Criticism, Pedagogy*. Ed. Chris Anderson. Carbondale: Southern Illinois University Press, 1989, 29–50.

S., E. "A Rencontre on the Alleghanies." *New-England Magazine* 7 (November 1834): 359–65.

Sanborn, Franklin B. "A New Twice-Told Tale by Nathaniel Hawthorne." *New-England Magazine* n.s. 18 (August 1898): 688–96.

Sedgwick, Catherine. "Mary Dyre." In *The Token; A Christmas and New Year's Present*. Ed. S. G. Goodrich. Boston: Gray and Bowen, 1831, 294–312.

Sidney, Sir Philip. "The Defence of Poesy" (1595). In *The Norton Anthology of English Literature*. 5th ed. Ed. M. H. Abrams et al. New York: W. W. Norton, 1986.

Sigourney, L. H. "Solace in Adversity." In *The Christian Keepsake and Missionary Annual*. Ed. Rev. John A. Clark. Philadelphia: William Marshall and Co., 1839, 78–81.

Stewart, Randall. *Nathaniel Hawthorne*. New Haven: Yale University Press, 1948.

Stern, Milton R. *Contexts for Hawthorne: The Marble Faun and the Politics of Openness and Closure in American Literature*. Urbana: University of Illinois Press, 1991.

Stowe, Harriet Beecher. "Let Every Man Mind His Own Business." In *The Christian Keepsake and Missionary Annual*. Ed. Rev. John A. Clark. Philadelphia: William Marshall and Co., 1839, 239–64.

Stowell, Marion Barber. "The Influence of Nathaniel Ames on the Literary Taste of His Time." *Early American Literature* 18 (1983): 127–45.

Strunk, William, Jr., and E. B. White. *The Elements of Style*. New York: Macmillan, 1966.

Thatcher, B. B. "The Last Request." In *The Token; A Christmas and New Year's Present*. Ed. S. G. Goodrich. Boston: Gray and Bowen, 1831, 319–20.

Thompson, Ralph. *American Literary Annuals & Gift Books: 1825–1865*. New York: H. W. Wilson, 1936.

Thoreau, Henry David. *Walden; or, Life in the Woods* (1854). New York: Rinehart & Co., 1958.

The Token; A Christmas and New Year's Present. Ed. S. G. Goodrich. Boston: Gray and Bowen, 1831.

Tompkins, Jane P. "An Introduction to Reader-Response Criticism." In *Reader-Response Criticism: From Formalism to Post-Structuralism.* Ed. Jane P. Tompkins. Baltimore: Johns Hopkins University Press, 1980, ix–xxvi.

———. *Sensational Designs: The Cultural Work of American Fiction 1790–1860.* New York: Oxford University Press, 1985.

Tuckerman, Henry T. *A Month in England* (1853). Gloucester, Eng.: Alan Sutton, 1982.

Turner, Arlin. *Nathaniel Hawthorne: A Biography.* New York: Oxford University Press, 1980.

Tymn, Marshall B. Introduction. In Thomas Cole, *Thomas Cole's Poetry.* Ed. Marshall B. Tymn. York, Pa.: Liberty Cap Books, 1972, 15–24.

van Deusen, Marshall. "Narrative Tone in 'The Custom-House' and *The Scarlet Letter.*" *Nineteenth-Century Fiction* 21, no. 1 (1966): 61–71.

Van Tassel, Mary M. "Hawthorne, His Narrator, and His Readers in 'Little Annie's Ramble.'" *ESQ: A Journal of the American Renaissance* 33 (1987): 168–79.

Waggoner, Hyatt H. "The New Hawthorne Notebook: Further Reflections on the Life and Work." *Novel: A Forum on Fiction* 11 (1978): 218–26.

———. *The Presence of Hawthorne.* Baton Rouge: Louisiana State University Press, 1979.

Wallace, James D. "Hawthorne and the Scribbling Women Reconsidered." *American Literature* 62 (1990): 201–22.

Weber, Alfred, Beth L. Lueck, and Dennis Berthold. *Hawthorne's American Travel Sketches.* Hanover, N.H.: University Press of New England, 1989.

Whittier, John G. "The Battle Autumn of 1862." *Atlantic Monthly* 10 (October 1862): 510–11.

Winterowd, W. Ross. *The Rhetoric of the "Other" Literature.* Carbondale: Southern Illinois University Press, 1990.

Zagarell, Sandra A. "Narrative of Community: The Identification of a Genre." *Signs: Journal of Women in Culture and Society* 13 (1988): 498–527.

Index